THE CREATION

REVISED EDITION

THE

A STUDIO BOOK

CREATION

ERNST HAAS

THE VIKING PRESS · NEW YORK

V.S.W.
Gift of publisher
Nov 14, 1984

Revised edition copyright © 1983 by Ernst Haas
First edition copyright © 1971 by Ernst Haas

Revised edition published in 1983 by
The Viking Press
A Studio Book
40 West 23rd Street
New York, N.Y. 10010

Published simultaneously in Canada by
Penguin Books Canada Limited

Library of Congress Cataloging in Publication Data

Haas, Ernst, 1921–
 The creation.

 (A Studio book)
1. Color photography. 2. Photography, Artistic.
 3. Creation. I. Title.
TR510.H25 1983 779'.3 83-1194
 ISBN 0-670-24591-7

The account of Genesis is from the
King James Version of the Bible.

The selection from the Rig Veda is taken from
Mircea Eliade, *From Primitives to Zen:
A Thematic Sourcebook of the History of Religions*,
page 110, © 1967 by Mircea Eliade; reprinted by
permission of Harper & Row, Publishers, Inc.

The selection from the Tao-Te King is taken
from *The Tao Te Ching* as it appears in
The Viking Portable World Bible,
edited by R. Ballou, copyright 1944,
renewed © 1972 by R. Ballou; reprinted by permission
of Viking Penguin Inc.

Set in Caslon
Printed in Japan by Dai Nippon Printing Company Ltd.

Contents

Acknowledgments

This book
is dedicated to my children
Alexander and Victoria
and to the memory of my mother

Among those people who have helped me
during its preparation
I am particularly indebted to the following:
Bryan Holme
Mauro and Marina Filicori
Marilyn Schroeder
Helen Wright
Dan Budnik
Takeko Kawai

6

Preface to the Revised Edition

Books lead strange, uncalculated lives. Some grow up and become very independent, make their own friends, and transform themselves into many languages so that their influence goes far beyond the original intention. *The Creation* is a book like that. Just a little over ten years old, it has brought new friends from all over the world into my life. One can even say that it has dominated all the other books I have done, and has made me what I never intended to be, a photographer of nature (though this is only one sector in the circle of my interests). Regardless of the main subjects of one's fascination, it seems that all of them have open ends.

I can truly say that all of my books are unfinished, for even after a book is published I continue photographing on its theme. After a few years, my earlier mistakes become more ob-

vious and these, together with all of the new images I have photographed, create in me a secret desire to do a revised edition.

The day finally came when I was told that the old plates of *The Creation* were no longer usable. *The Creation* needed a re-creation. I was so happy. Finally I could correct my old mistakes—and no doubt make some new ones—not only in pictures, text, and layout, but also in the whole concept, which began to redo itself. Reseeing becomes rethinking. When a book achieves world renown, its responsibility becomes transformed. Letters from people on other continents and discussions with them had made it clear to me that the use of the Old Testament Book of Genesis alone created resentments in people who belong to other religions, who have other beliefs. And so the beautiful

words of the Hindu Rig Veda as well as of the Tao-Te King by Lao-tse now stand alongside those from the Old Testament.

I have had to change many of my old pictures, not always because I wanted to, but because some had been damaged in laboratories, some were lost, and others had faded slightly from overuse in making prints. Also, my concept of the arrangement of the images had changed through the years. And this time I wanted to concentrate on straight photography, avoiding, for the most part, double exposures or other artificial effects.

For the text, I considered choosing creation myths from each continent, but I soon decided against that and selected only those words and sentences that had inspired me even before the first edition of this book was published. I feel

much better because I have included them in this new edition. My many years in India, for instance, had brought me close to the powerful words of the Rig Veda. The opening words of the Tao-Te King still accompany me on my travels. So small, so precise, so concentrated, so deep, Lao-tse's philosophy—the wisdom of the paradox, the unity of opposites—is one that I can identify with closely. One can go on forever thinking and writing about the beginning. All of human creation is re-creation.

Introduction

In moments of truth we ask ourselves the eternal questions: Why are we here? Where did we come from? What is the reason for all existence?

Contemporary intelligence finds it hard to accept that man was created, suddenly, as a separate entity. A more popular belief is that organic life grew and developed by itself, and that man gradually evolved. The first approach, as presented in Genesis, is poetic, and the other, perhaps, more scientific. Yet, lacking evidence that an animal has ever shown signs of human consciousness, we stand somewhere between the two philosophies: original creation and evolution. If we believe that the whole of creation was an accident, then we are a continuing part of that accident; if it was meant, then we are part of that meaning.

However much we try to rebel against na-

ture, we cannot escape being a part of it. The elements that surround us also flow through us; and the cycle of human life bears a close relationship to the span of the four seasons. The one faculty that distinguishes us from other creatures is a brain that offers us the opportunity of free choice.

In this present age of science, at once so powerfully constructive and destructive, we seek instinctively to defend ourselves by searching for the elemental, the natural, the absolute, the universal. But in our desire to discover, to know, and to label all the columns that support the roof of our existence we realize that one link must always remain an enigma. The idea of the beginning, of something originating out of nothing, of existence born out of nonexistence, remains beyond human comprehension. Science, while en-

larging our view of the solar system, has never solved the mystery of the universe itself. This quest, a spiritual one, has always been within the realm of religion and of the highest forms of art and literature.

In his endeavor to remake himself and to remake his world, man is confronted with the cruel truth that his intelligence frequently works against instinct and that out of greed he mistreats what was given to him in trust.

Never has youth been obliged to take greater interest in what science on the one hand and the wisdom of the ages on the other have to offer for the future welfare of mankind. And the cause of responsive members of the new generation has become to effect a better balance between materialism and the affairs of the spirit. In their own idealistic and energetic way, they are

struggling to establish a simpler concept and conduct of life, nearer to nature, since nature remains the source of all new beginnings.

If truth is what we believe to be true, then every period, every culture, has created its own truth, which has always been deeply rooted in man's concept of the reason for existence. But in extreme situations, such as pain, love, or joy, man reaches from the narrower fact of truth into the broader dimensions of poetry to express better all that he feels, sees, and believes.

In the first chapter of Genesis we find a related situation, where the unknown is given credence through poetic vision. Today the abstract idea of the beginning of the world still lives in all of us, filling us with a longing to understand how it came about.

In Genesis the implications are so deep and far-reaching that it seems miraculous that so much can be said in so few words, and in such simple ones. To read the moving passages in the first page of the Old Testament is to expose one's mind to a constant flow of images: light, darkness, movement, color, space, power; the conflict and union of opposing elements; the birth of the earth and the coming of the seasons; the emergence of vegetation, fish, fowl, animals; and eventually the crowning of the evolutionary pyramid, the birth of man.

Myths, the religious answers to questions about the beginning, are to be found in many cultures. The Bible story of the Creation is most familiar to readers in the West, but the theme recurs in most scriptures, notably the Egyptian and Babylonian and the Rig Veda of the Hindus. In addition there are the creeds of cultures with-

out scriptures—the American Indian, for example. This is based firmly on nature, the elements and the seasons, incorporating rituals that draw freely, simply, and beautifully on the whole concept of creation and re-creation.

"In the beginning God created the heaven and the earth." The opening statement of Genesis induces in one an immediate sense of awe, and of humility. It was in such a mood that this book was begun and is presented here. No claim should be made for it other than that it represents a sort of "spiritual ecology" in praise of the earth which man inherited and should seek ardently to protect.

William Blake saw "the world in a grain of sand." It can be seen in many such things, for in the smallest cells are reflections of the largest. And in photography, through an interplay of scales, a whole universe within a universe can be revealed. This has been attempted both in the selection of the pictures on the following pages and in the particular way that they have been arranged.

A recurring phrase in Genesis is: "And God saw that it was good." It is hoped that this book may prove that it is still "good," and suggest that it can remain good if only man will appreciate what he has far too long taken for granted.

The Bible
From Genesis

In the beginning God created the heaven and the earth.

And the earth was without form, and void; and darkness was upon the face of the deep. And the Spirit of God moved upon the face of the waters.

And God said, Let there be light: and there was light.

And God saw the light, that it was good: and God divided the light from the darkness.

And God called the light Day, and the darkness he called Night. And the evening and the morning were the first day.

And God said, Let there be a firmament in the midst of the waters, and let it divide the waters from the waters.

And God made the firmament, and divided the waters which were under the firmament

from the waters which were above the firma-
ment: and it was so.

And God called the firmament Heaven.
And the evening and the morning were the
second day.

And God said, Let the waters under the
heaven be gathered together unto one place, and
let the dry land appear: and it was so.

And God called the dry land Earth; and the
gathering together of the waters called he Seas:
and God saw that it was good.

And God said, Let the earth bring forth
grass, the herb yielding seed, and the fruit tree
yielding fruit after his kind, whose seed is in
itself, upon the earth: and it was so.

And the earth brought forth grass, and
herb yielding seed after his kind, and the tree
yielding fruit, whose seed was in itself, after his
kind: and God saw that it was good.

And the evening and the morning were the
third day.

And God said, Let there be lights in the
firmament of the heaven to divide the day from
the night; and let them be for signs, and for sea-
sons, and for days, and years:

And let them be for lights in the firmament
of the heaven to give light upon the earth: and it
was so.

And God made two great lights; the
greater light to rule the day, and the lesser light
to rule the night: he made the stars also.

And God set them in the firmament of the
heaven to give light upon the earth,

And to rule over the day and over the
night, and to divide the light from the darkness:
and God saw that it was good.

And the evening and the morning were the
fourth day.

And God said, Let the waters bring forth abundantly the moving creature that hath life, and fowl that may fly above the earth in the open firmament of heaven.

And God created whales, and every living creature that moveth, which the waters brought forth abundantly, after their kind, and every winged fowl after his kind: and God saw that it was good.

And God blessed them, saying, Be fruitful, and multiply, and fill the waters in the seas, and let fowl multiply in the earth.

And the evening and the morning were the fifth day.

And God said, Let the earth bring forth the living creature after his kind, cattle, and creeping thing, and beast of the earth after his kind: and it was so.

And God made the beast of the earth after his kind, and cattle after their kind, and every thing that creepeth upon the earth after his kind: and God saw that it was good.

And God said, Let us make man in our image, after our likeness: and let them have dominion over the fish of the sea, and over the fowl of the air, and over the cattle, and over all the earth, and over every creeping thing that creepeth upon the earth.

So God created man in his own image, in the image of God created he him; male and female created he them.

And God blessed them, and God said unto them, Be fruitful, and multiply, and replenish the earth, and subdue it: and have dominion over the fish of the sea, and over the fowl of the air, and over every living thing that moveth upon the earth.

And God said, Behold, I have given you

every herb bearing seed, which is upon the face of all the earth, and every tree, in the which is the fruit of a tree yielding seed; to you it shall be for meat.

And to every beast of the earth, and to every fowl of the air, and to every thing that creepeth upon the earth, wherein there is life, I have given every green herb for meat: and it was so.

And God saw every thing that he had made, and, behold, it was very good. And the evening and the morning were the sixth day.

Thus the heavens and the earth were finished, and all the host of them.

And on the seventh day God ended his work which he had made; and he rested on the seventh day from all his work which he had made.

And God blessed the seventh day, and sanctified it: because that in it he had rested from all his work which God created and made.

These are the generations of the heavens and of the earth when they were created, in the day that the Lord God made the earth and the heavens.

And every plant of the field before it was in the earth, and every herb of the field before it grew: for the Lord God had not caused it to rain upon the earth, and there was not a man to till the ground.

But there went up a mist from the earth, and watered the whole face of the ground.

And the Lord God formed man of the dust of the ground, and breathed into his nostrils the breath of life; and man became a living soul.

The Rig Veda

Then even nothingness was not, nor existence. There was no air then, nor the heavens beyond it.

What covered it? Where was it? In whose keeping? Was there then cosmic water, in depths unfathomed?

Then there was neither death nor immortality, nor was there then the torch of night and day.

The One breathed windlessly and self-sustaining. There was that One then, and there was no other.

At first there was only darkness wrapped in darkness. All this was only unillumined water.

That One which came to be, enclosed in nothing, arose at last, born of the power of heat.

In the beginning desire descended on it— that was the primal seed, born of the mind.

The sages who have searched their hearts
with wisdom know that which is, is kin to that
which is not.

And they have stretched their cord across
the void, and know what was above, and what
below.

Seminal powers made fertile mighty forces.
Below was strength, and over it was impulse.

But, after all, who knows, and who can say
whence it all came, and how creation happened?

The gods themselves are later than crea-
tion, so who knows truly whence it has arisen?

Whence all creation had its origin, he,
whether he fashioned it or whether he did not,
he, who surveys it all from highest heaven, he
knows—or maybe even he does not know.

20

The Tao-Te King
The Mother of All Things

The Tao that can be expressed is not the eternal Tao;

The name that can be defined is not the unchanging name.

Non-existence is called the antecedent of heaven and earth;

Existence is the mother of all things.

From eternal non-existence, therefore, we serenely observe the mysterious beginning of the universe;

From eternal existence we clearly see the apparent distinctions.

These two are the same in source and become different when manifested.

This sameness is called profundity. Infinite profundity is the gate whence comes the beginning of all parts of the universe.

The Elements

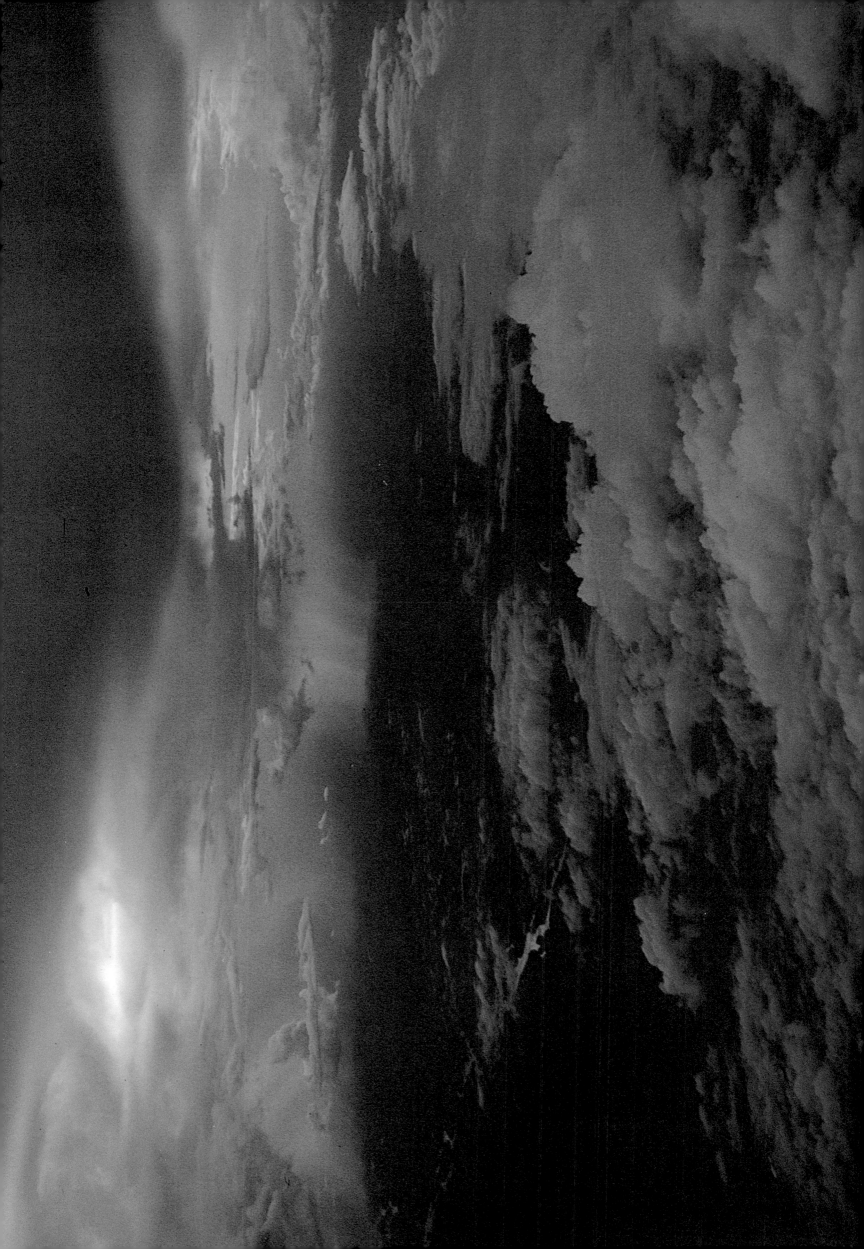

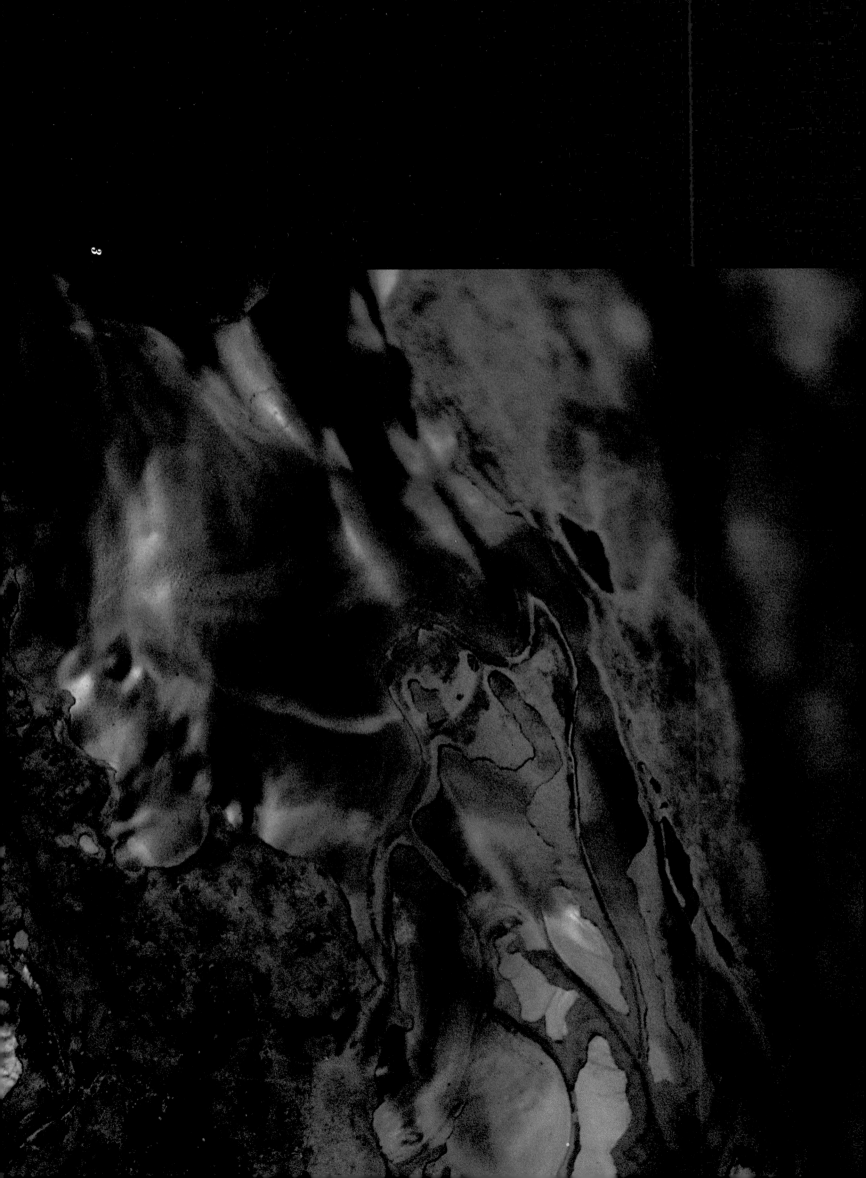

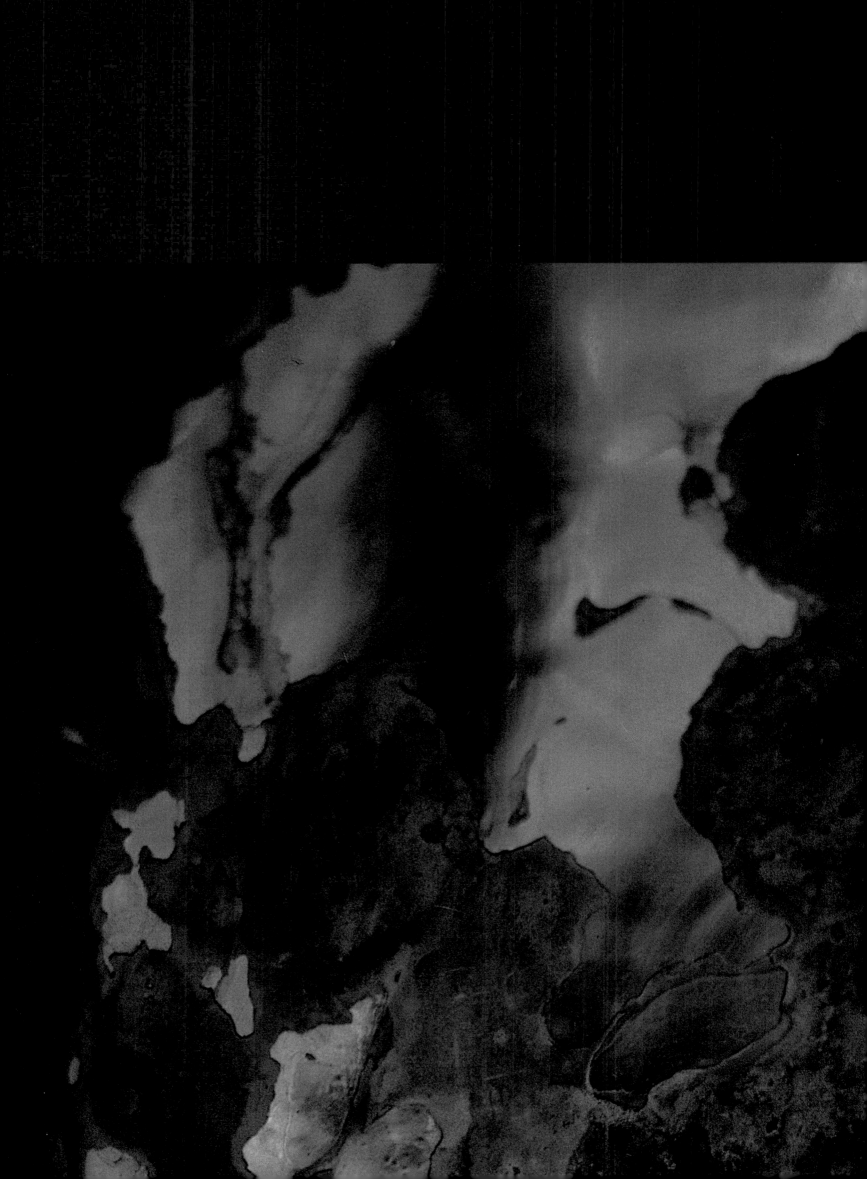

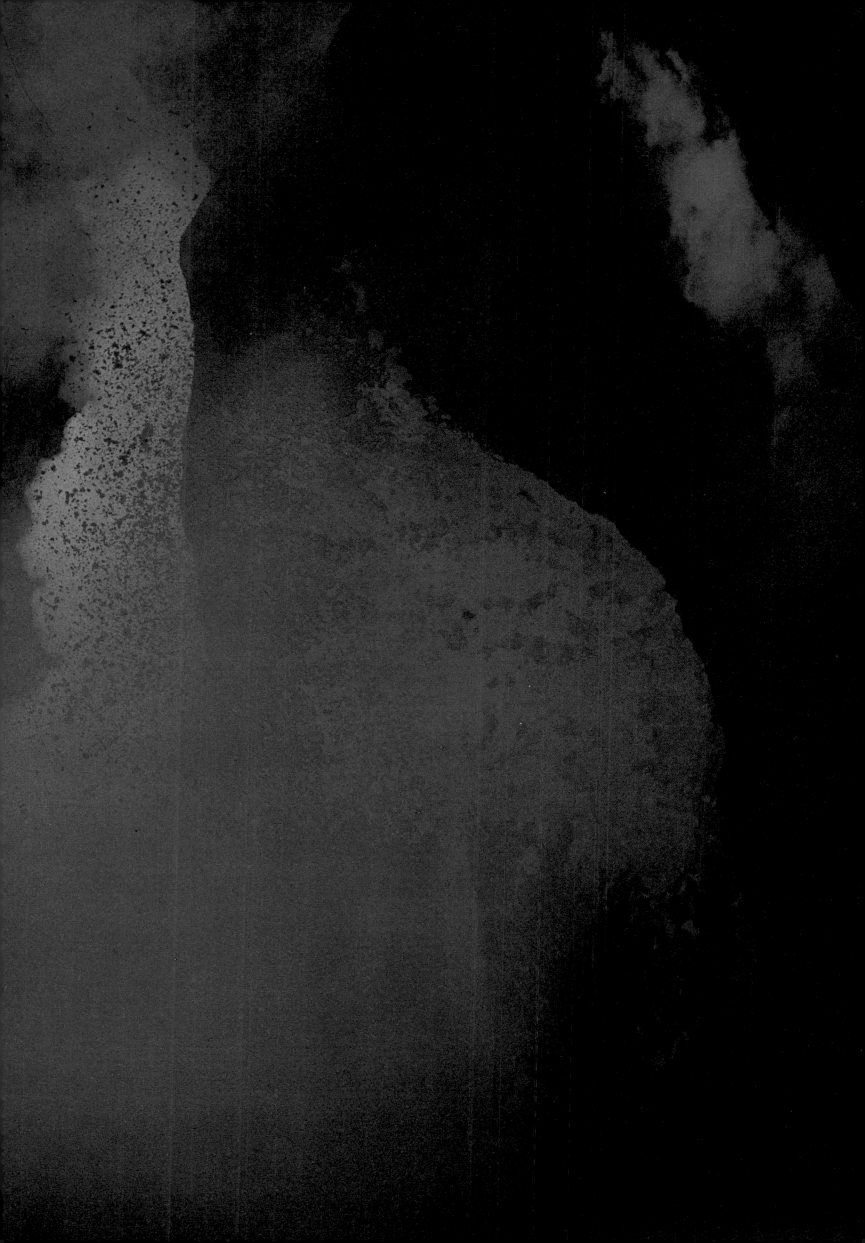

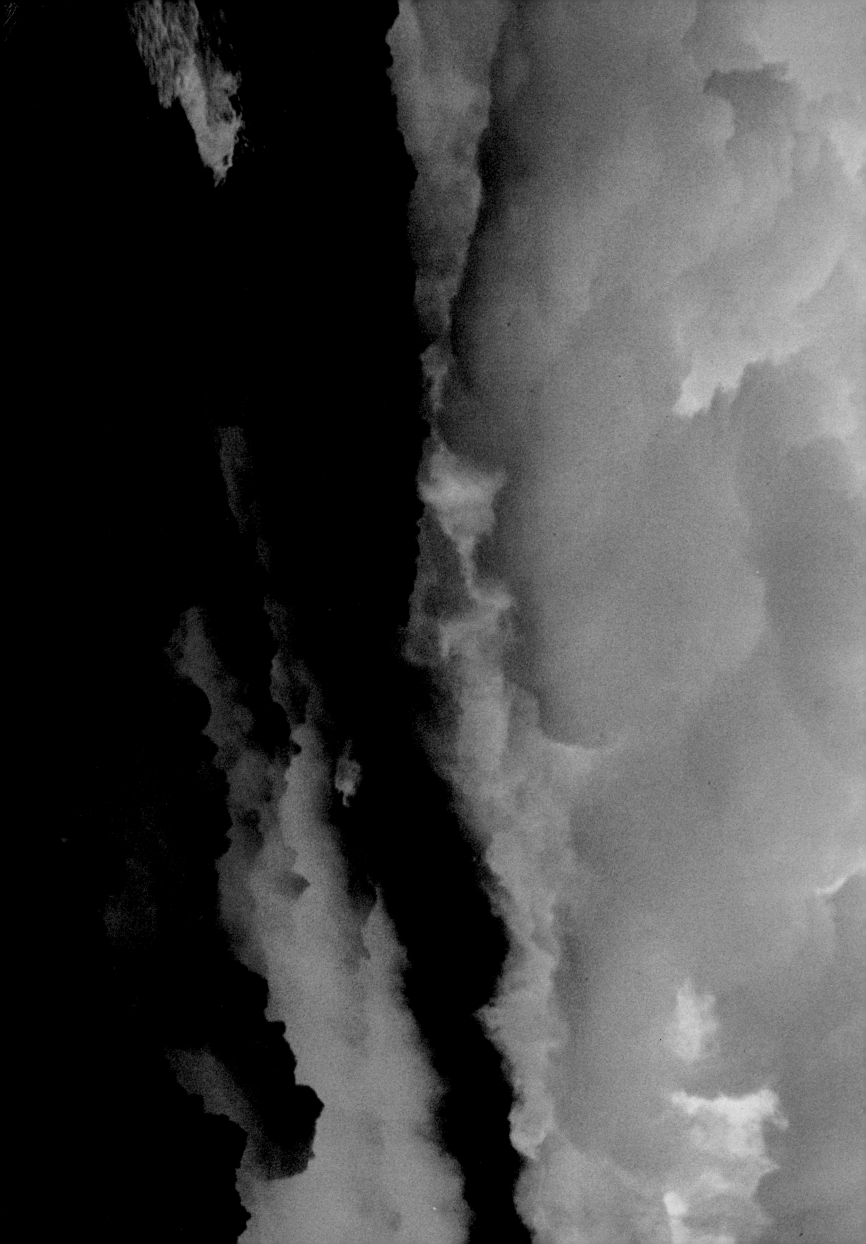

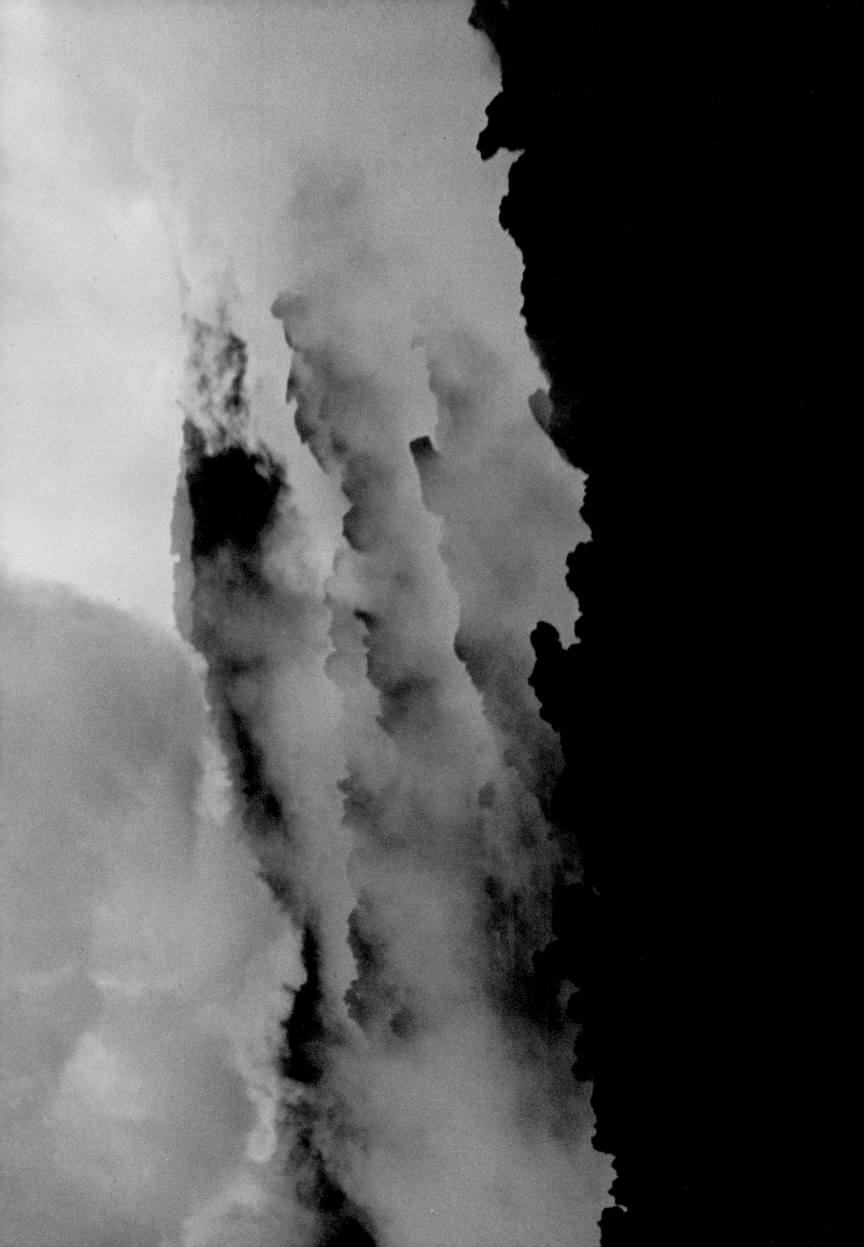

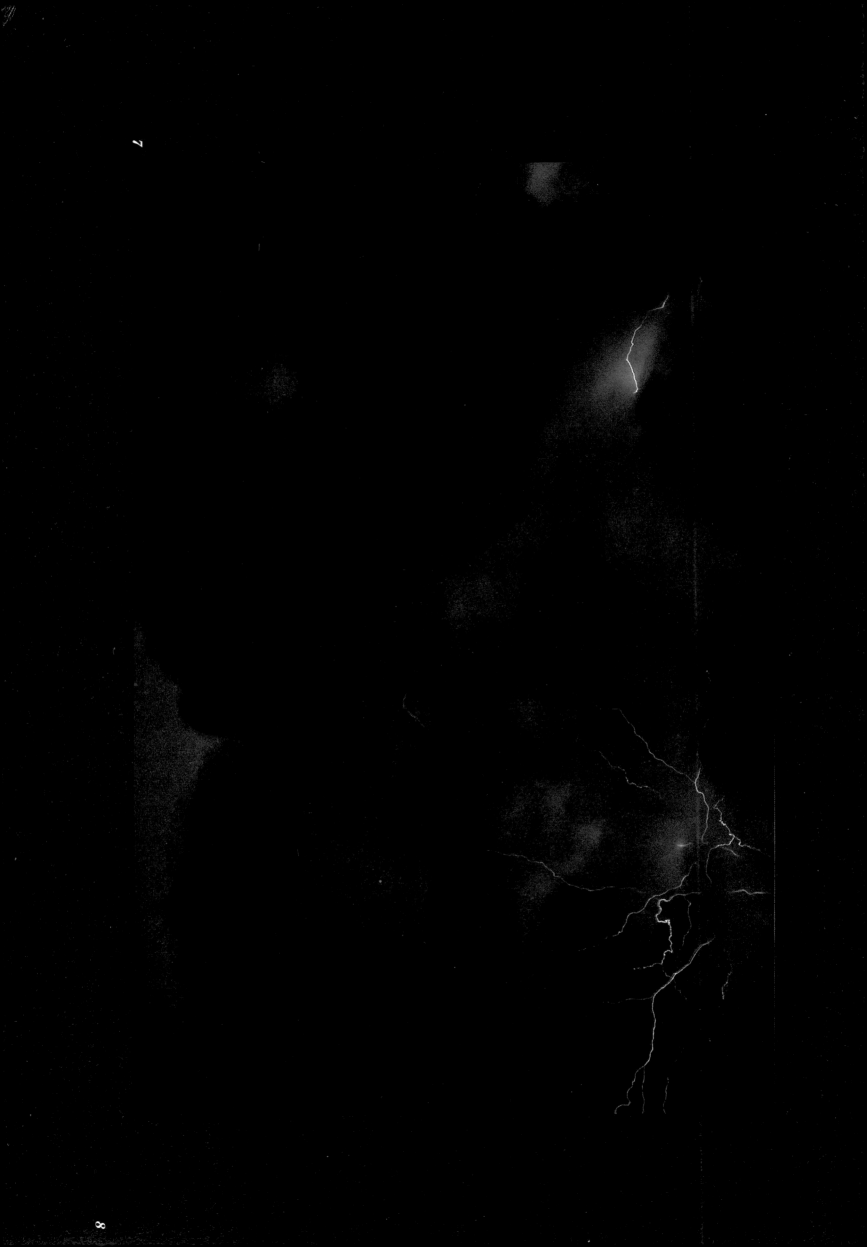

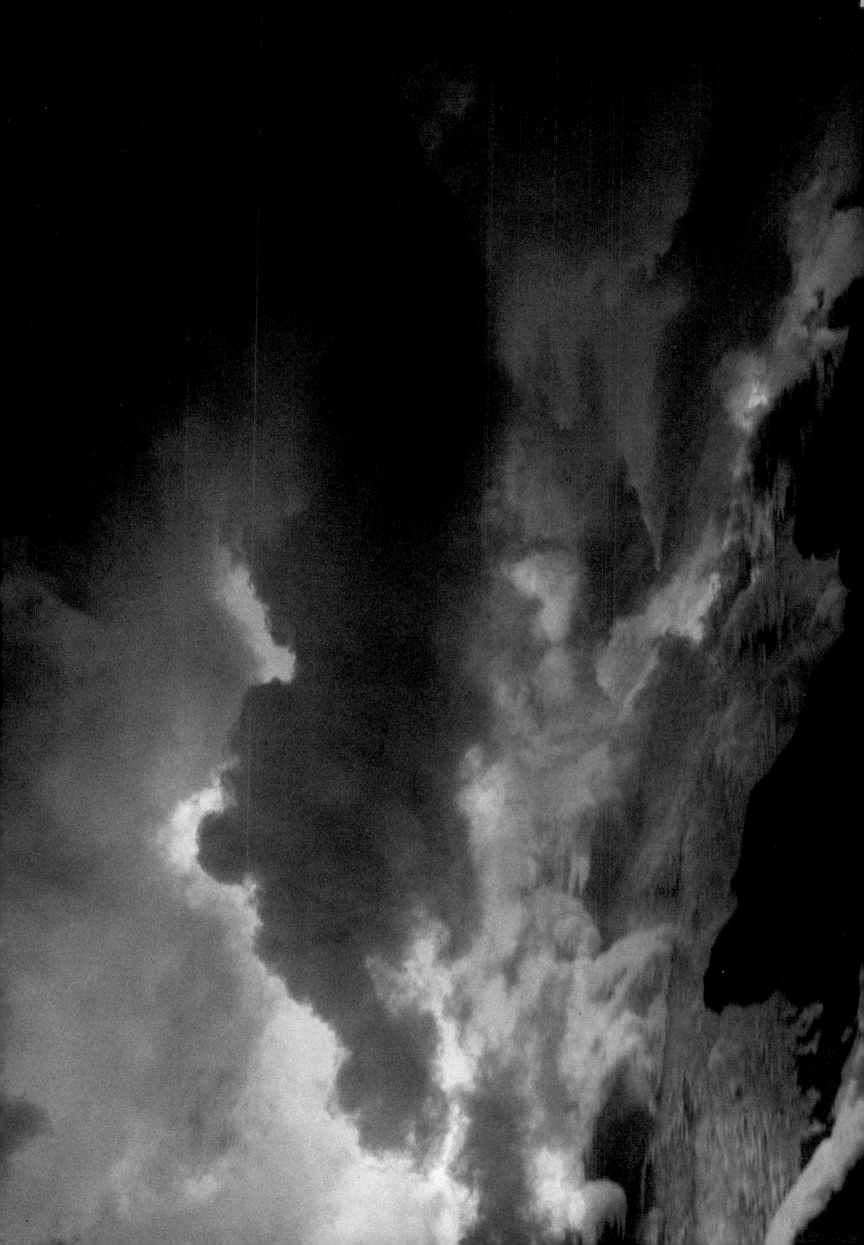

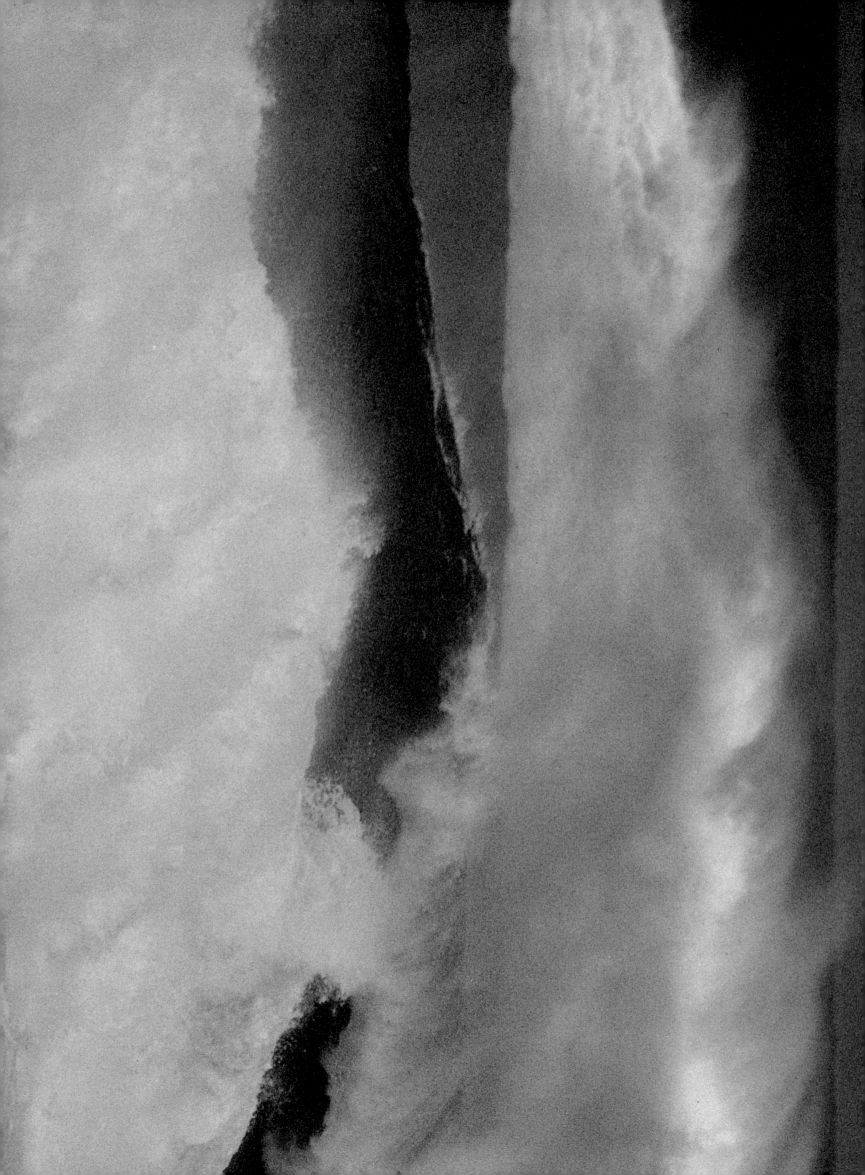

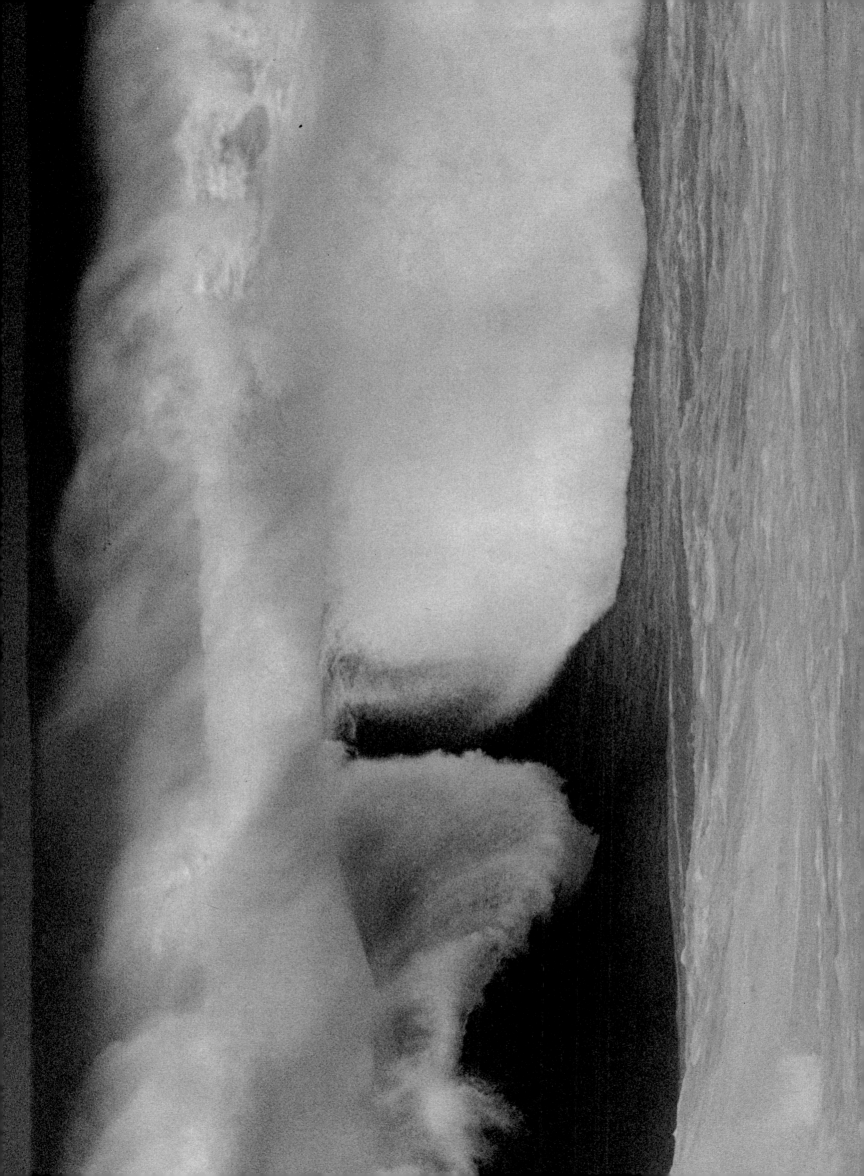

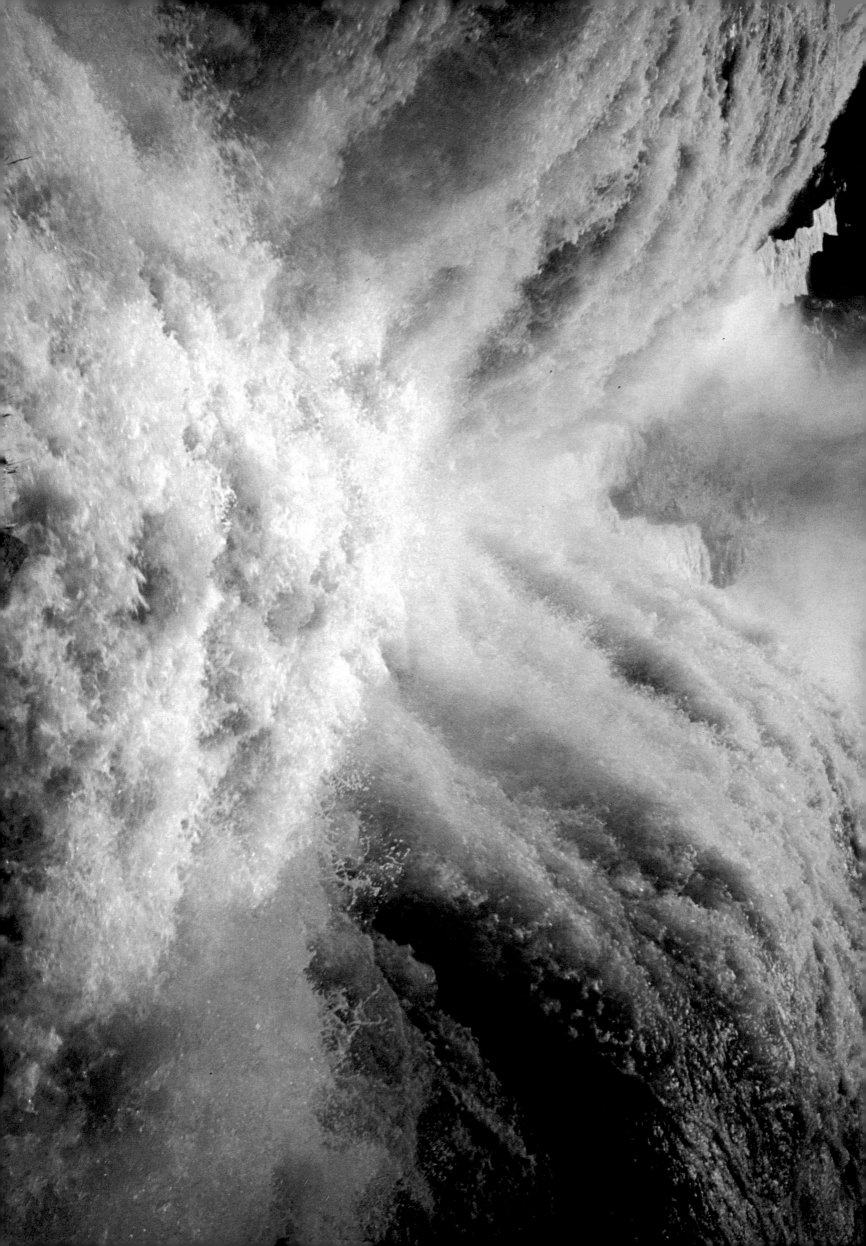

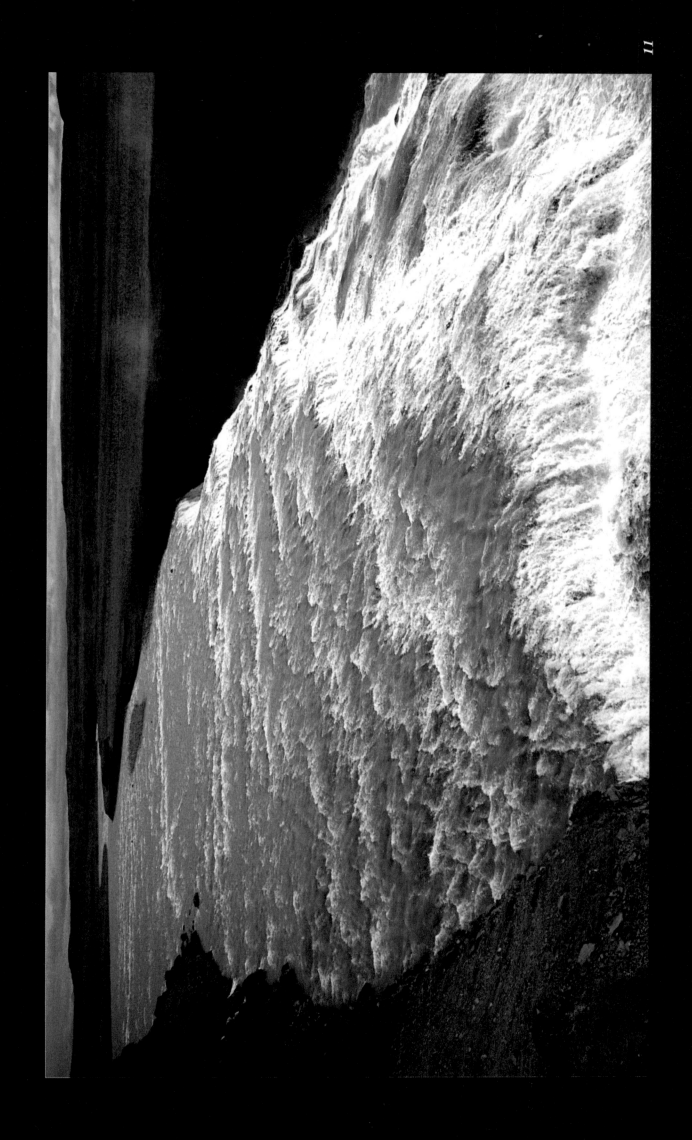

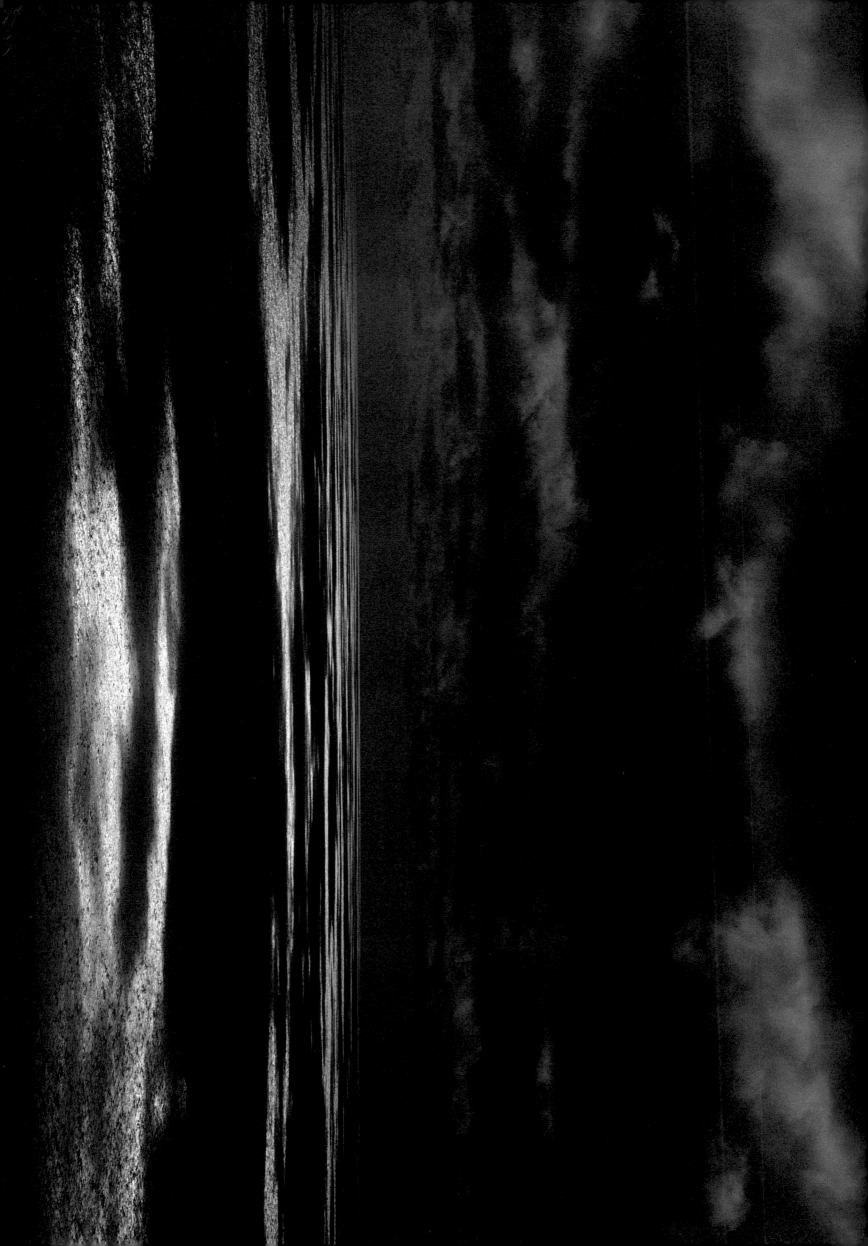

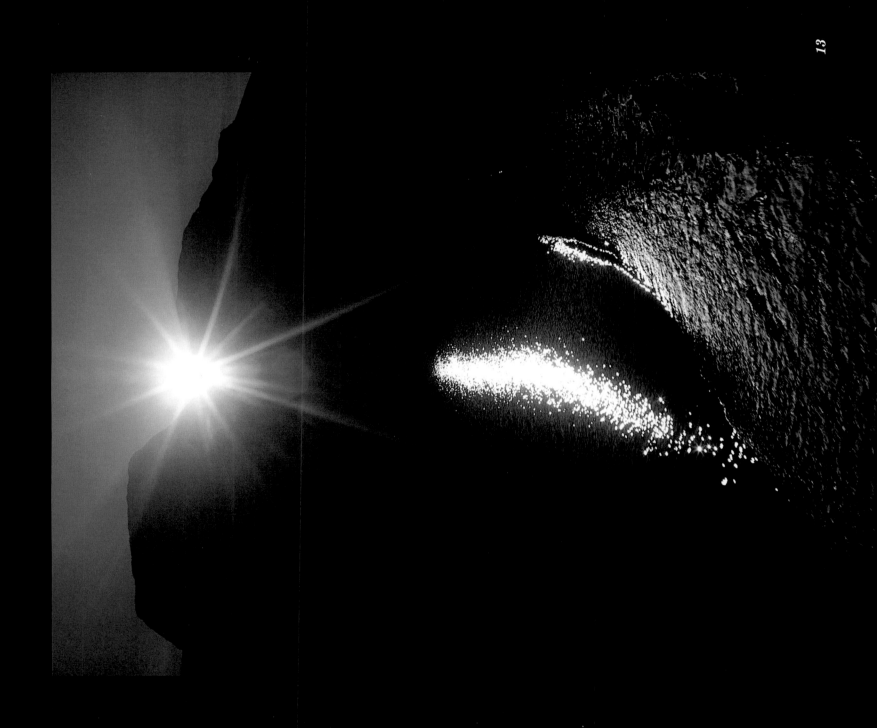

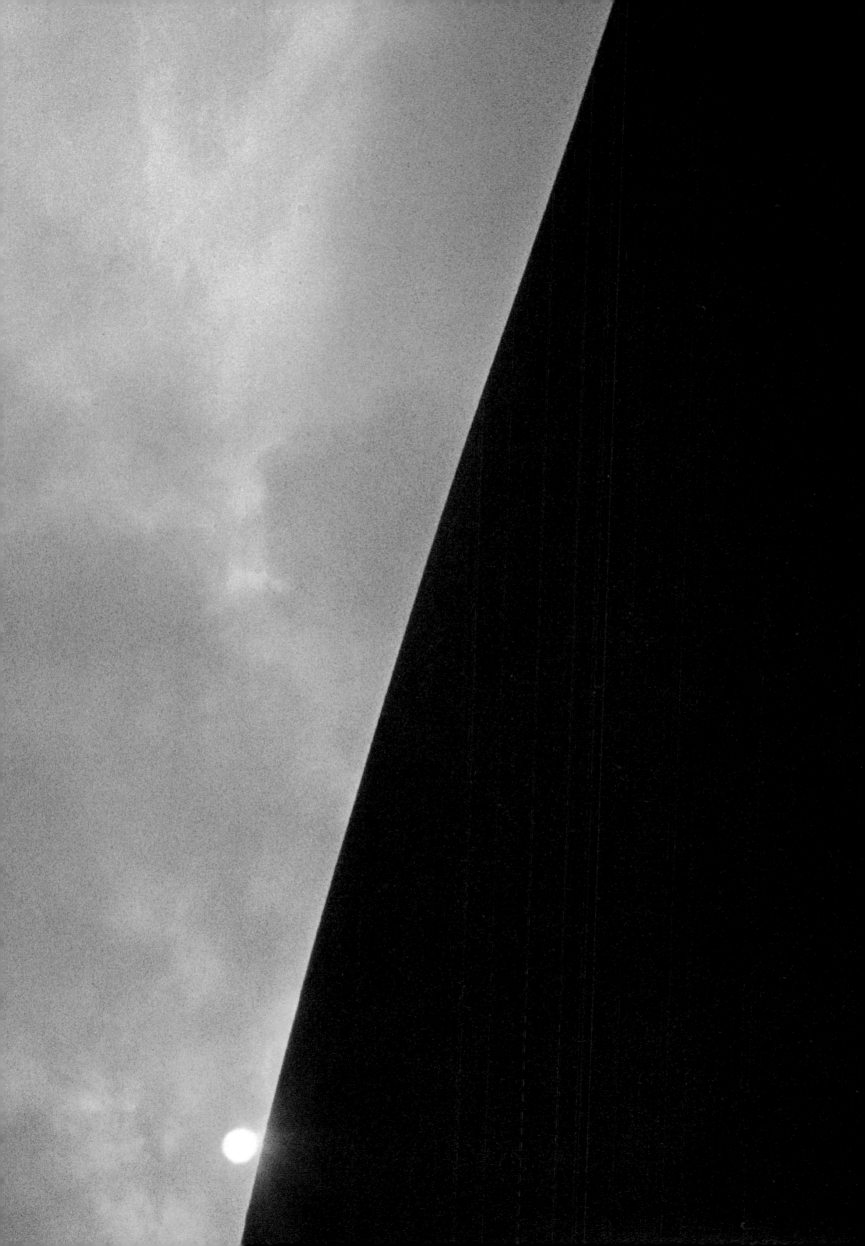

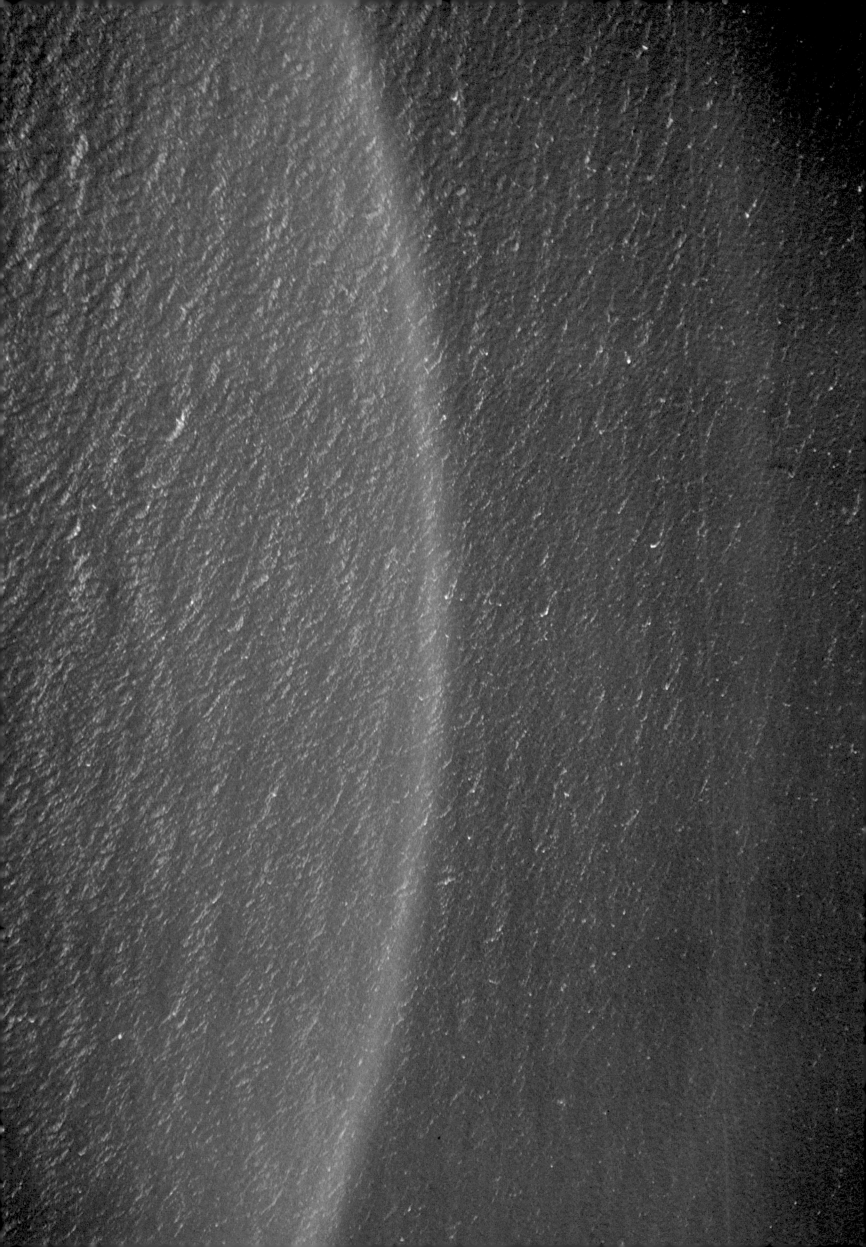

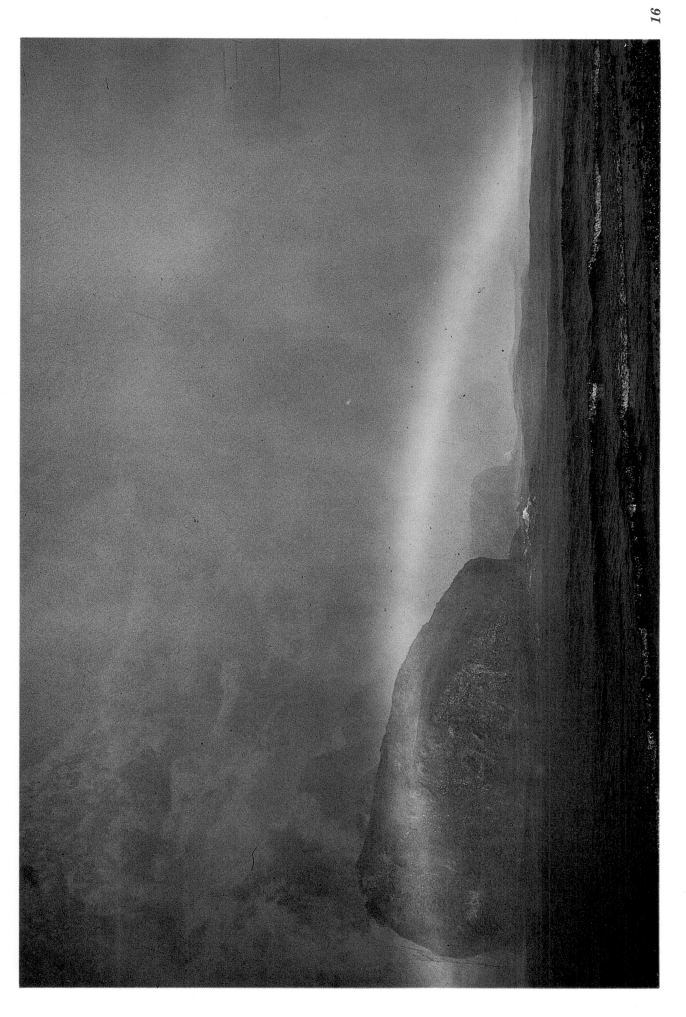

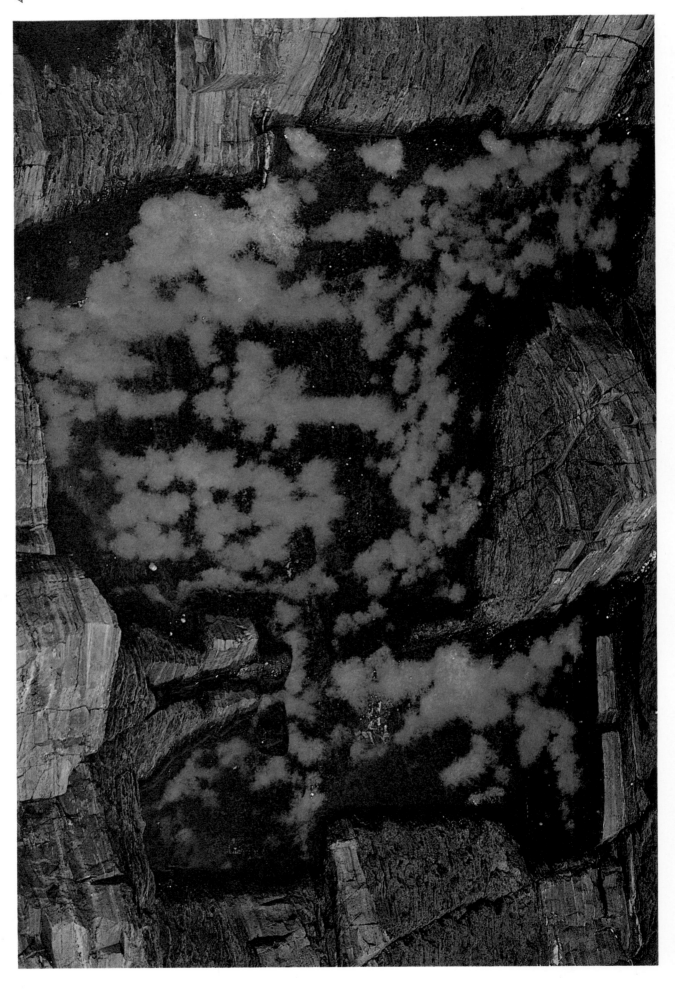

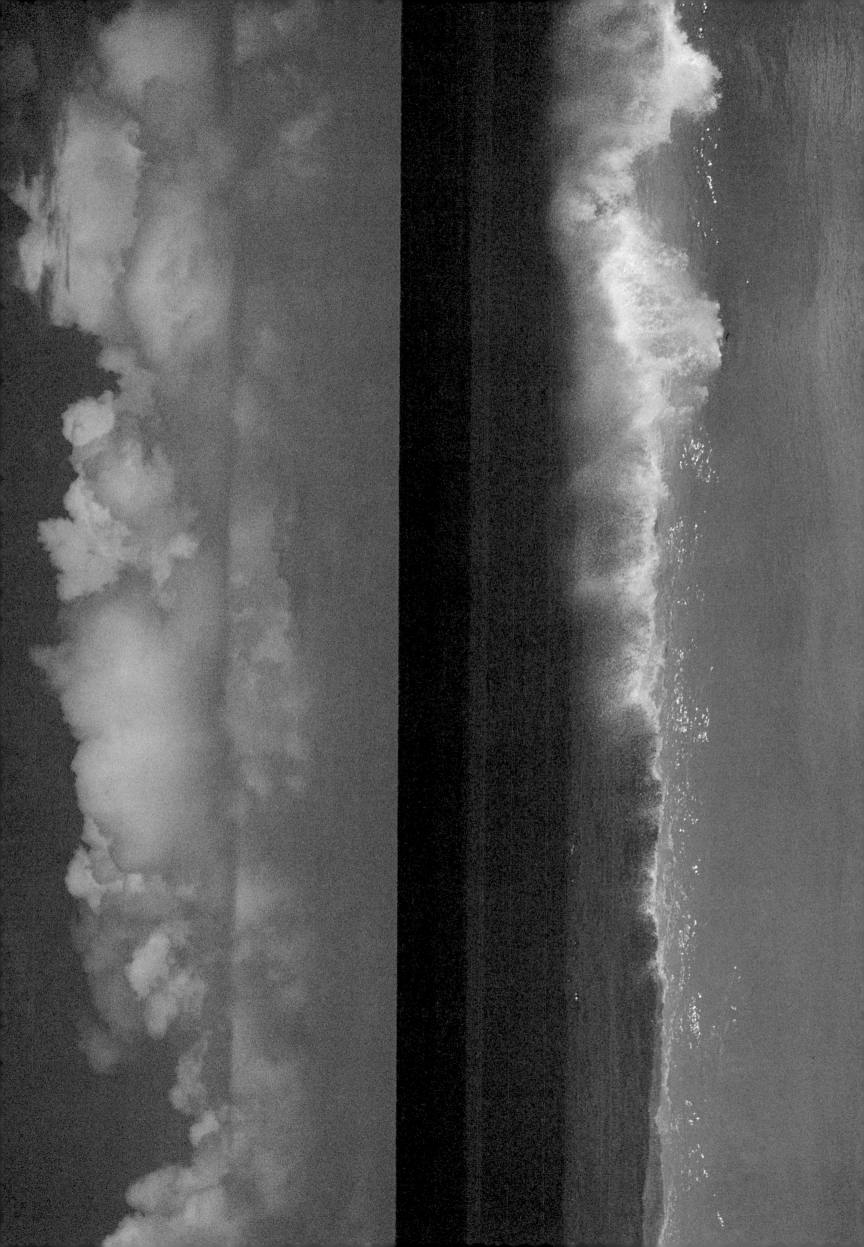

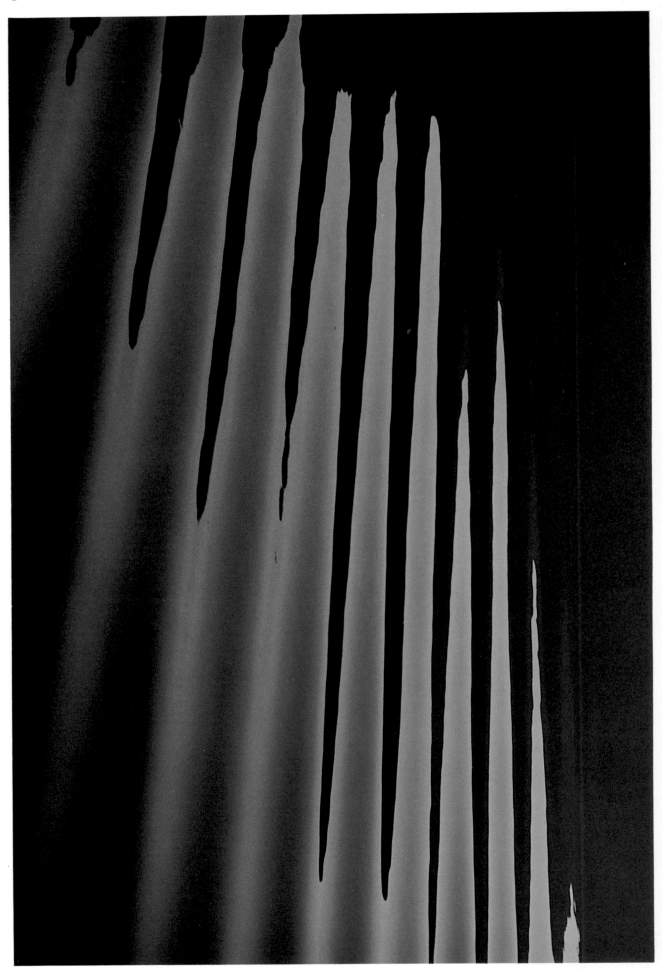

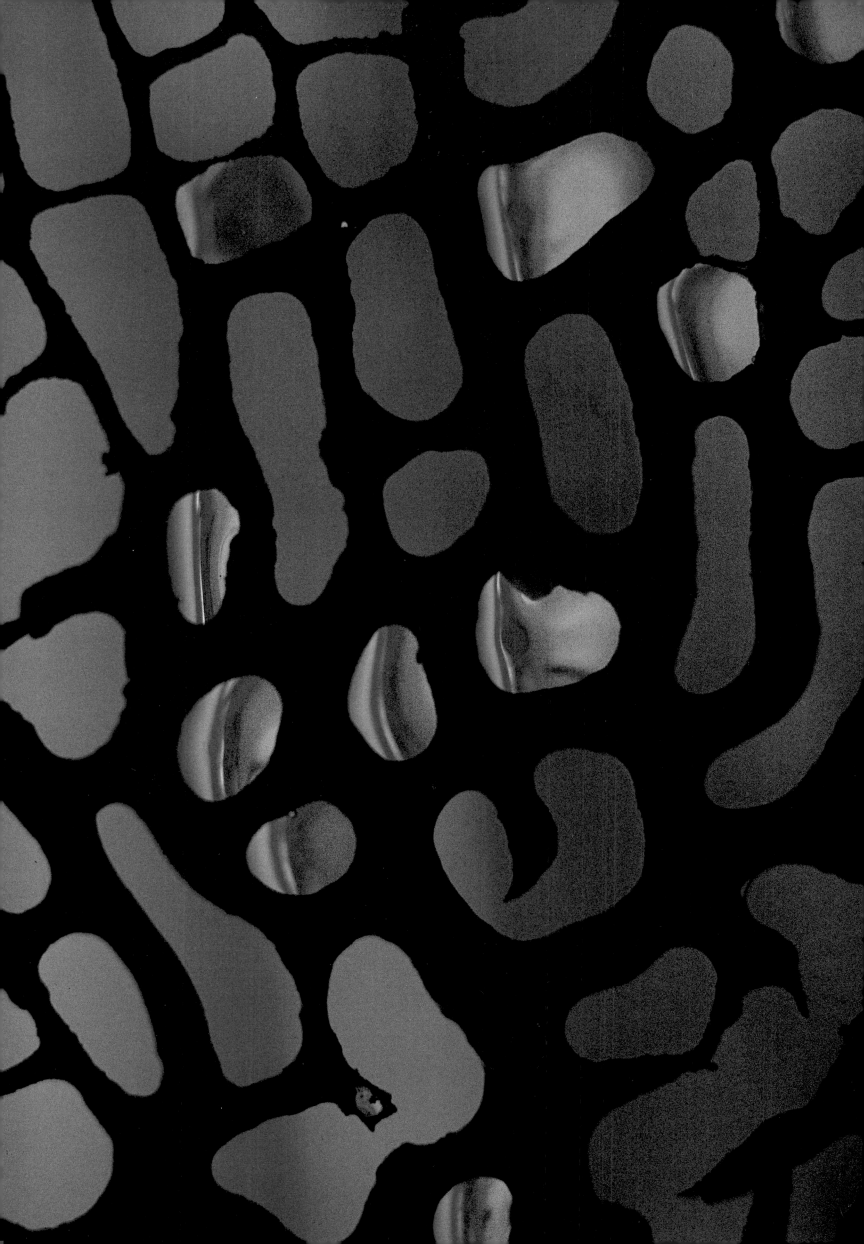

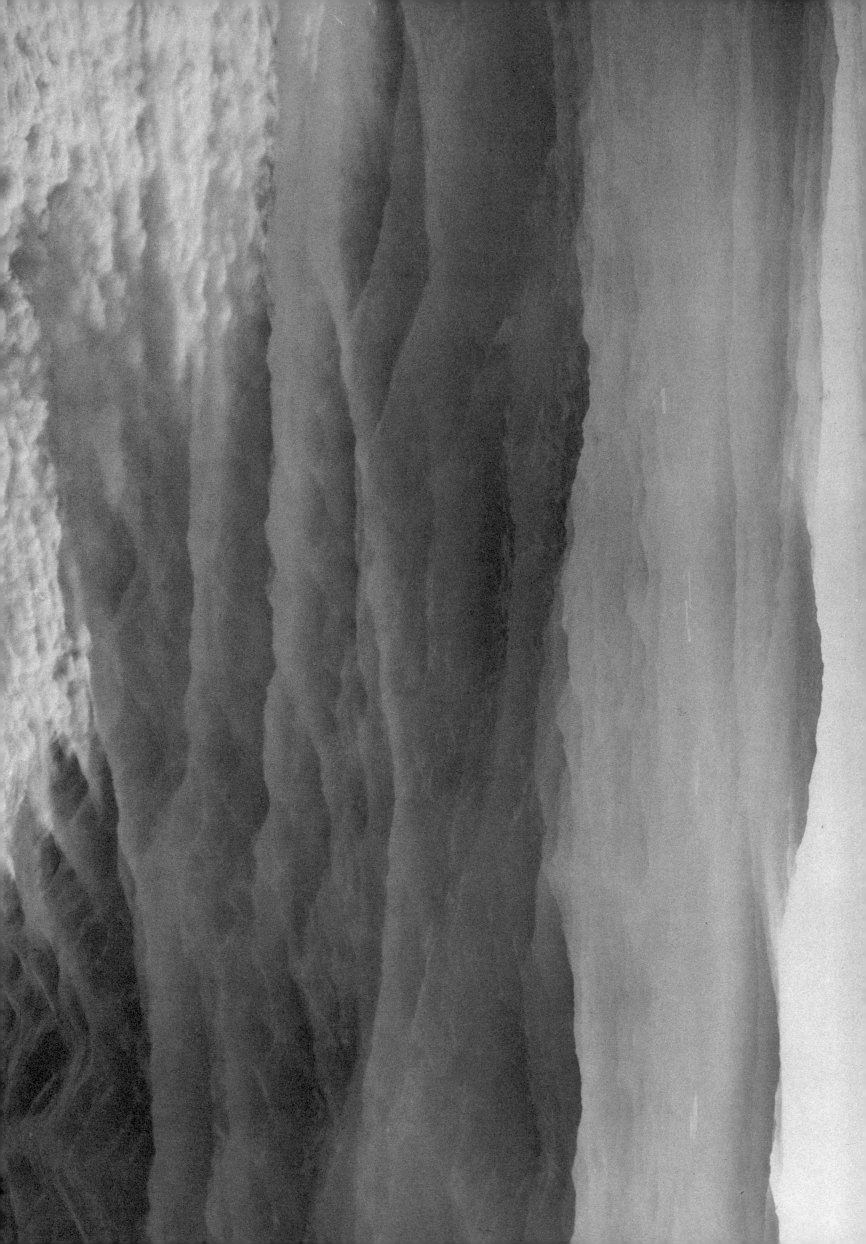

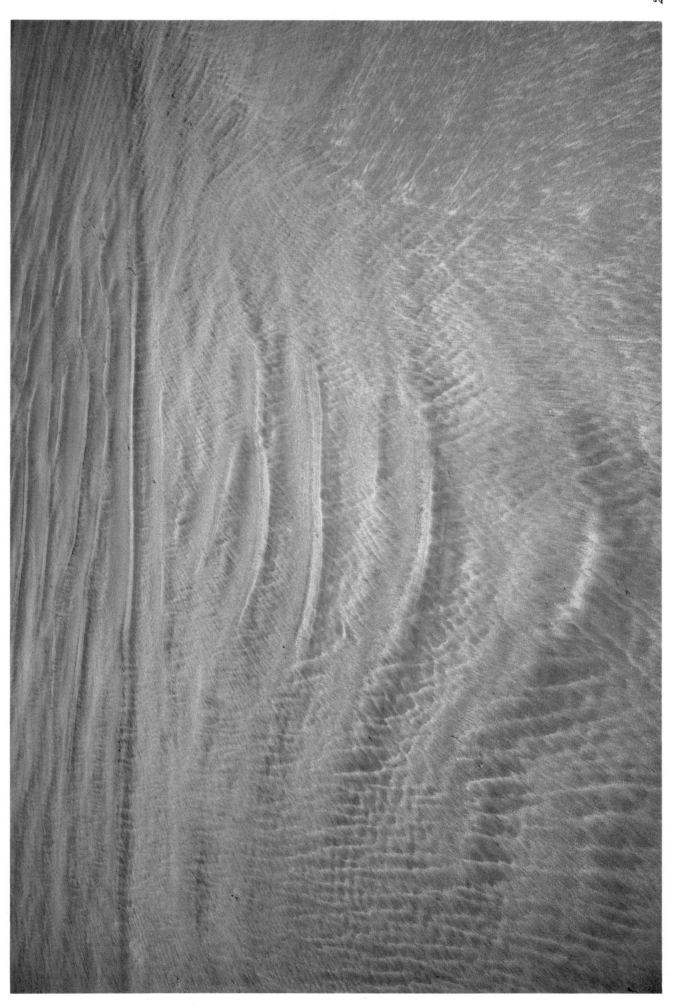

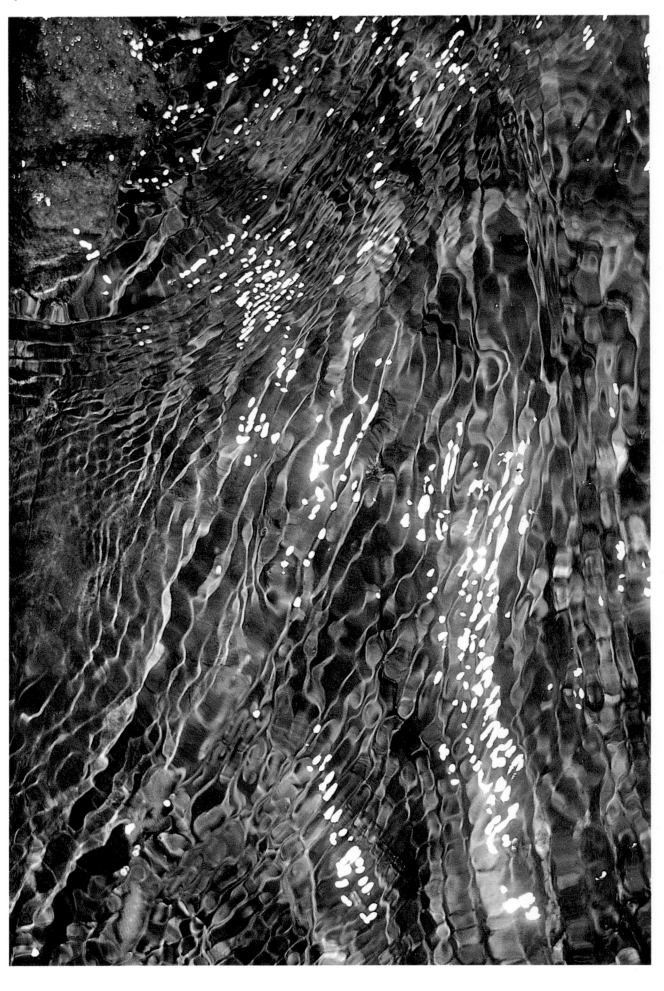

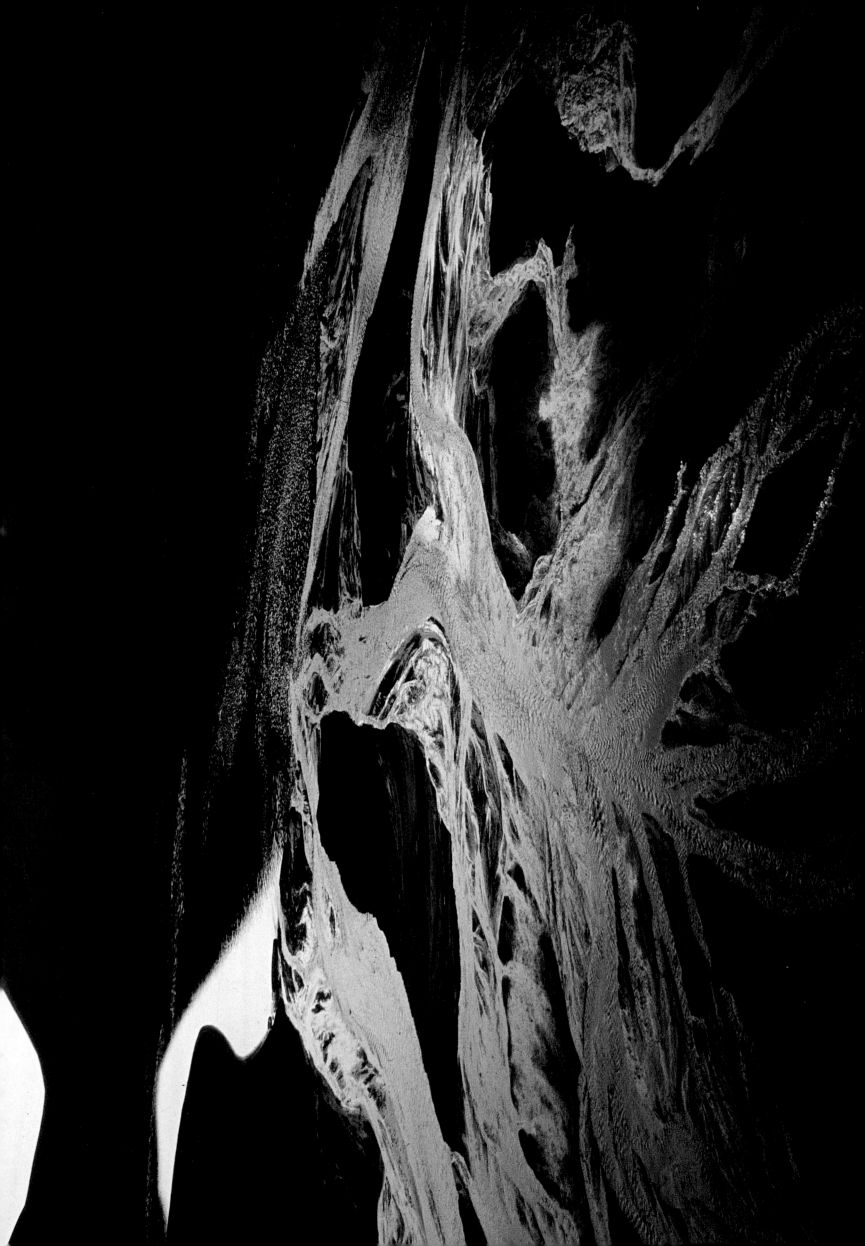

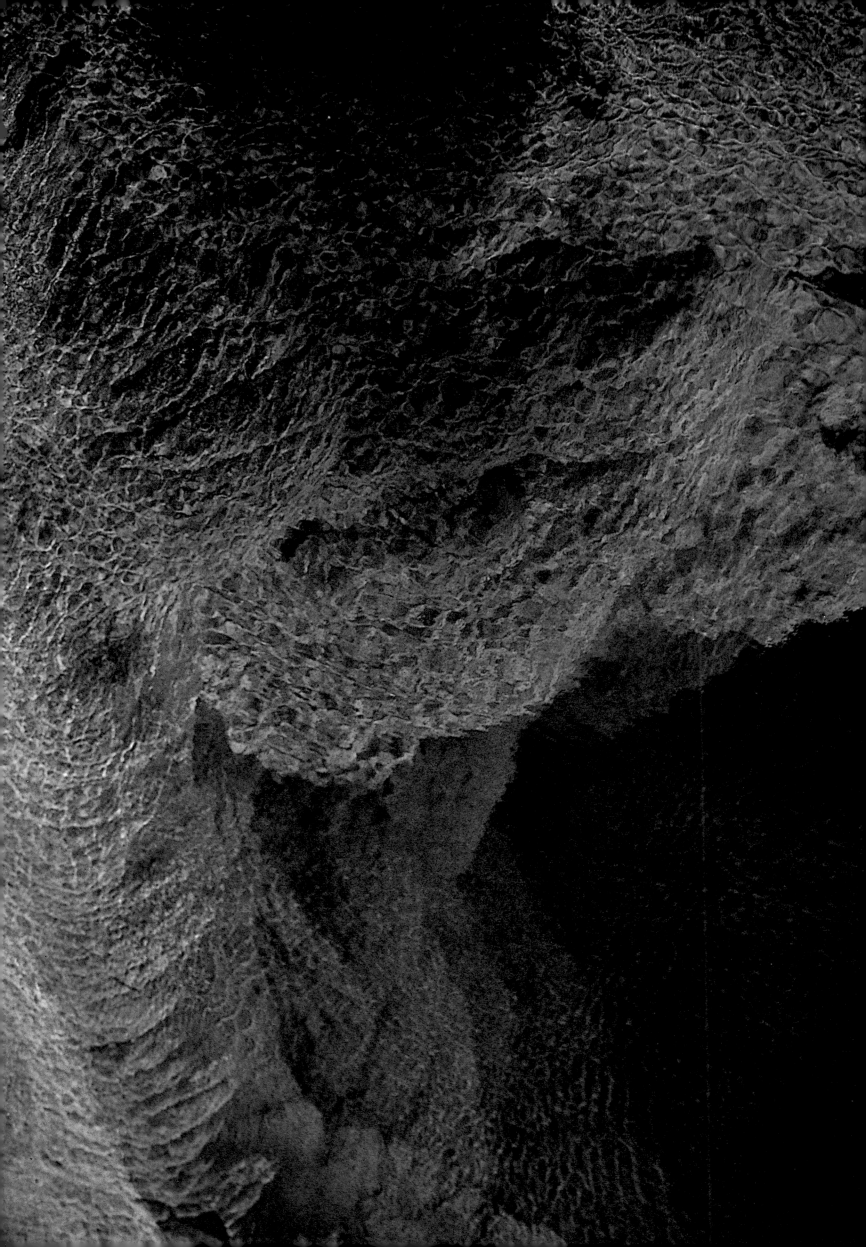

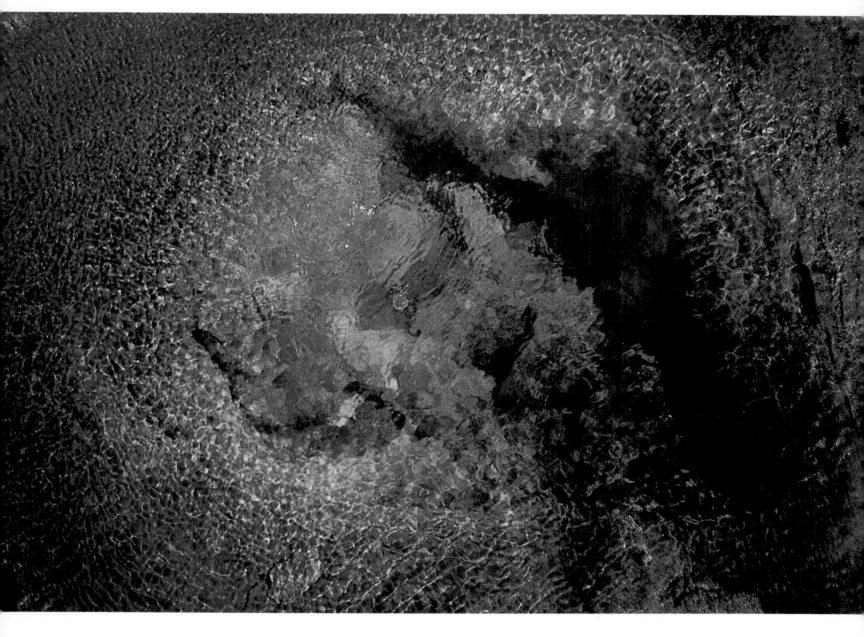

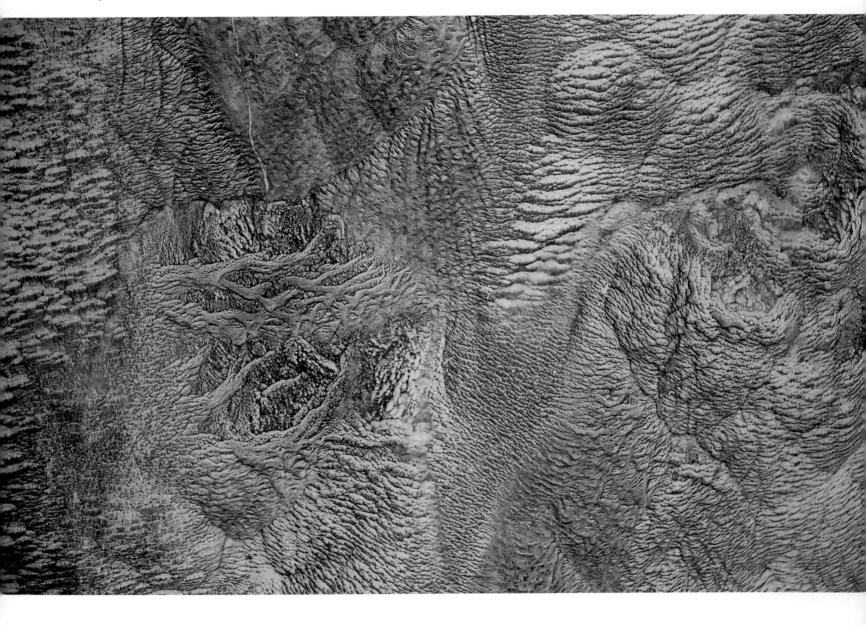

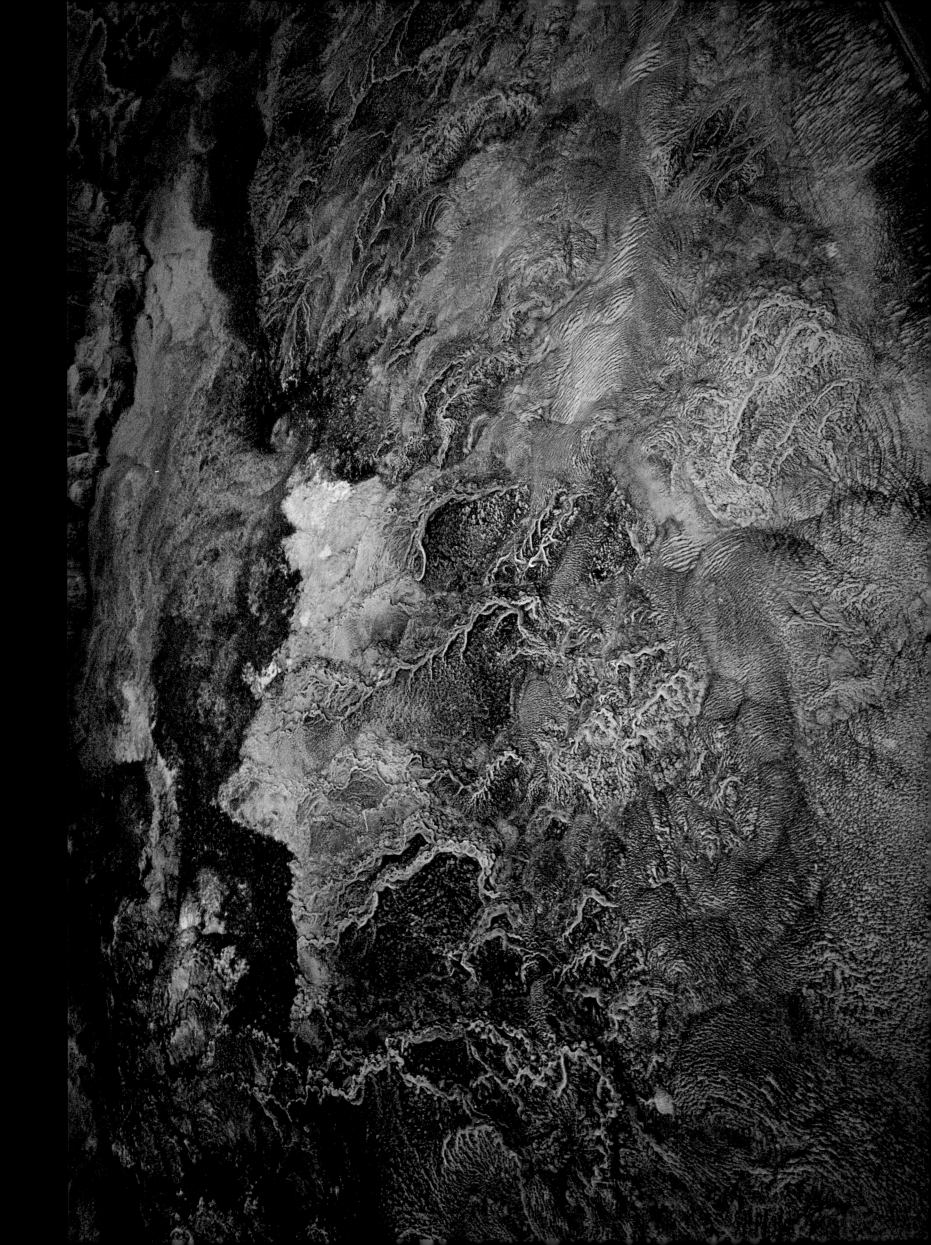

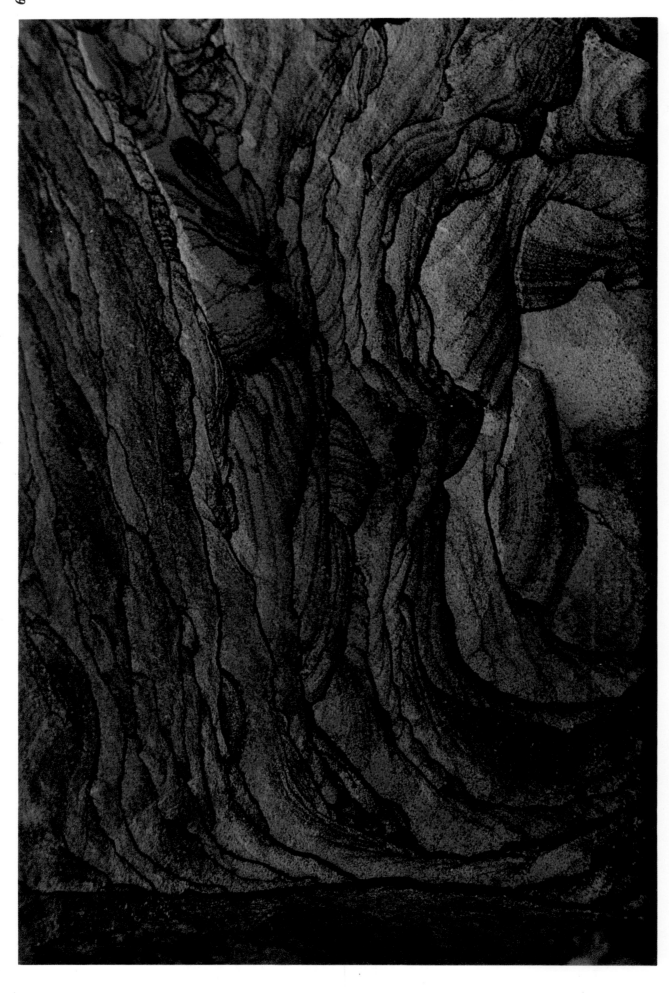

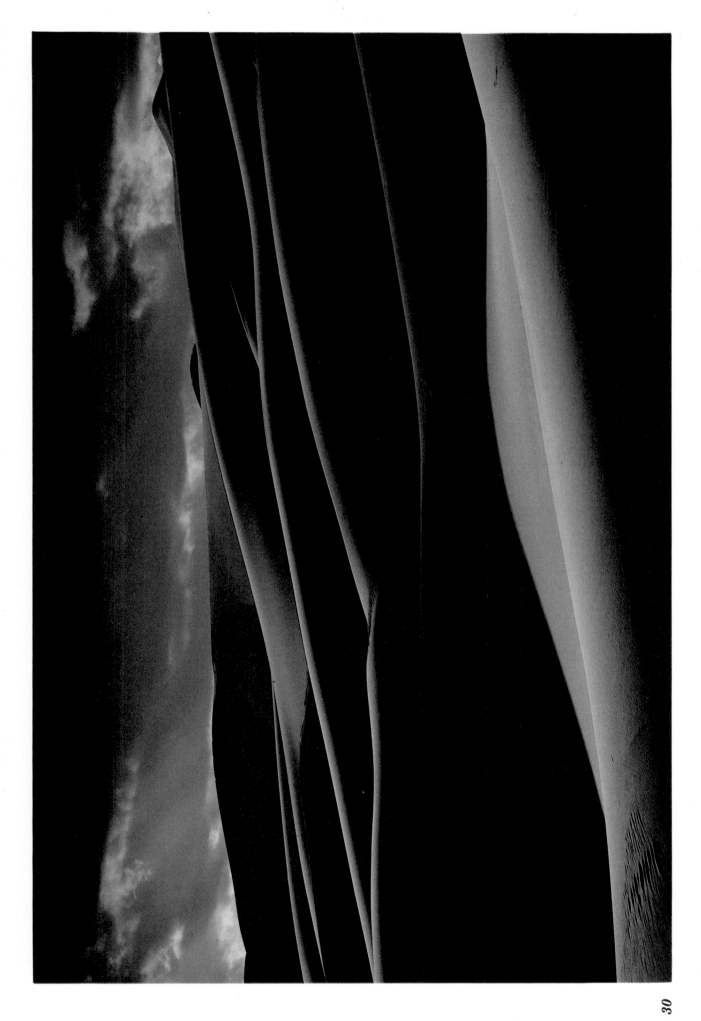

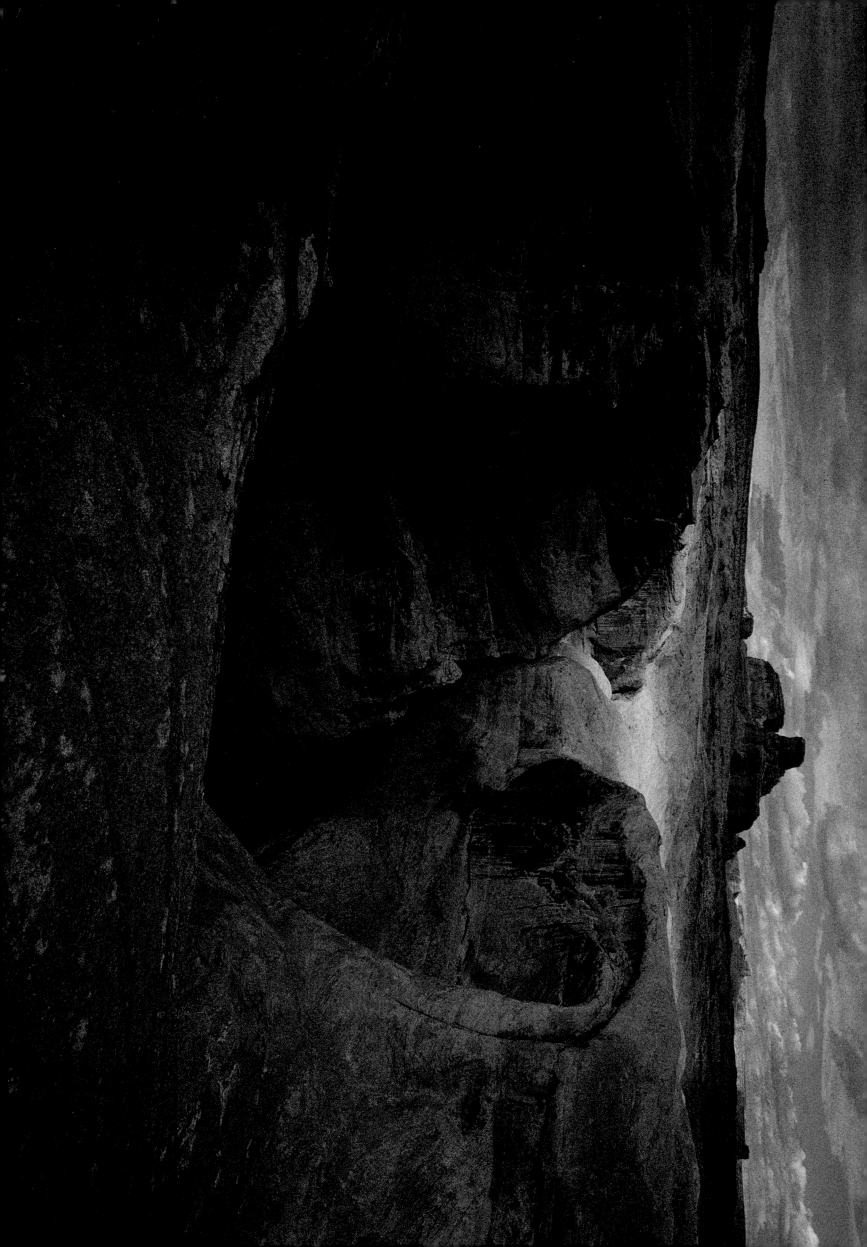

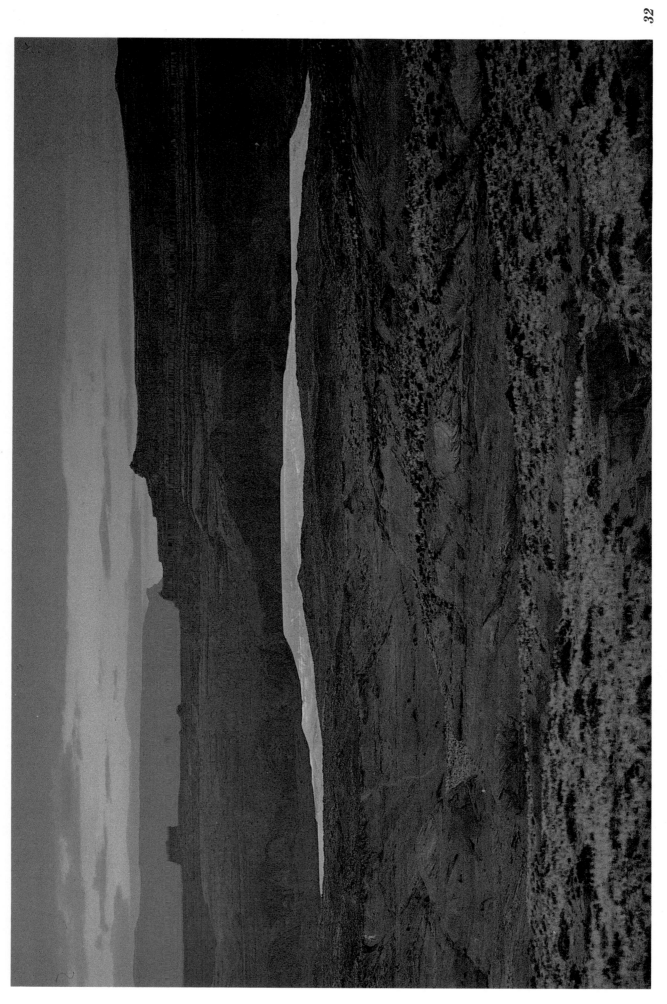

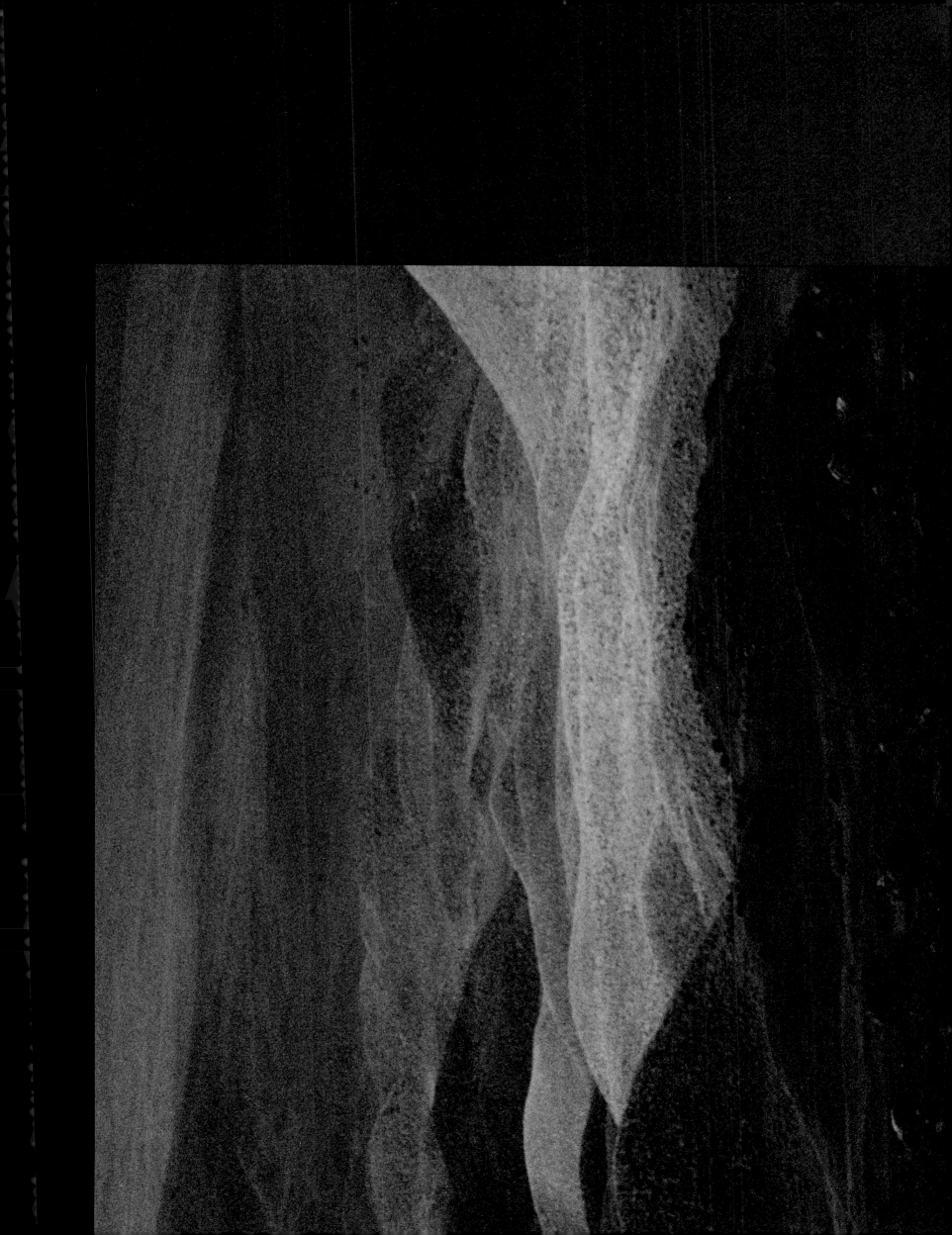

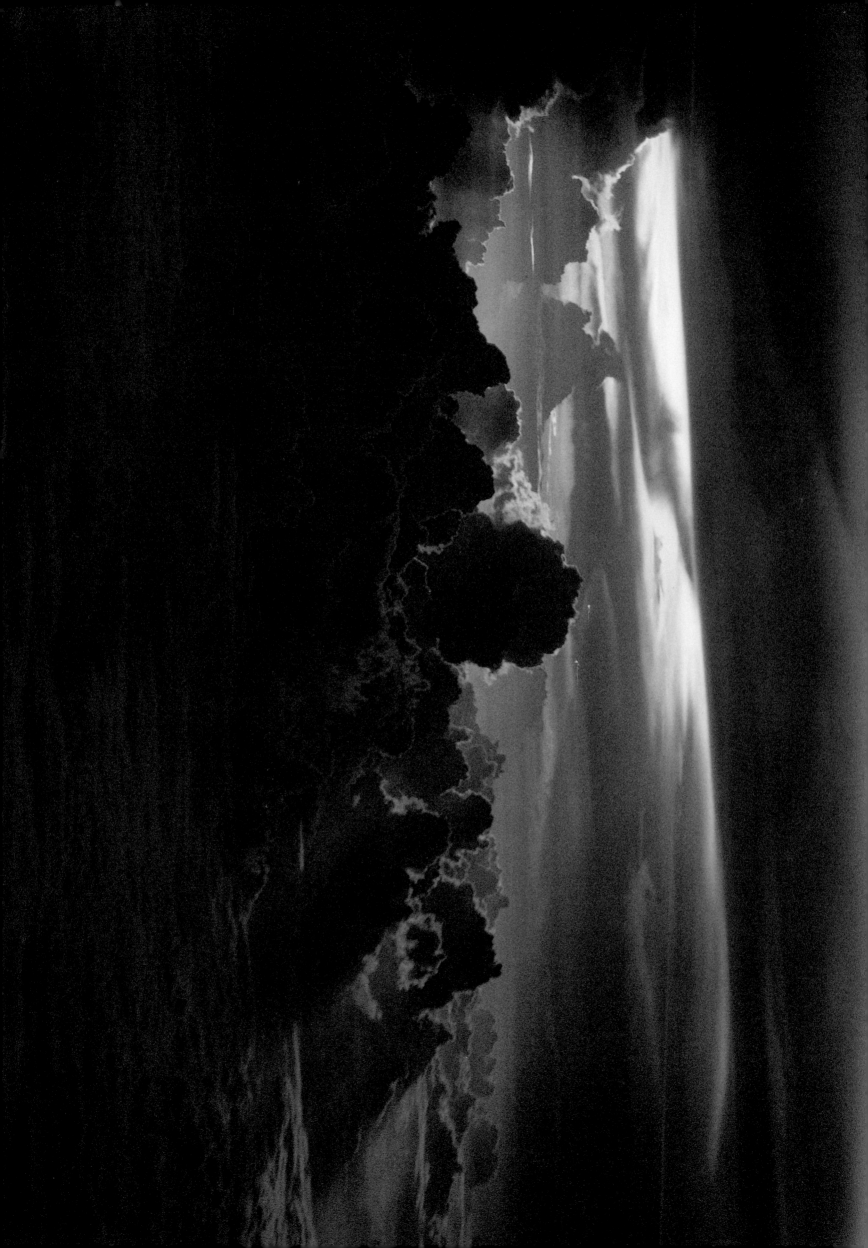

The Seasons

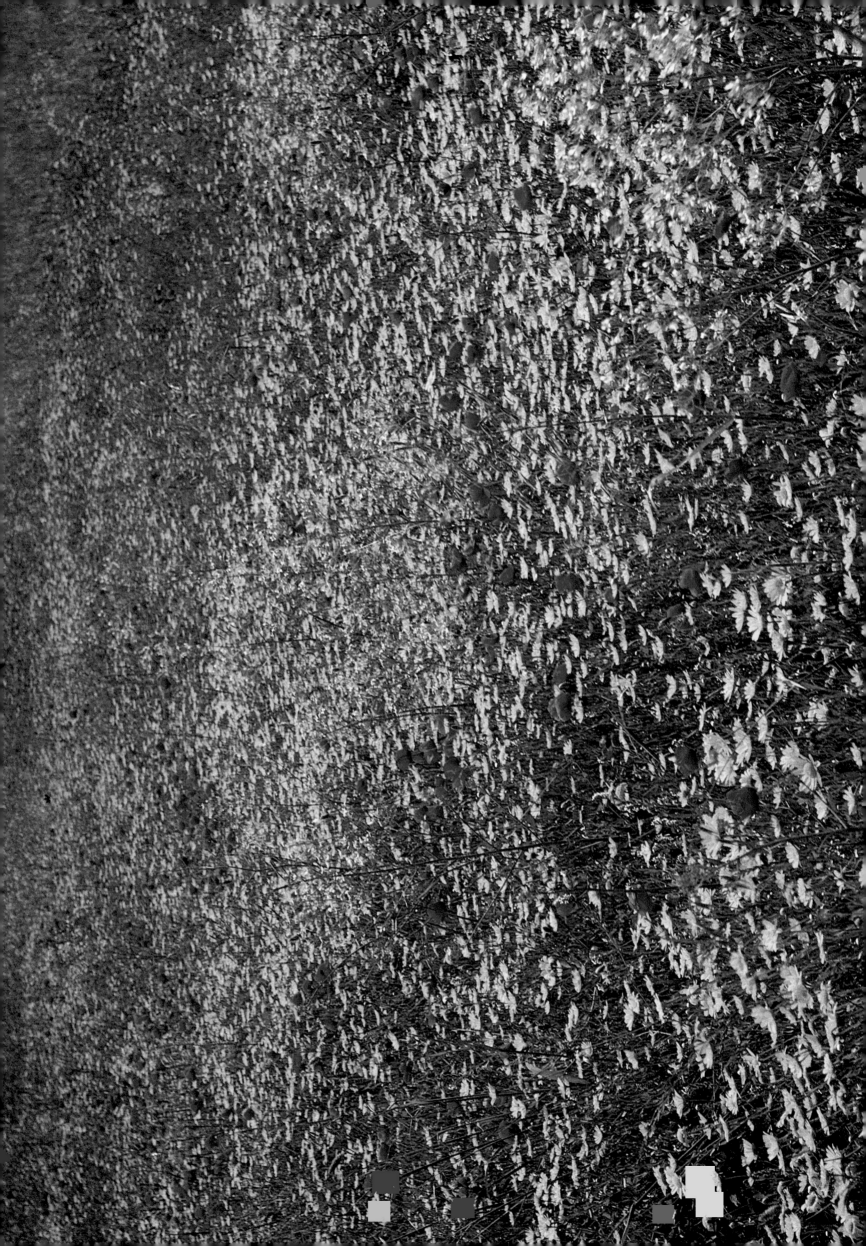

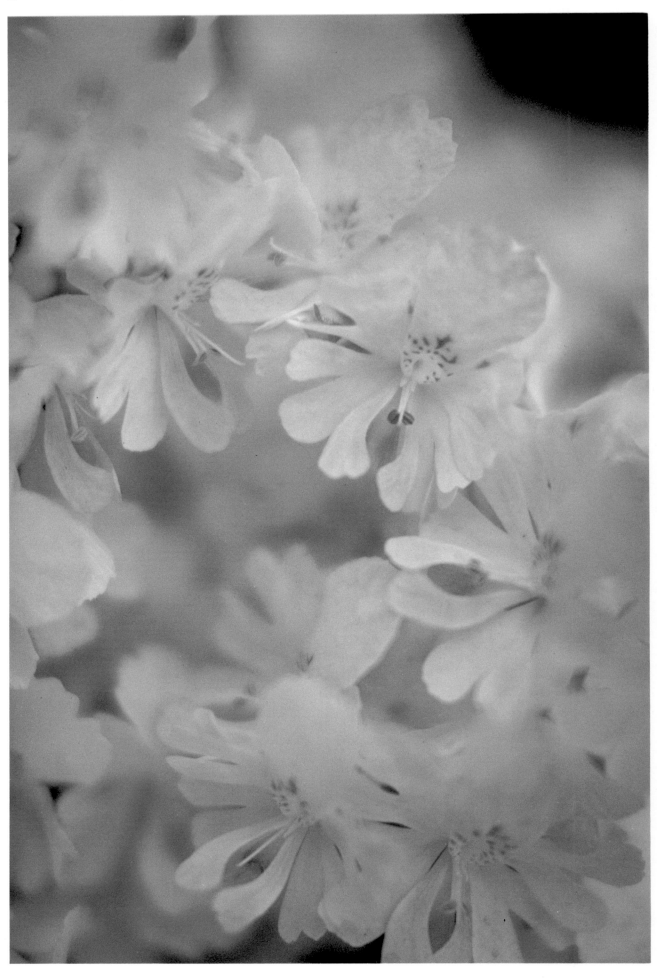

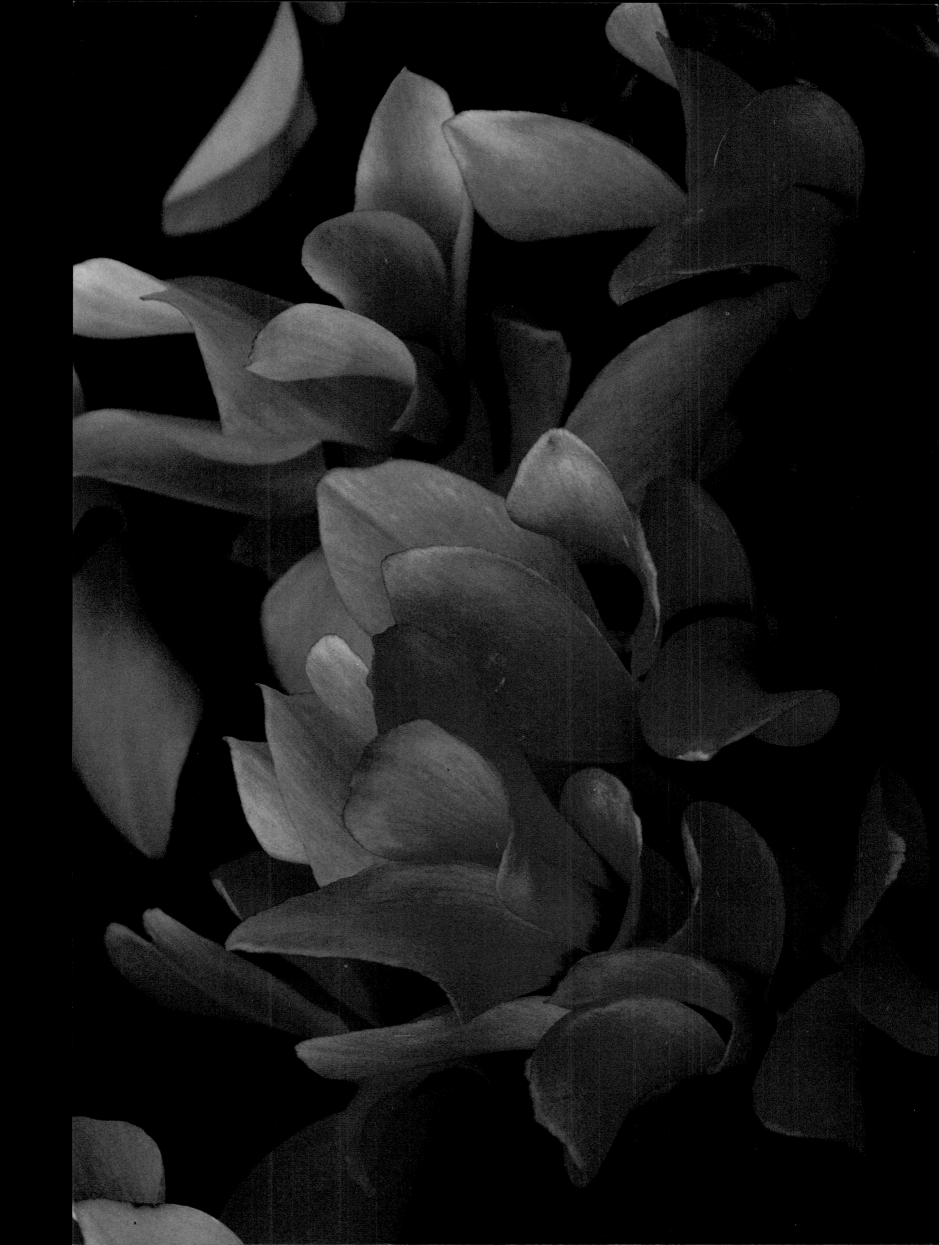

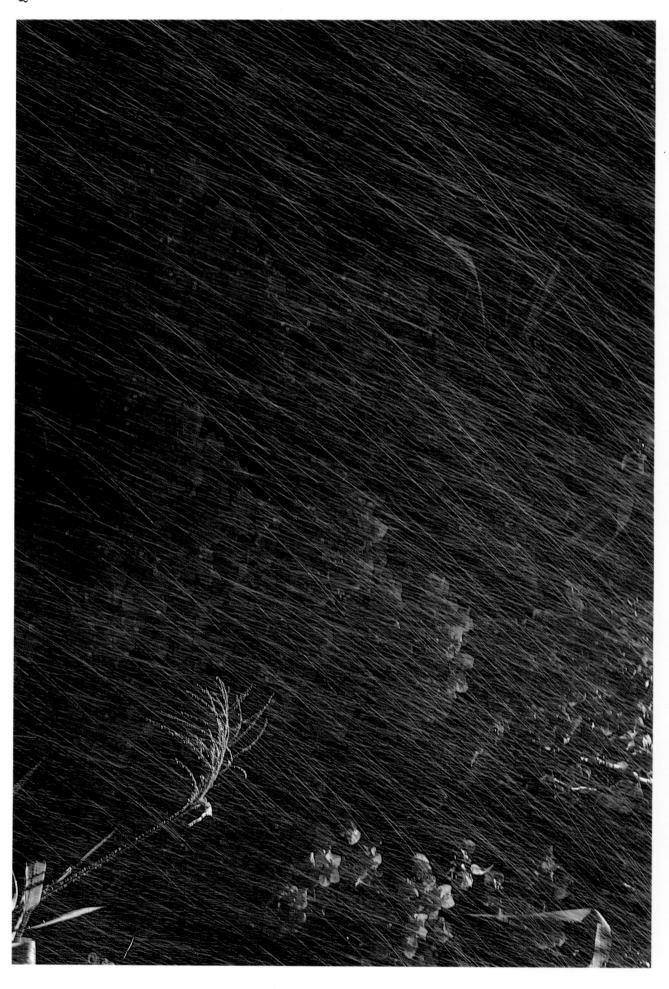

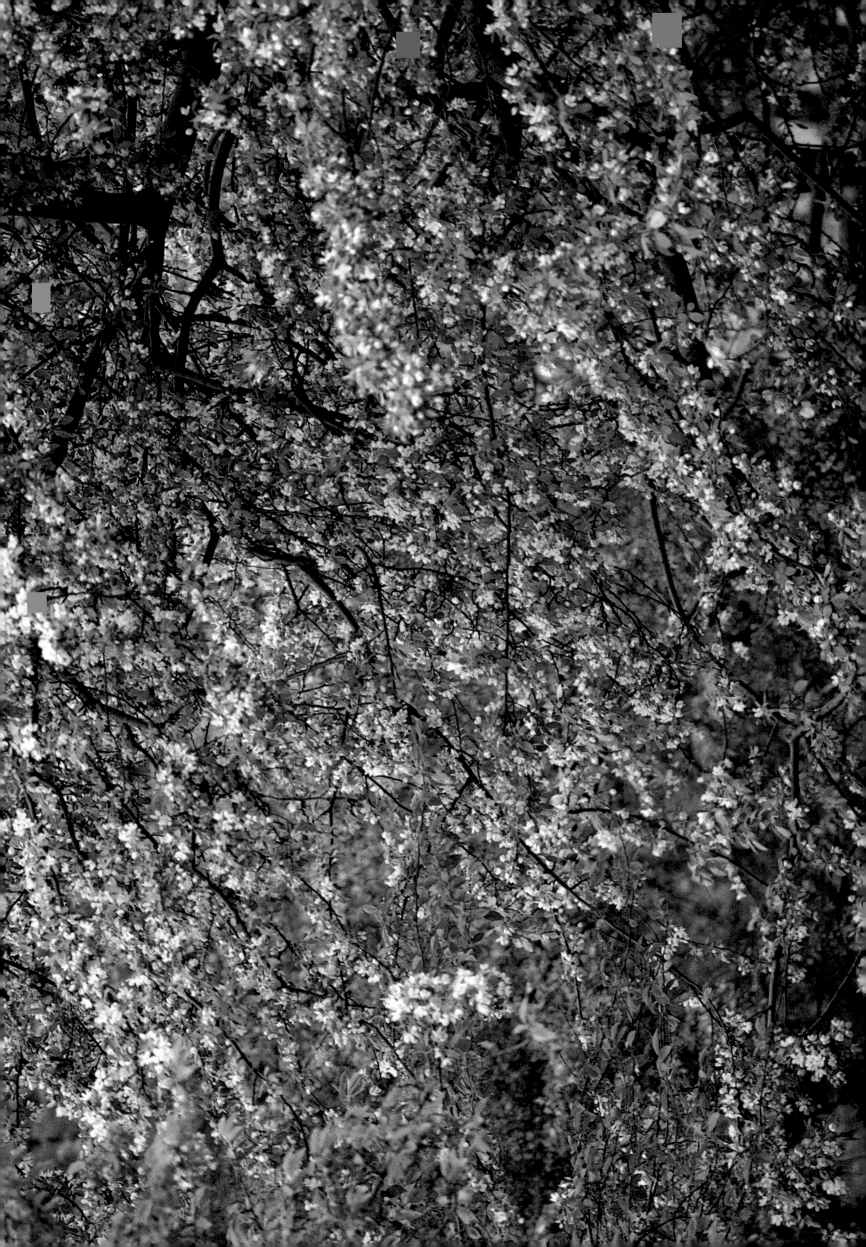

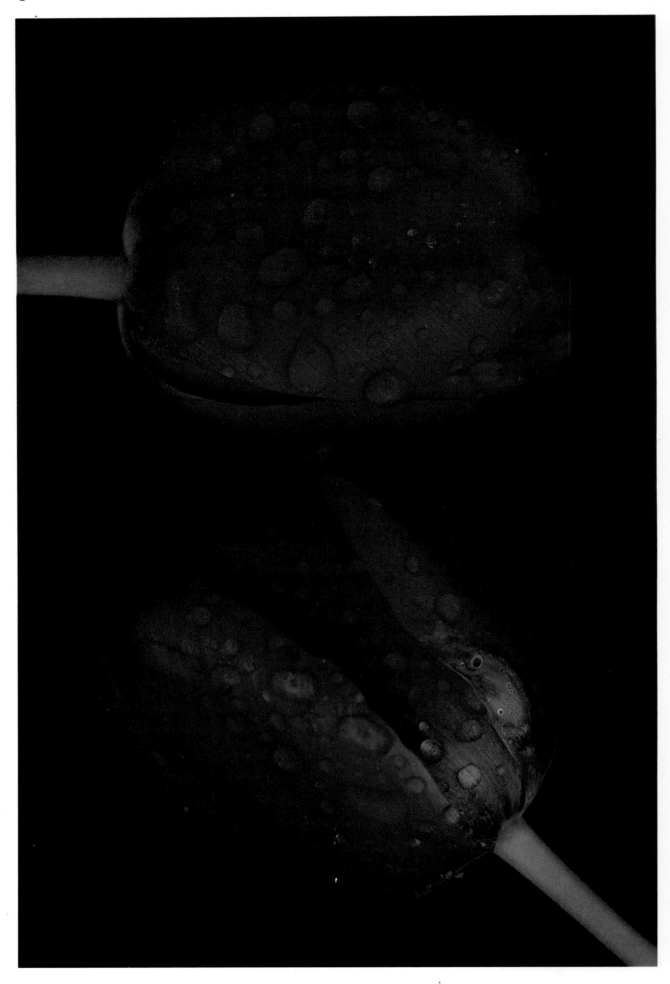

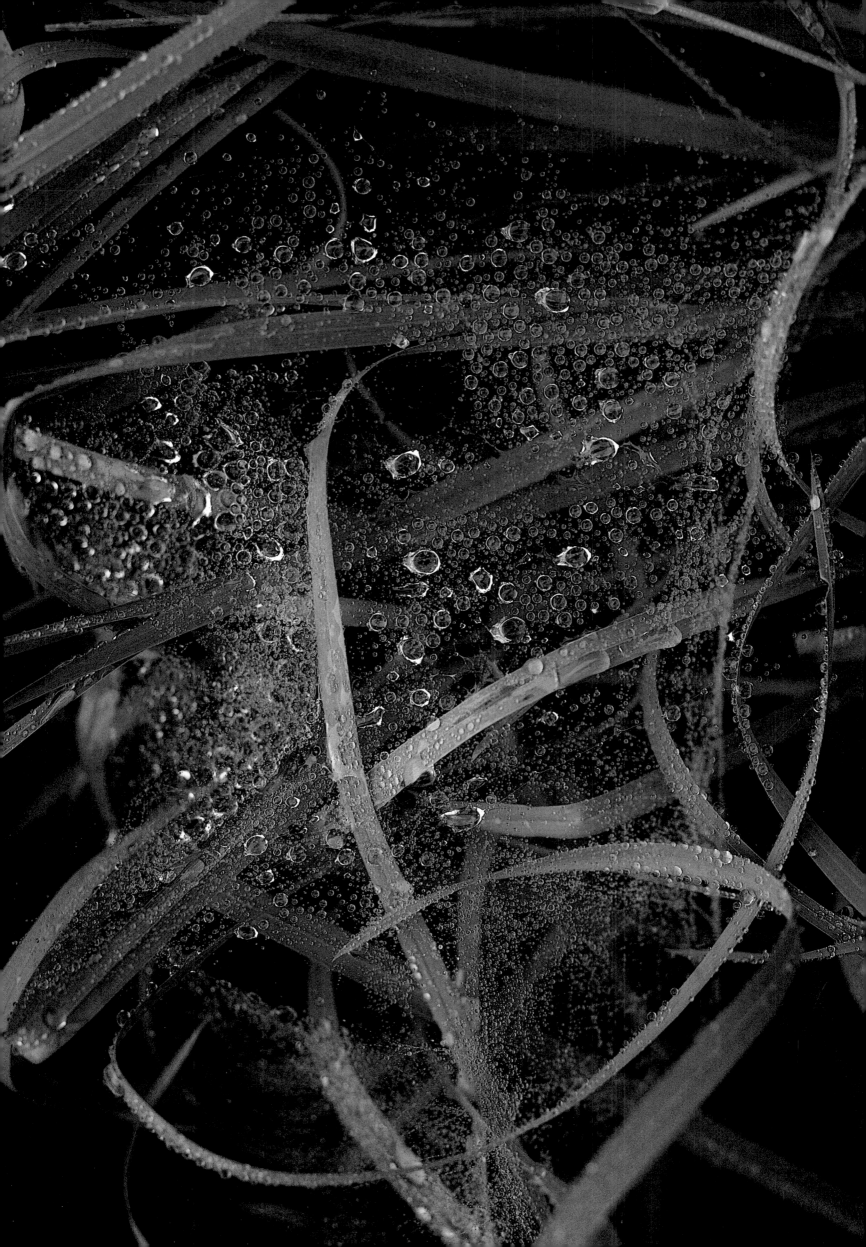

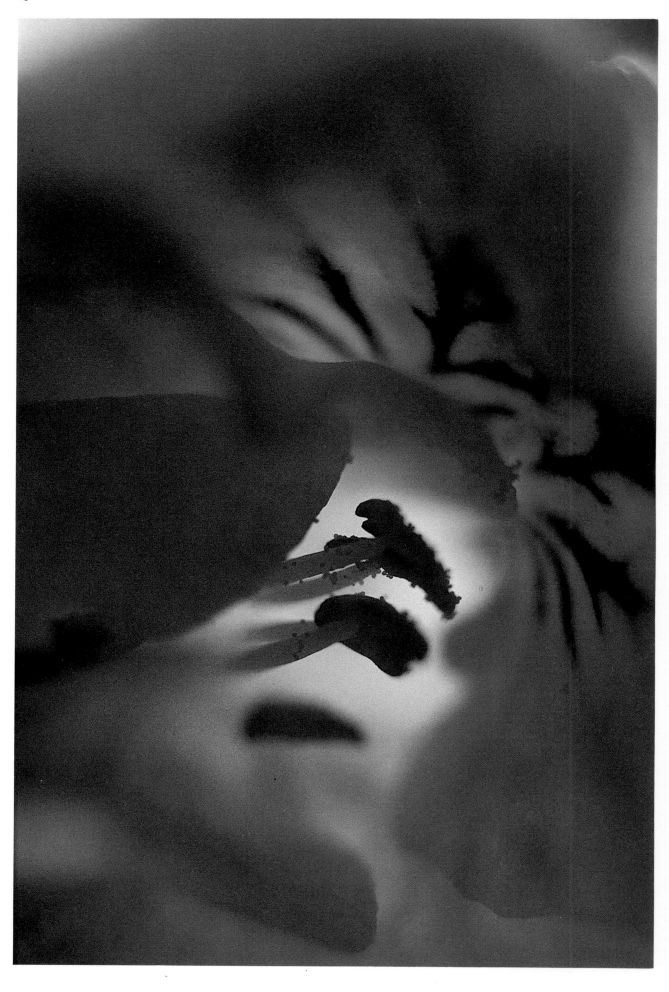

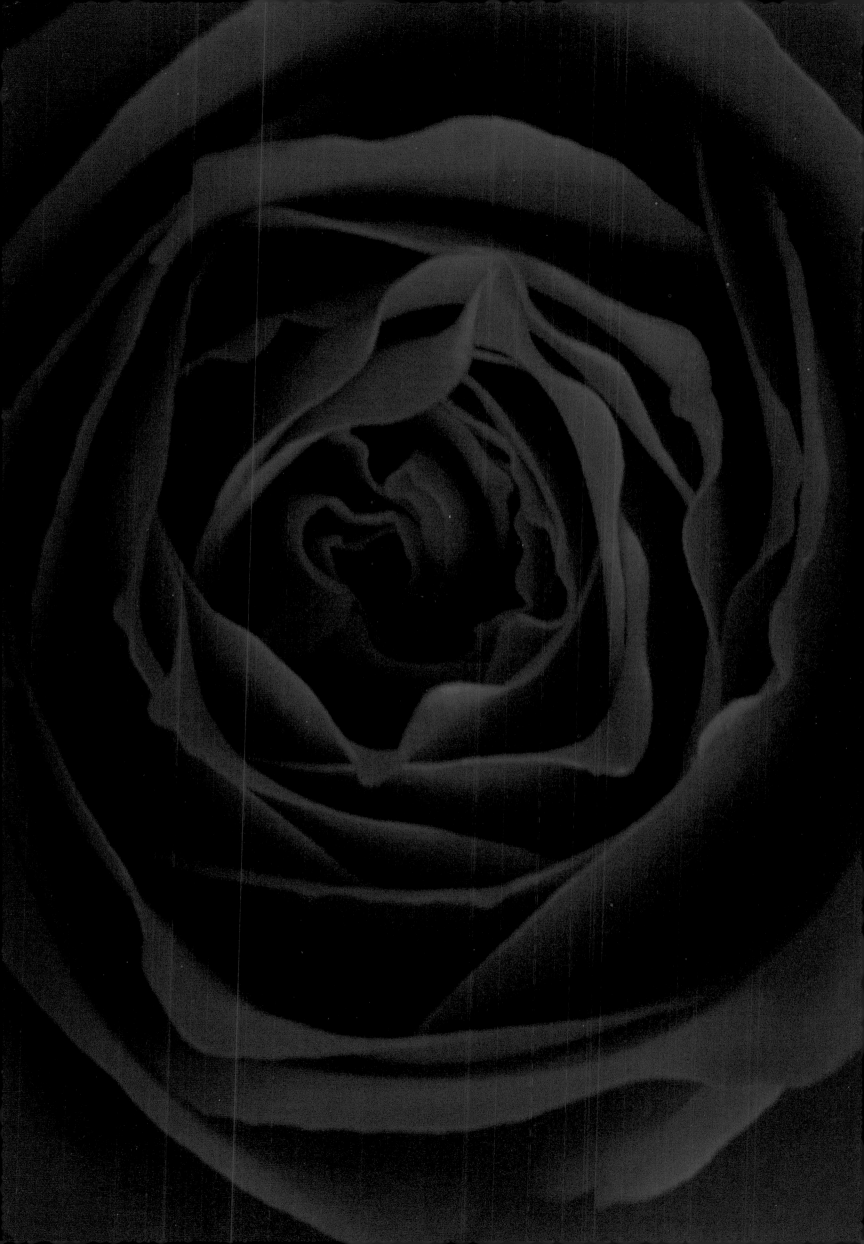

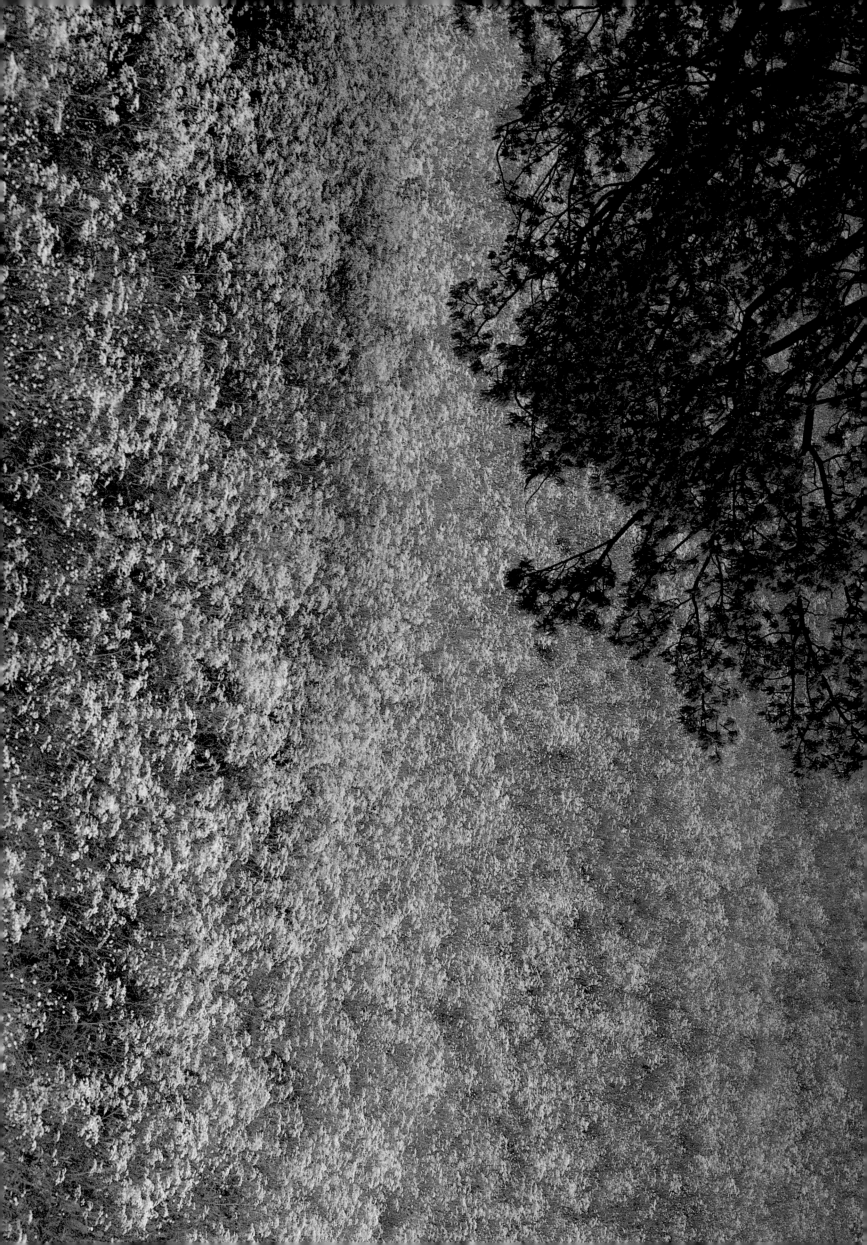

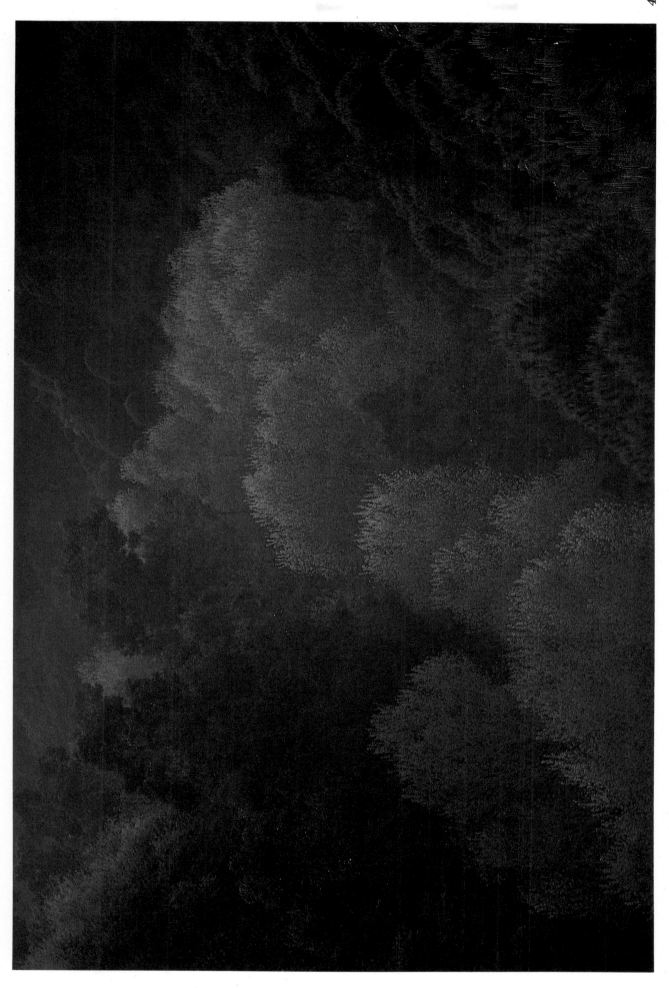

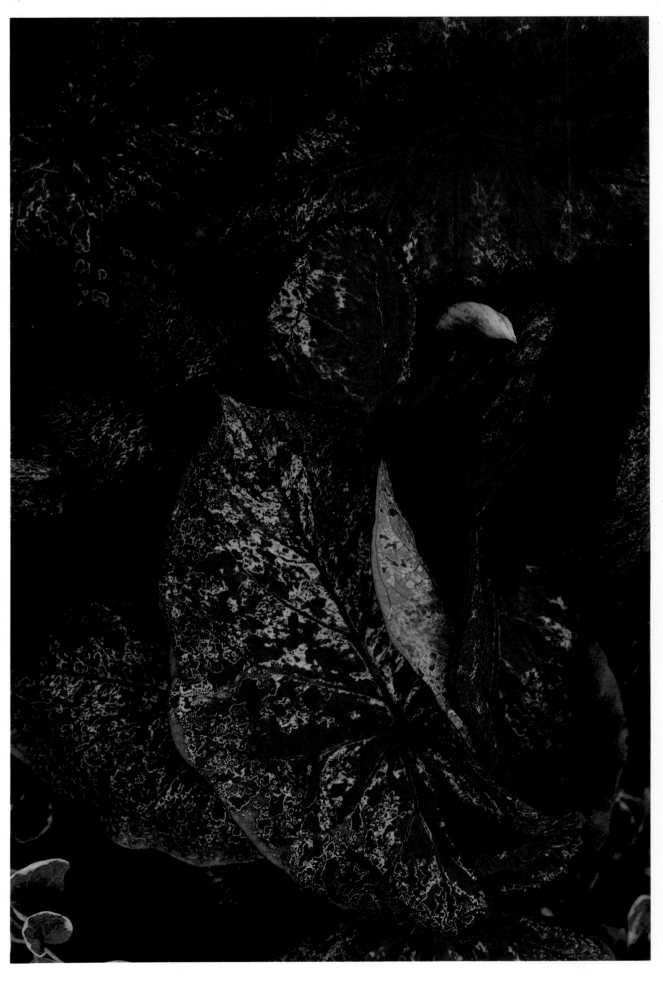

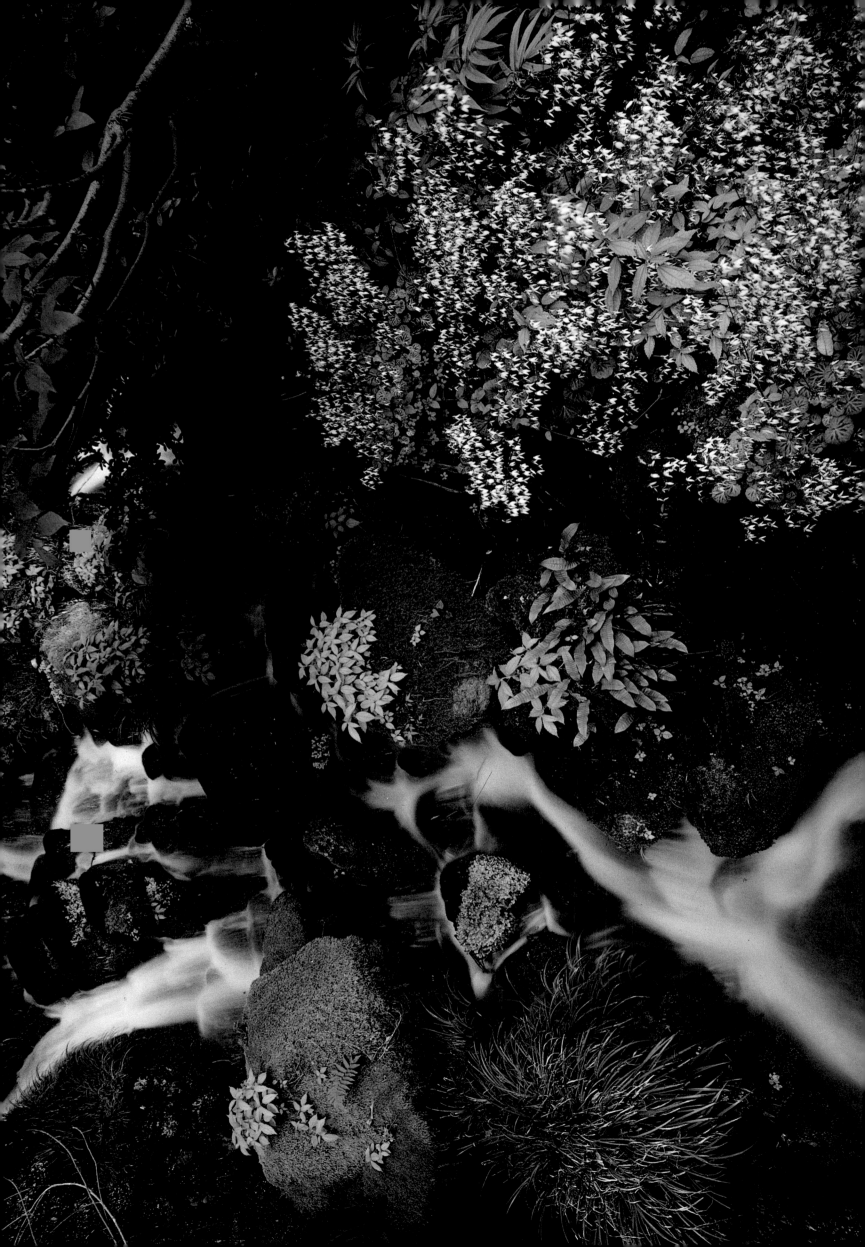

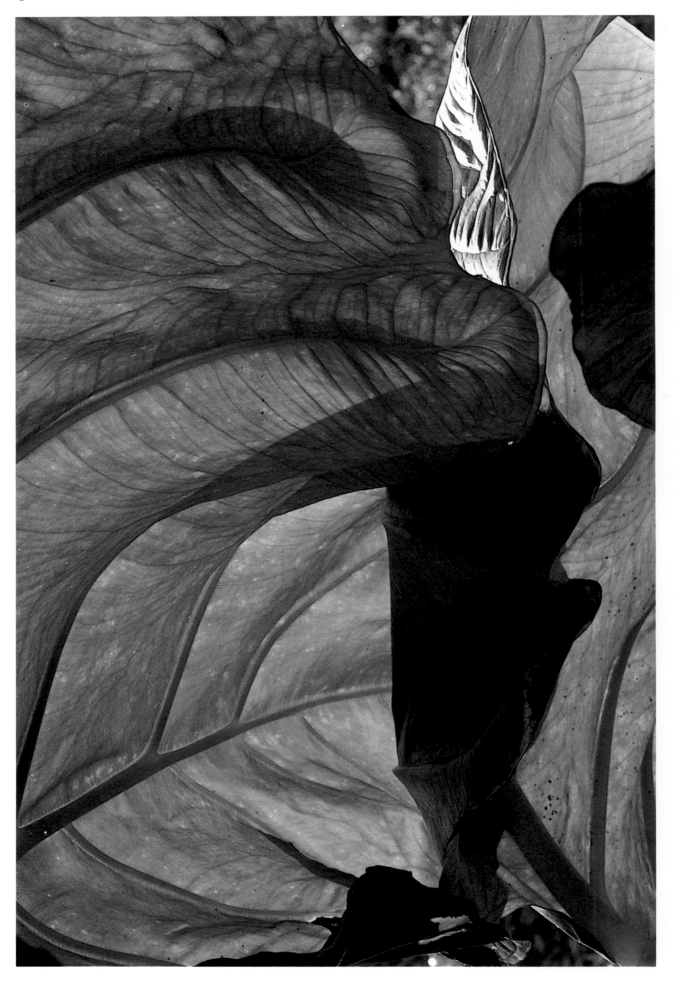

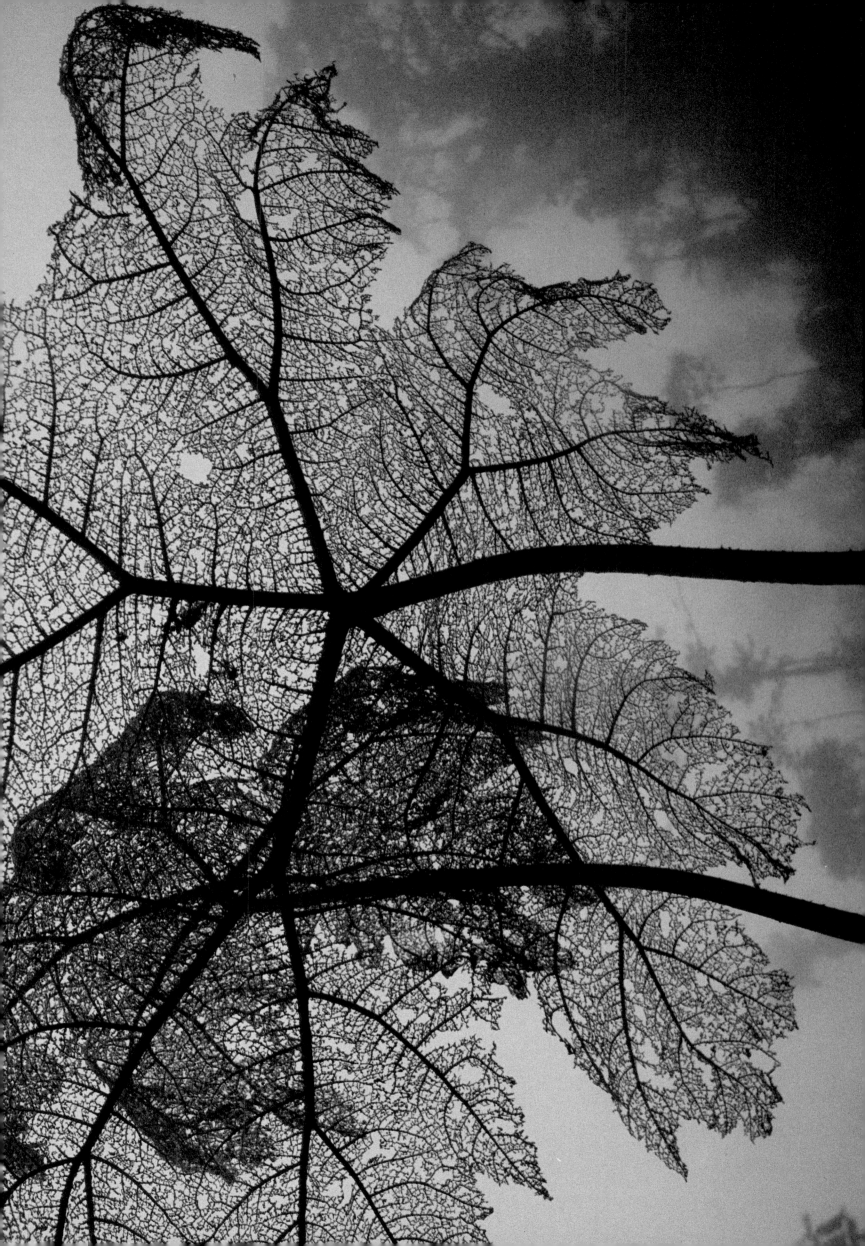

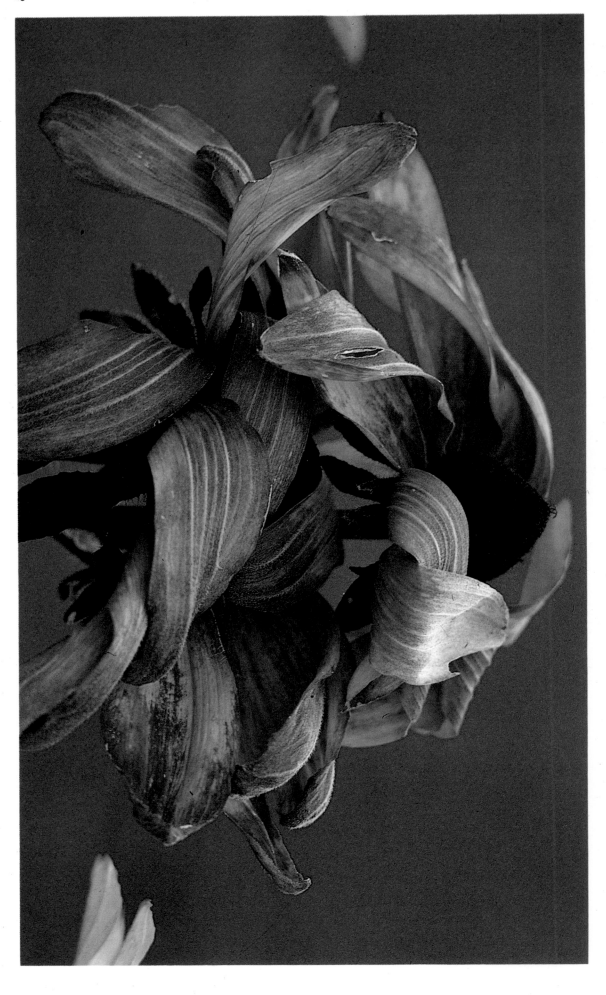

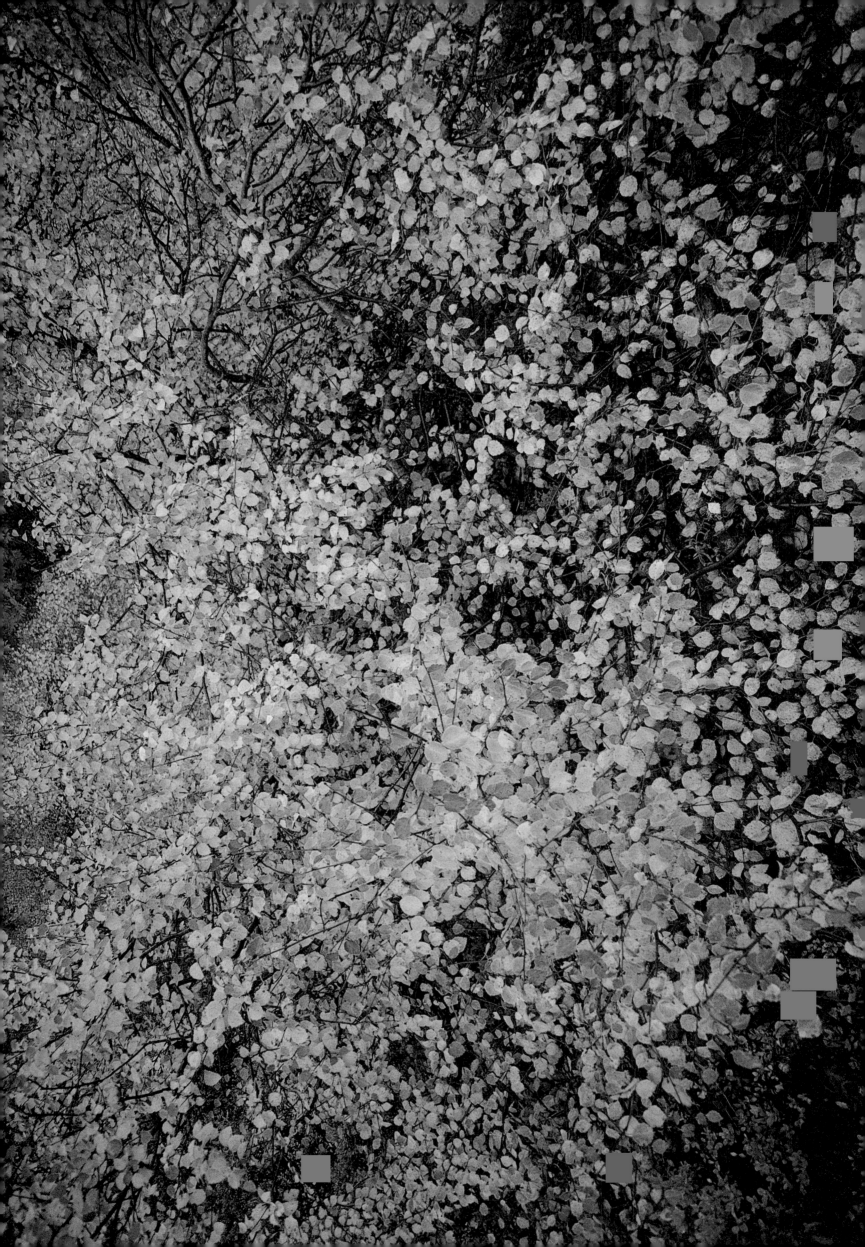

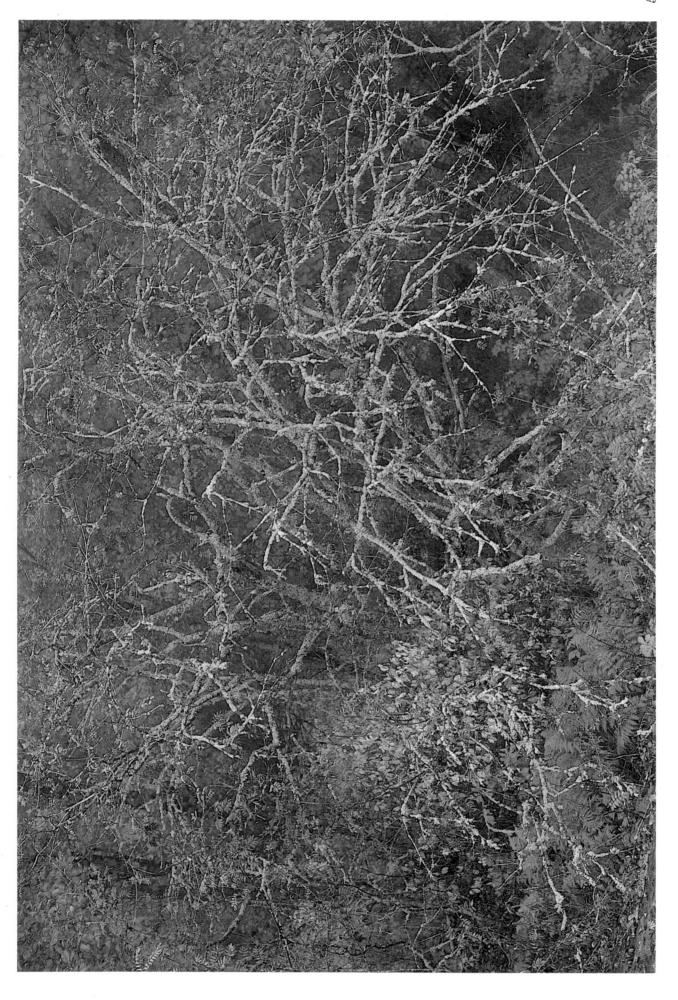

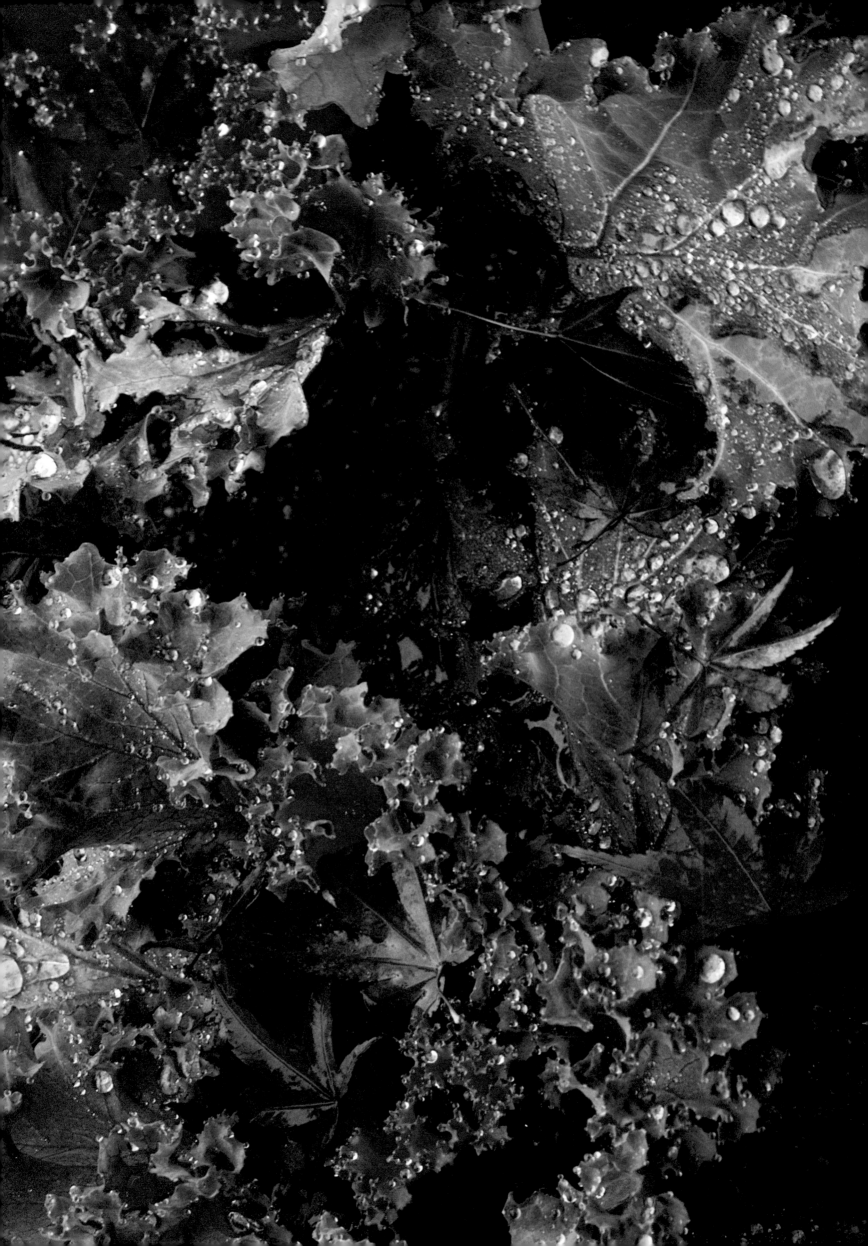

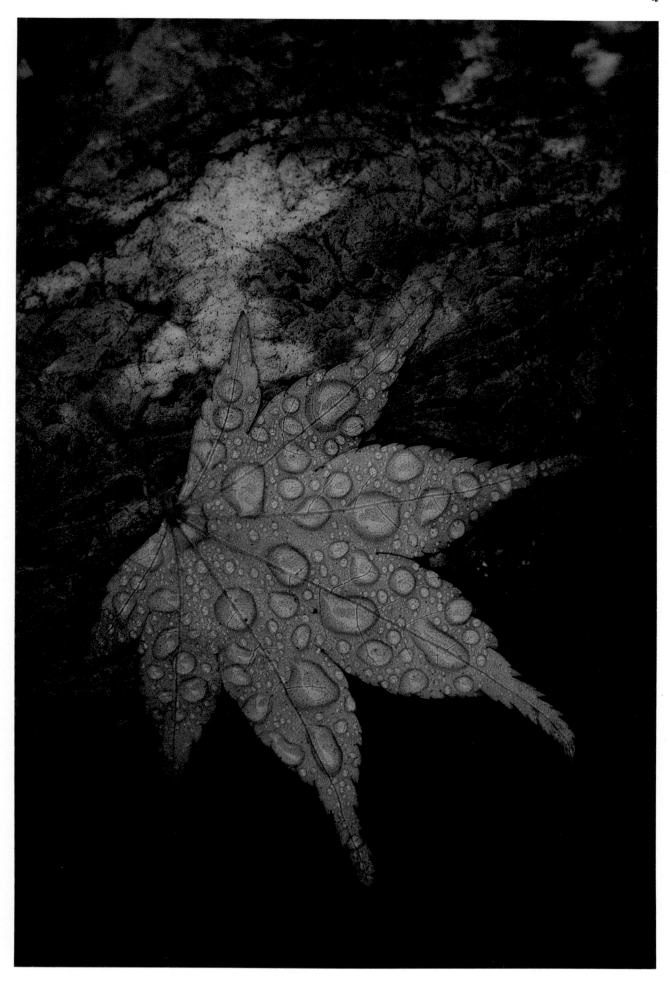

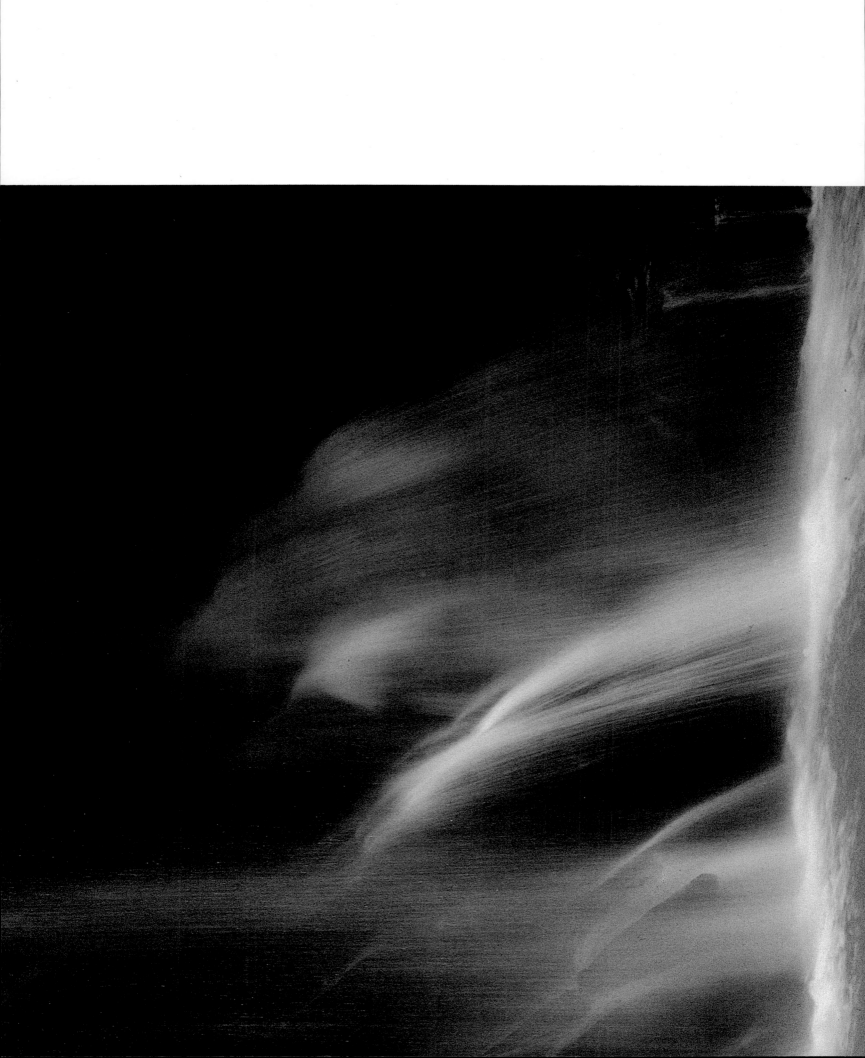

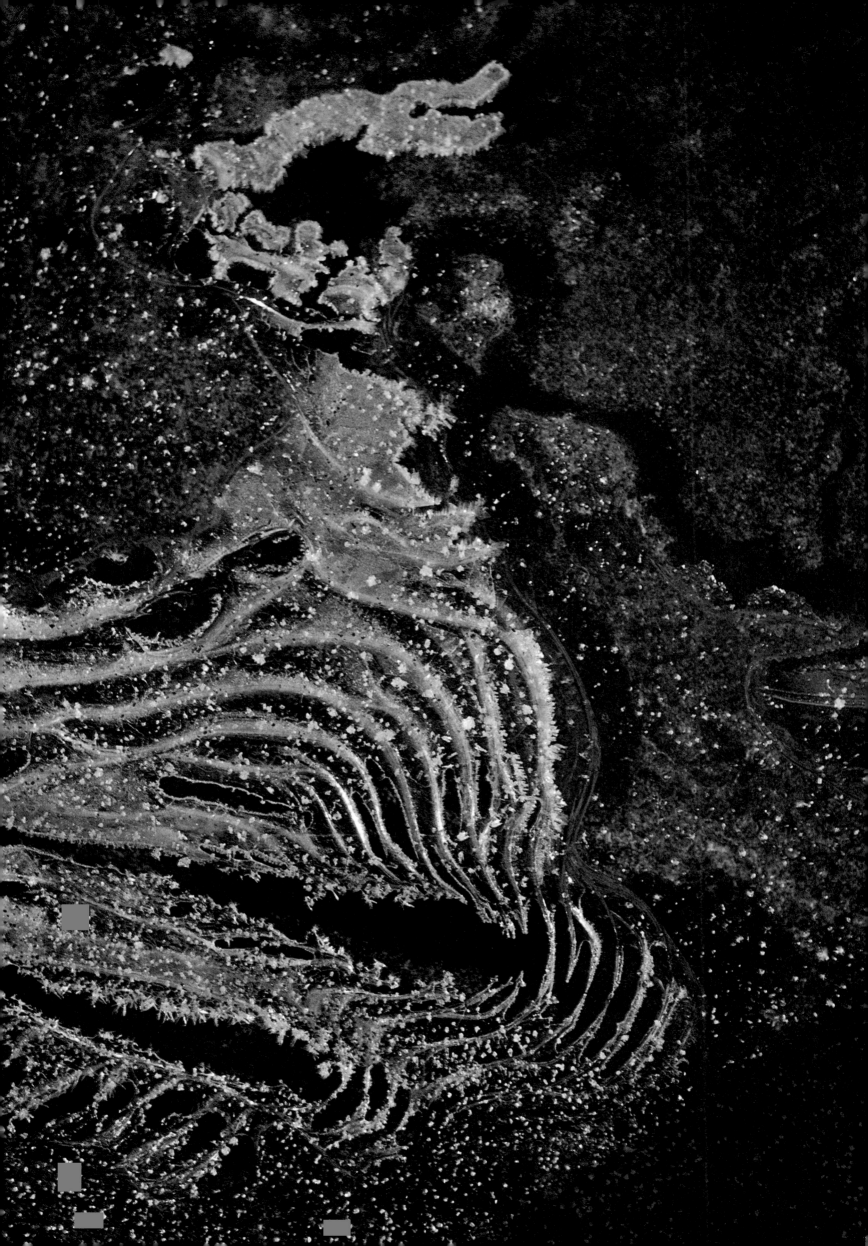

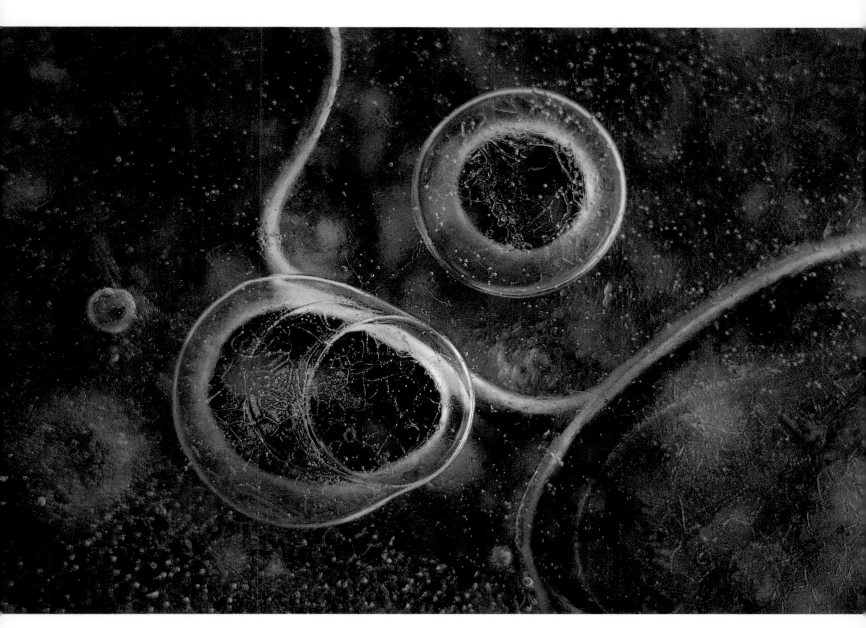

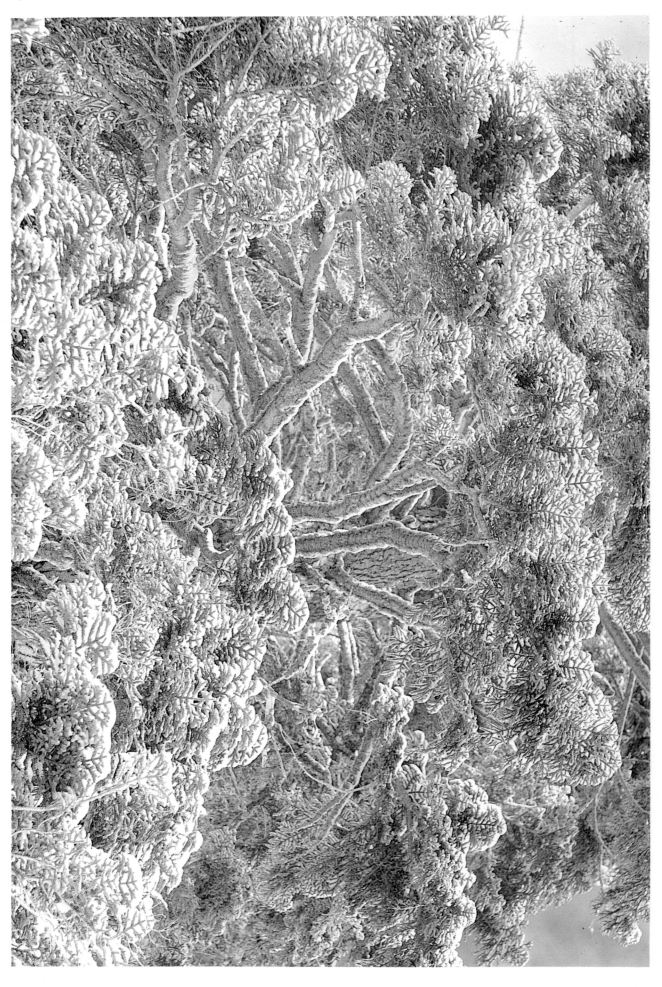

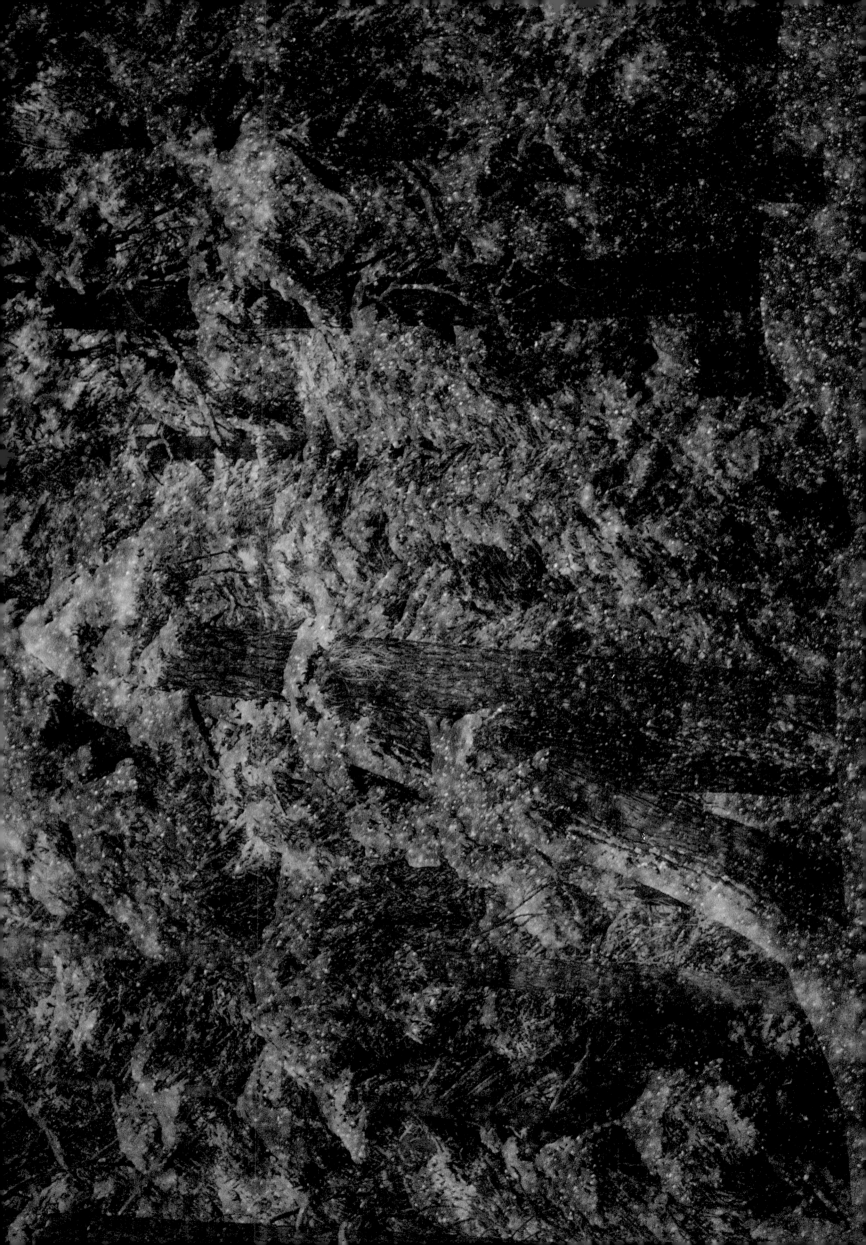

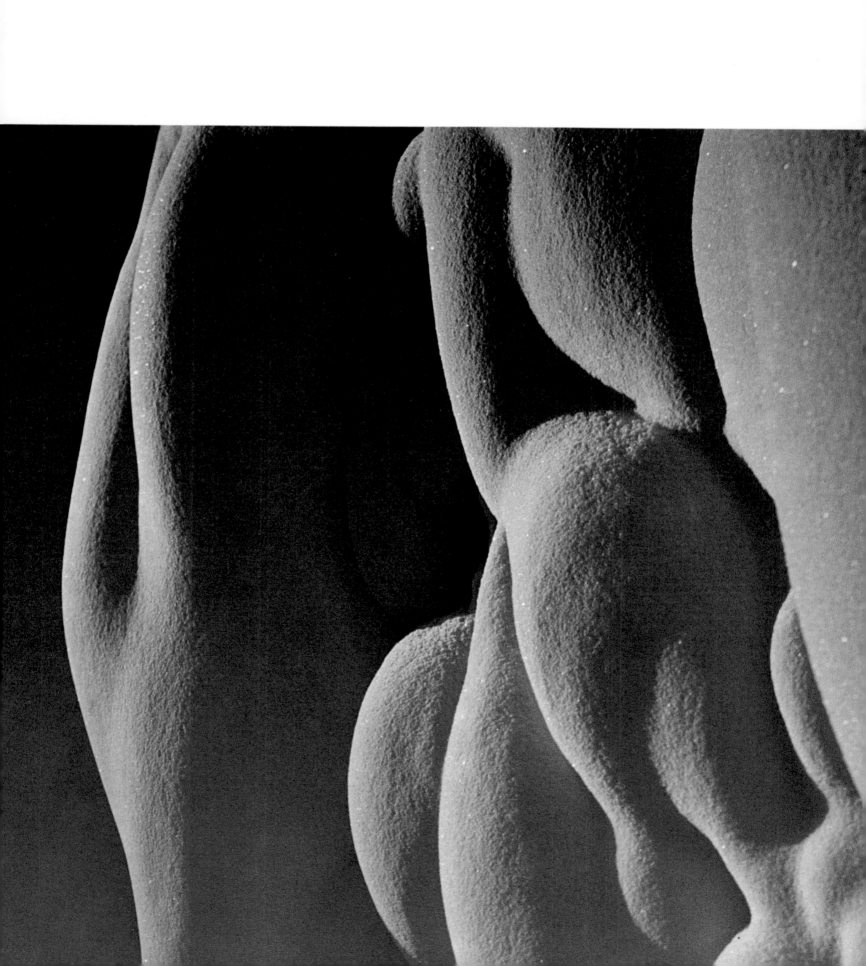

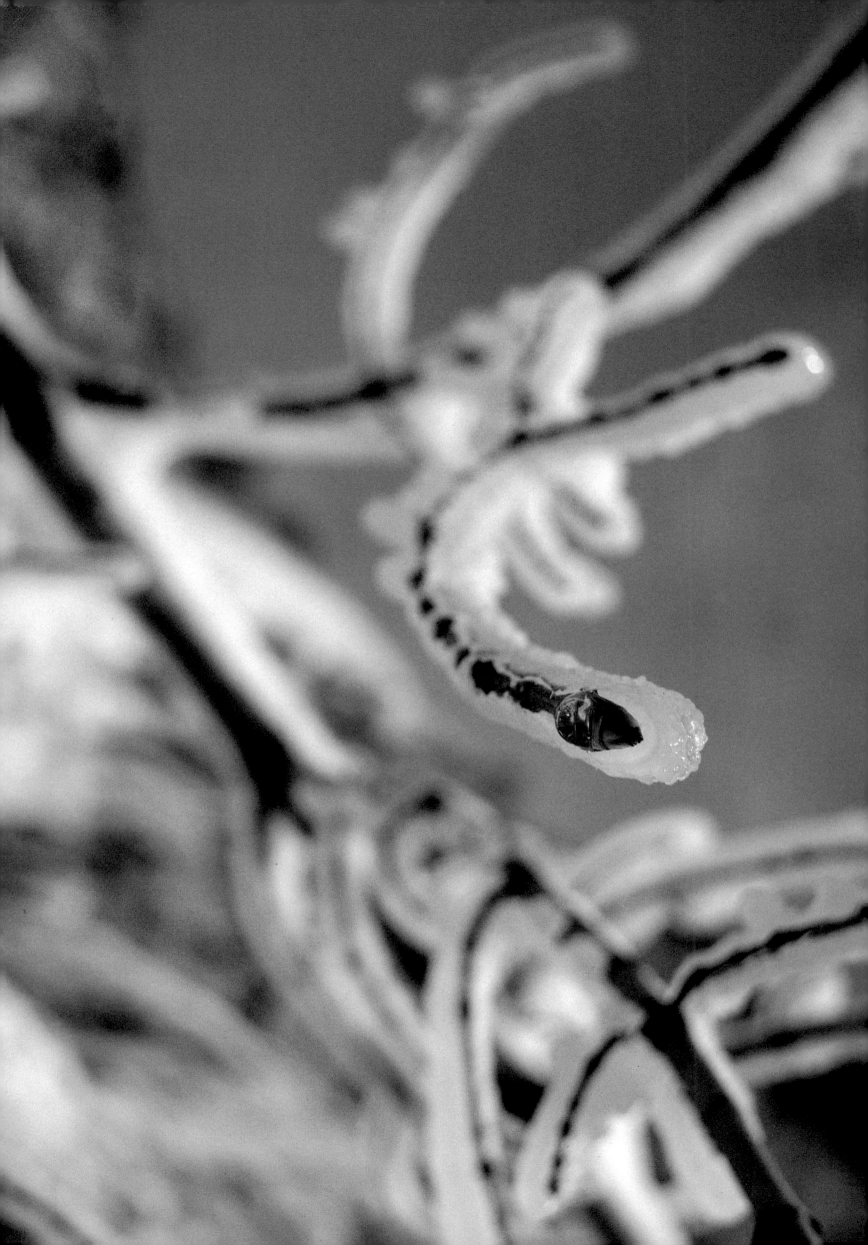

The Creatures

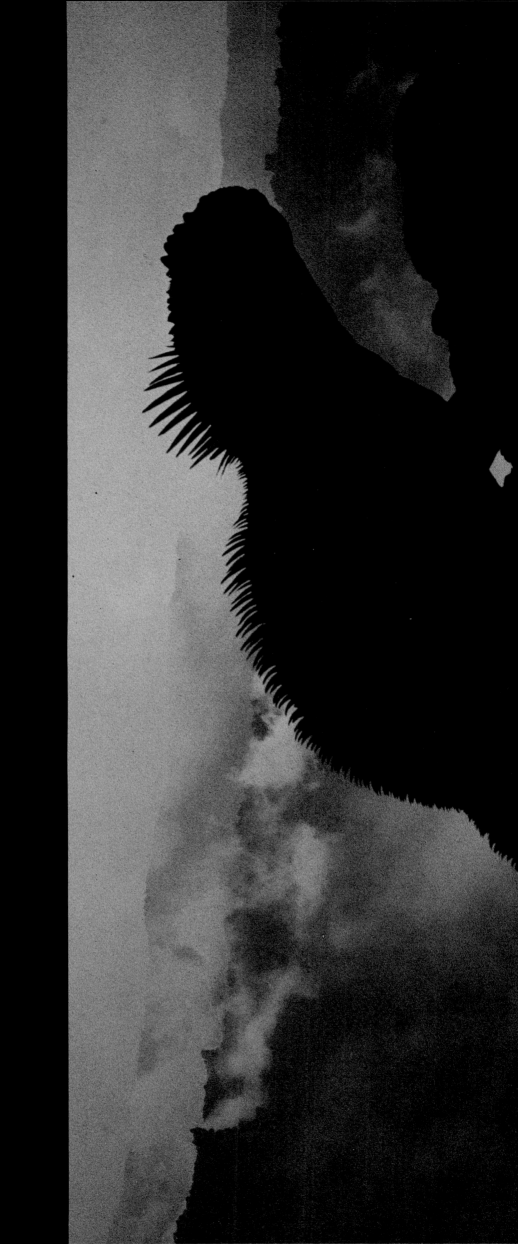

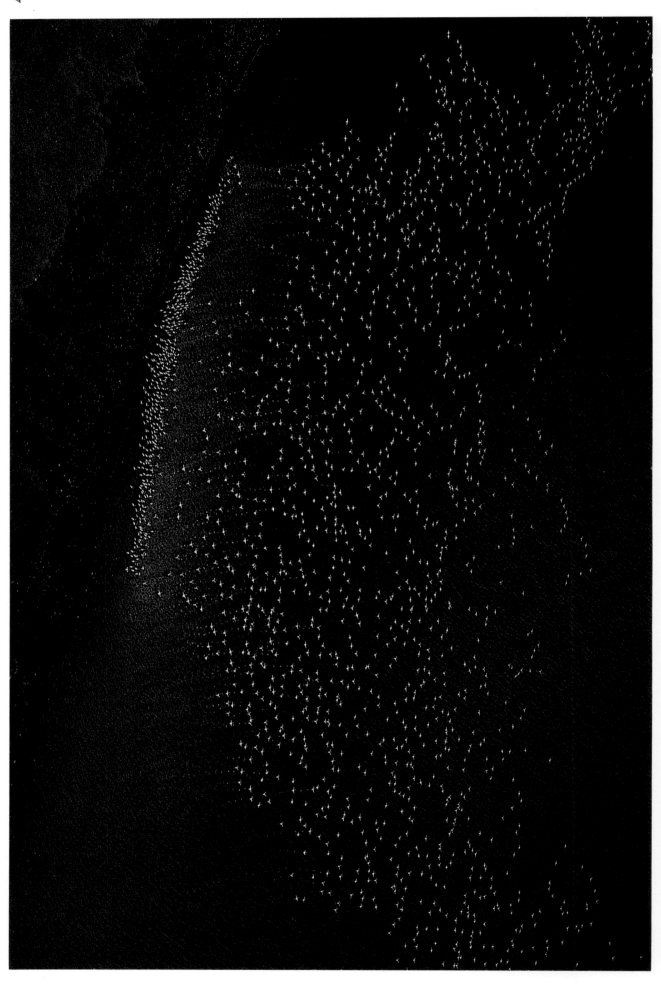

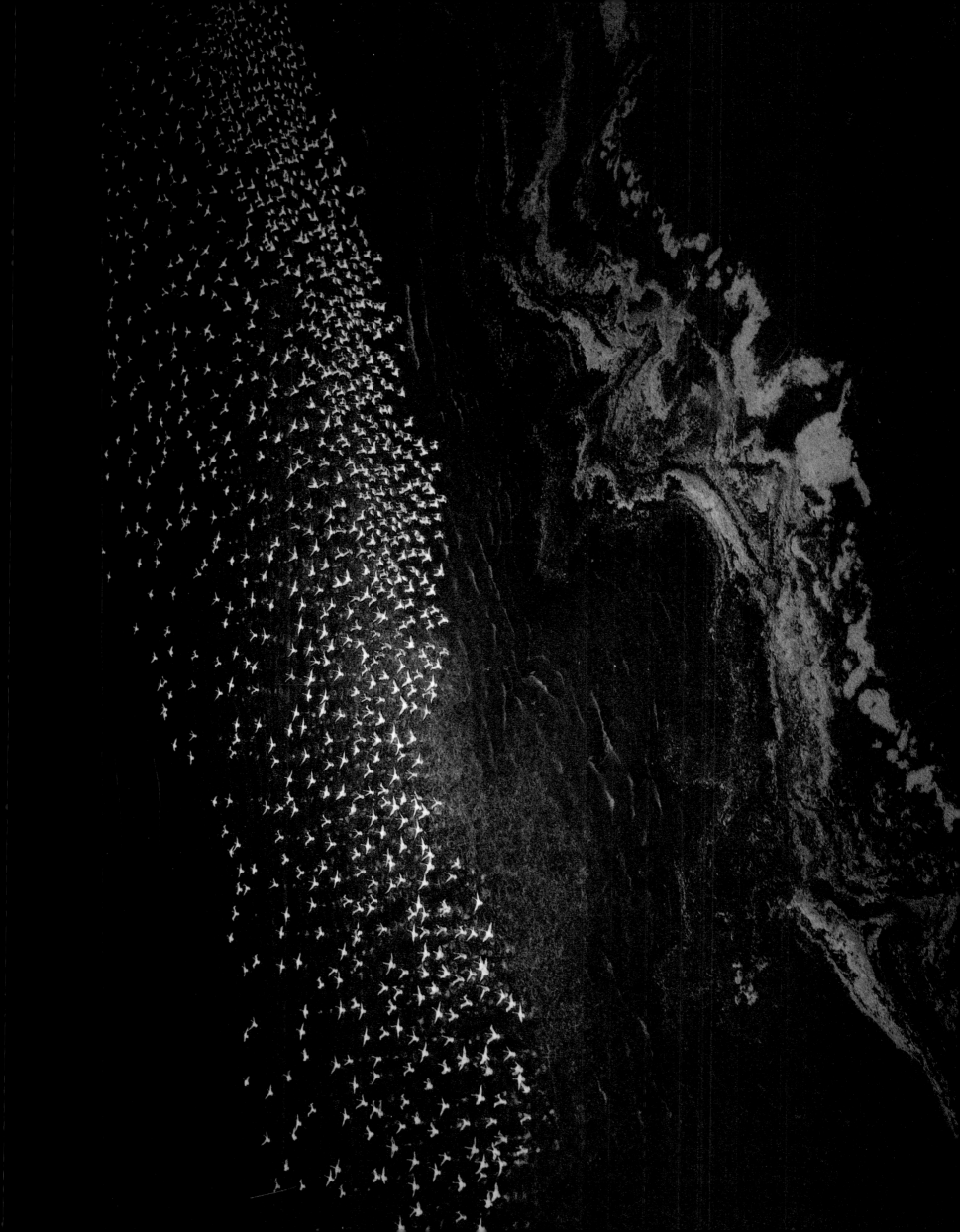

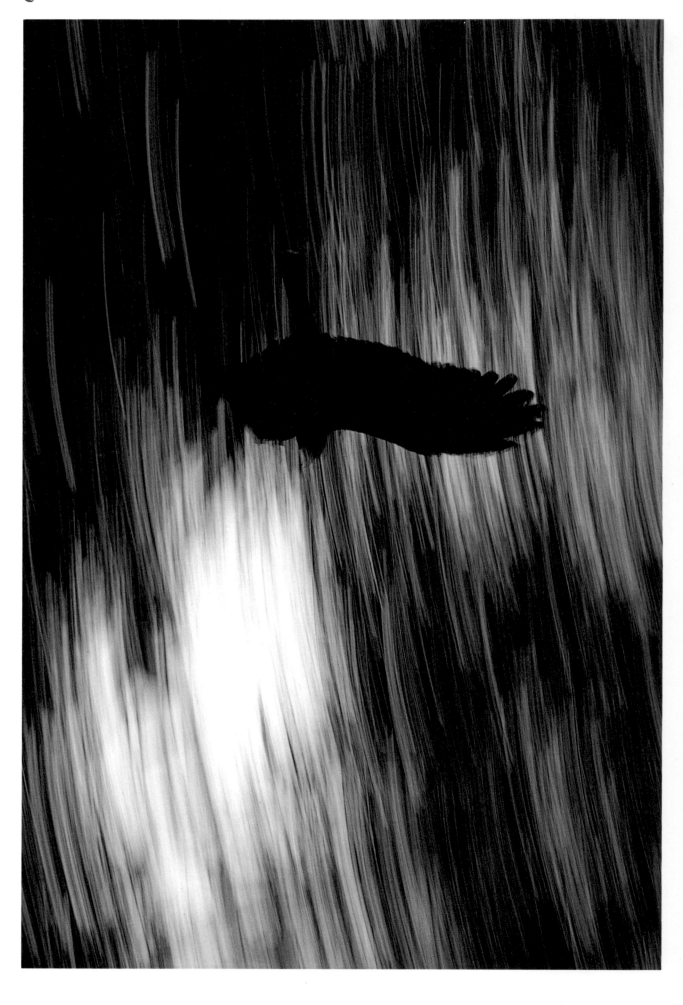

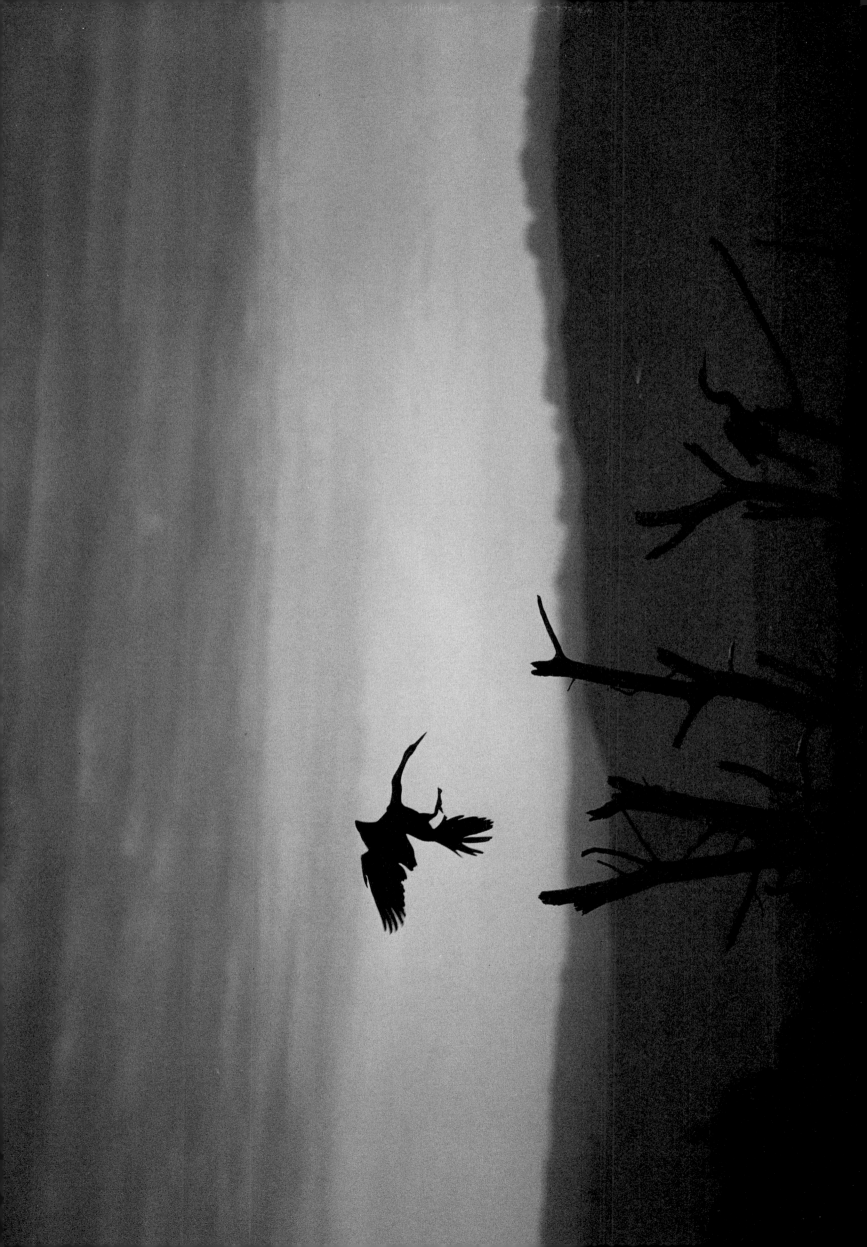

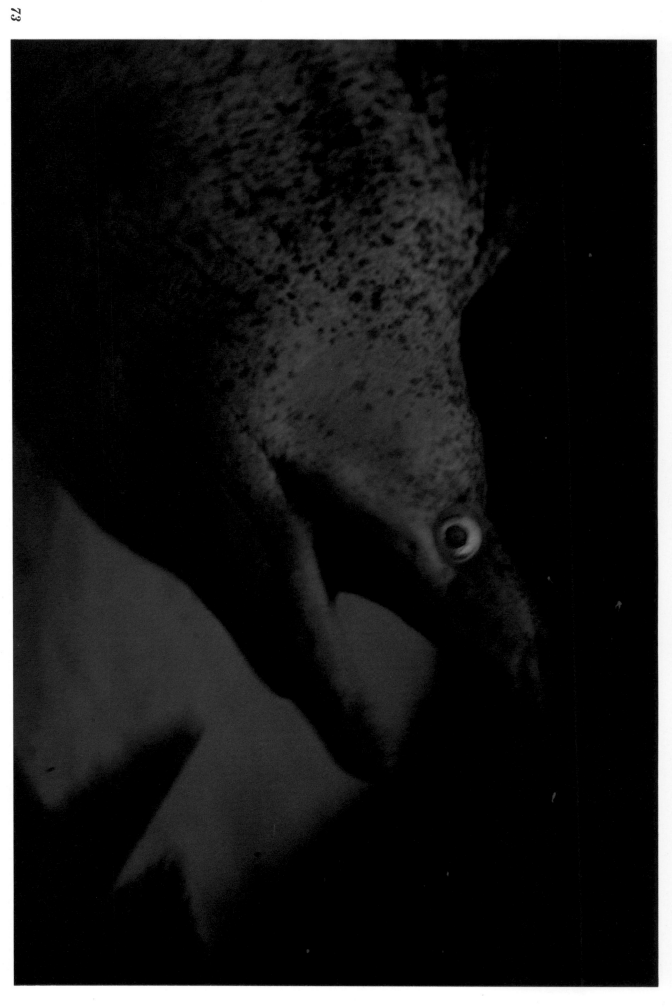

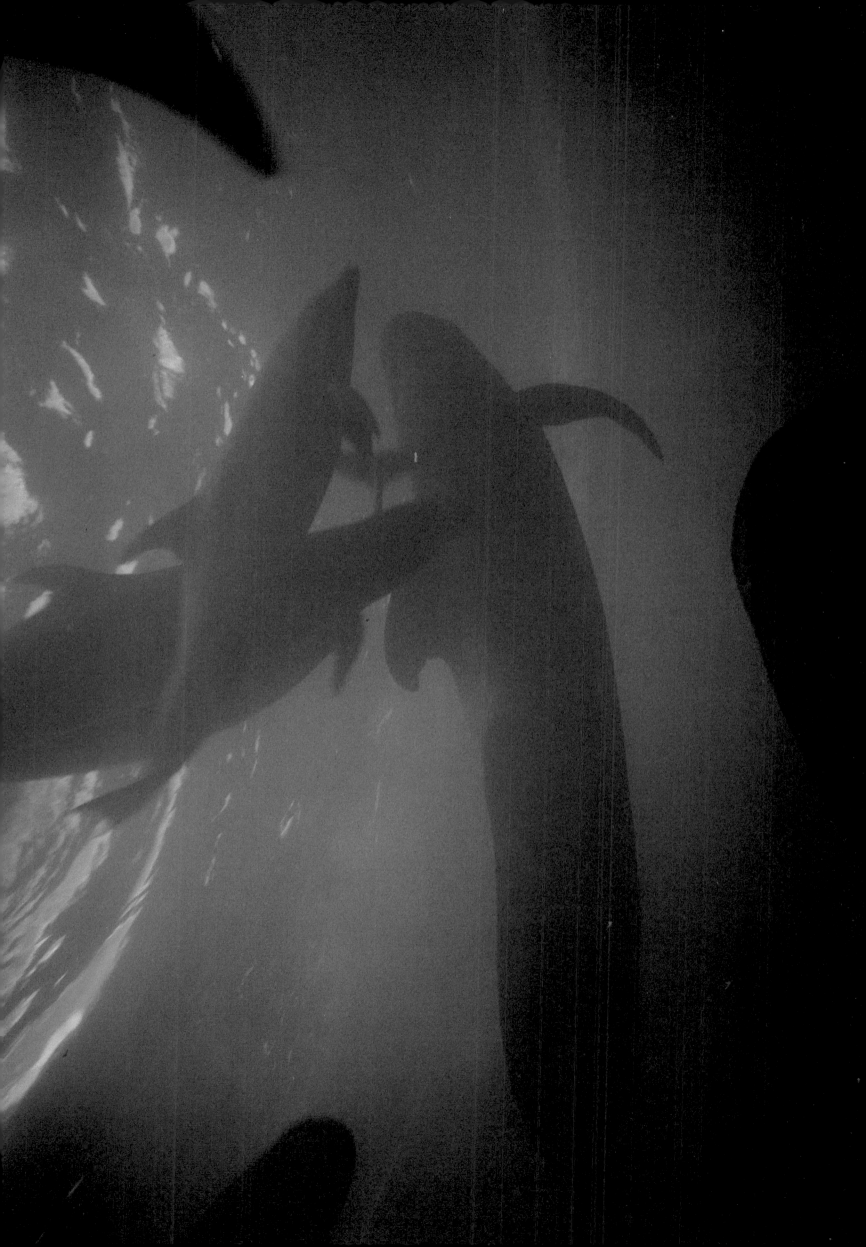

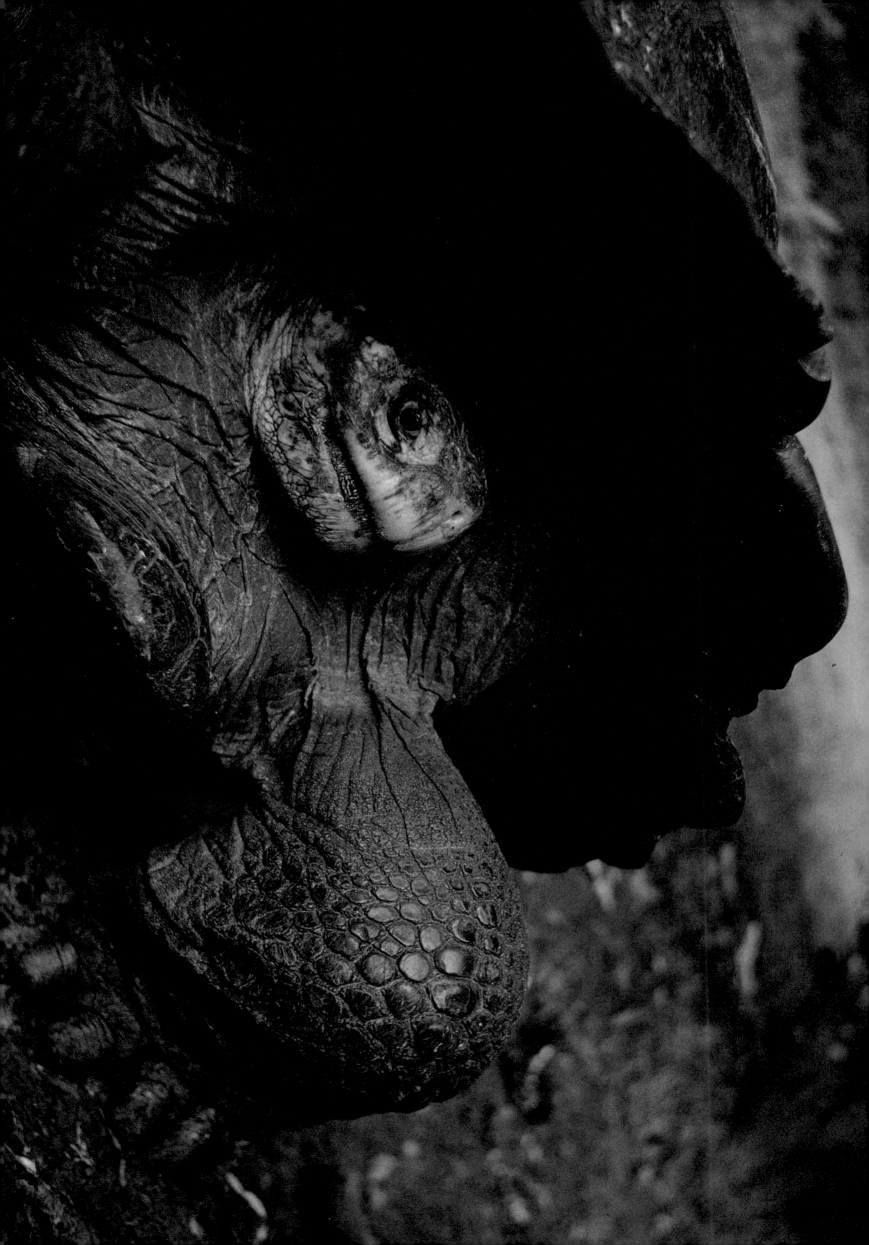

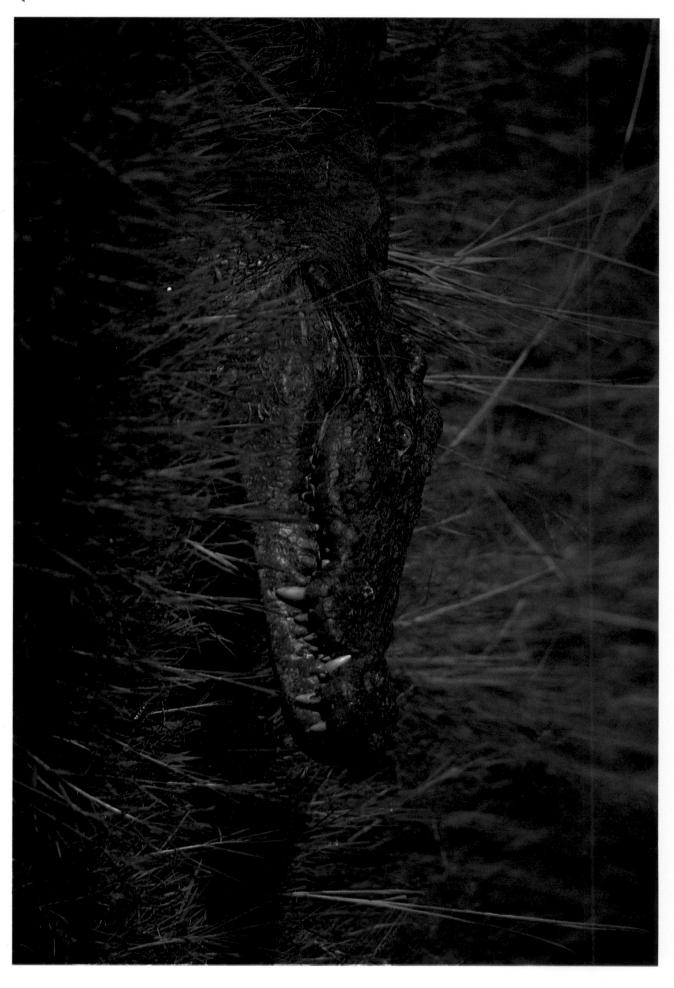

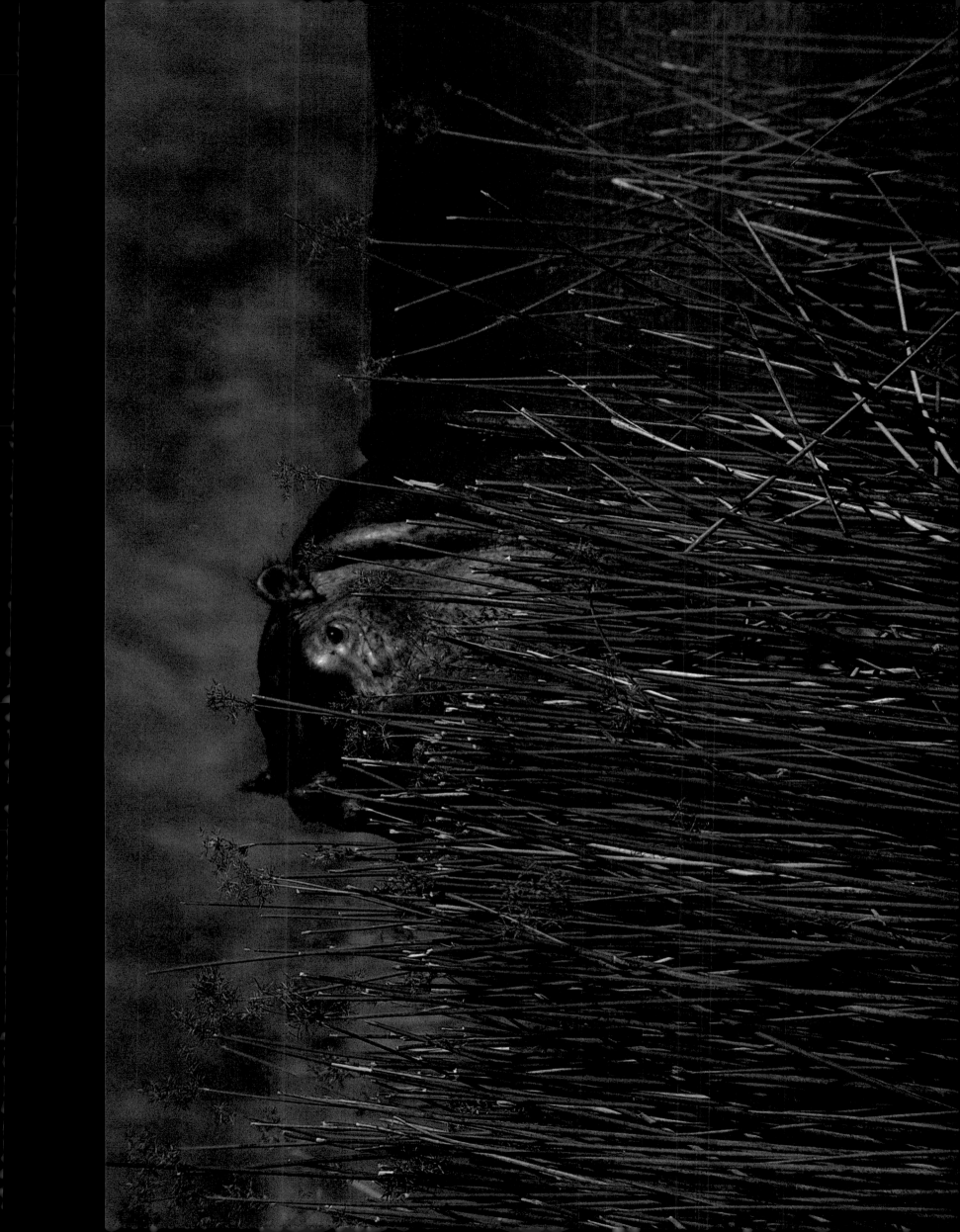

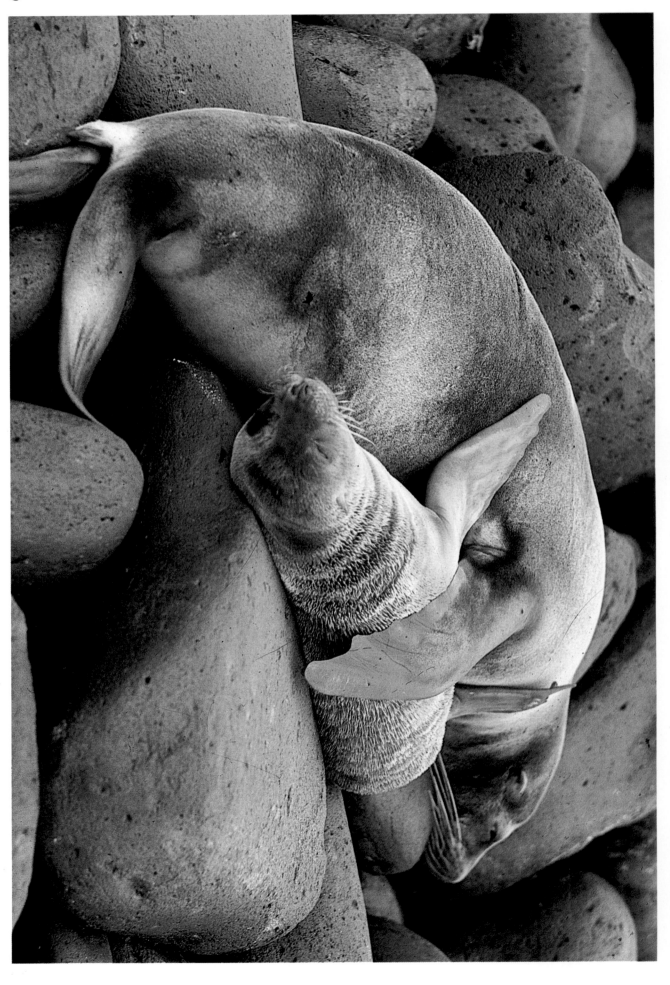

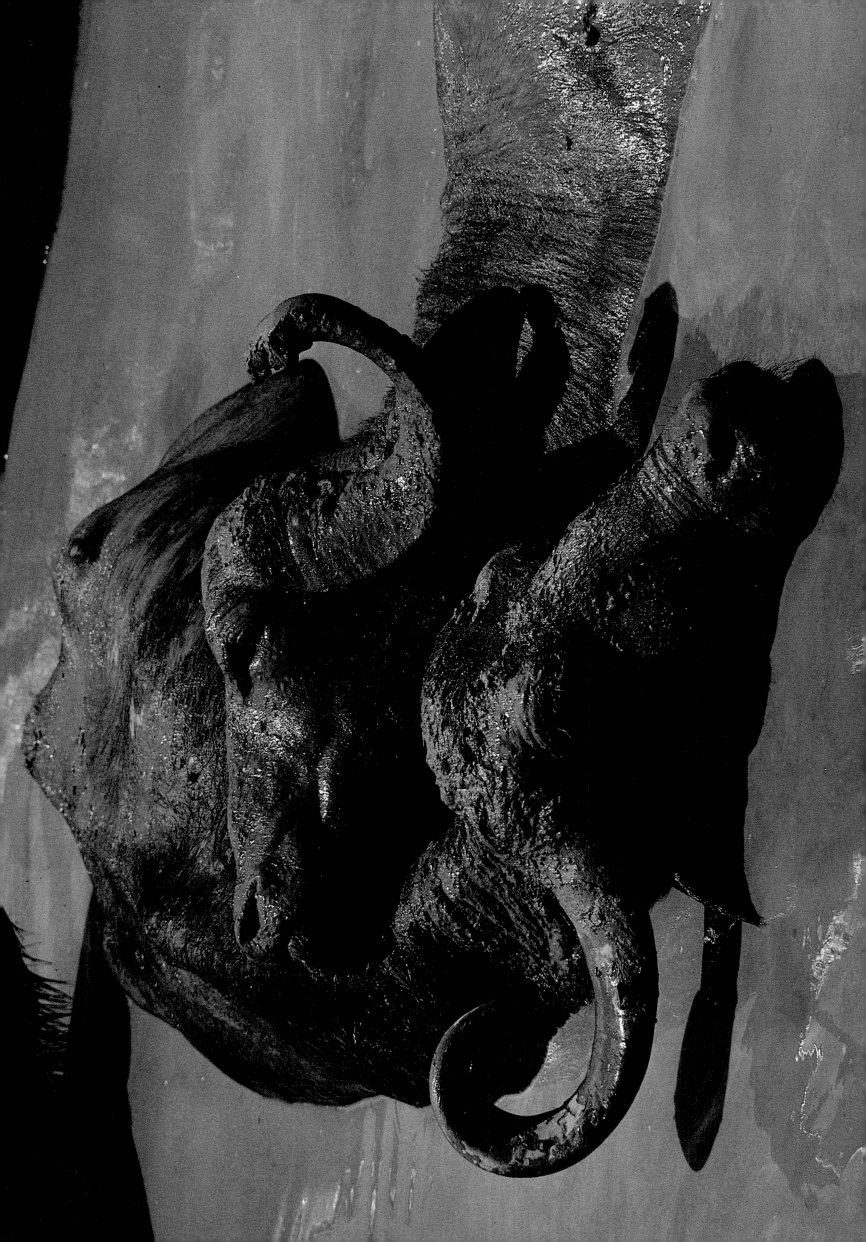

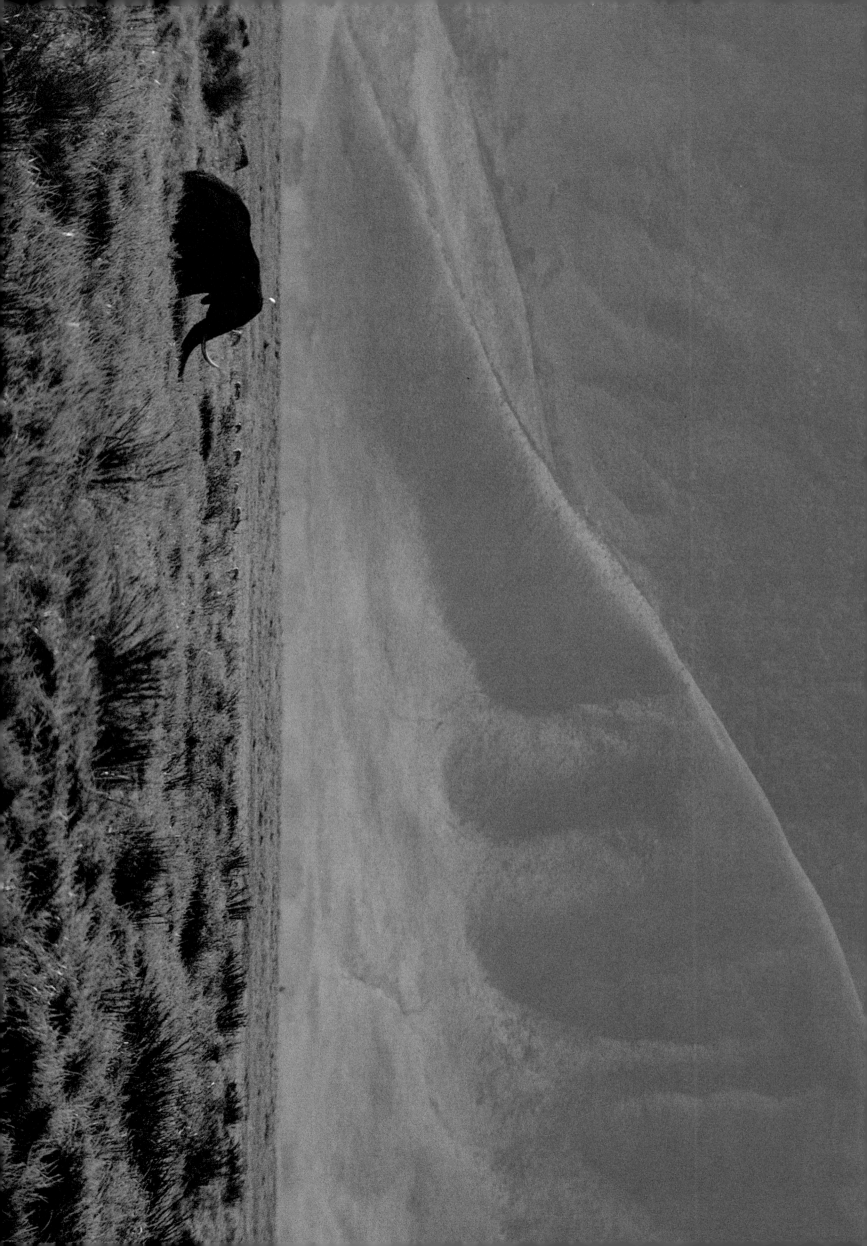

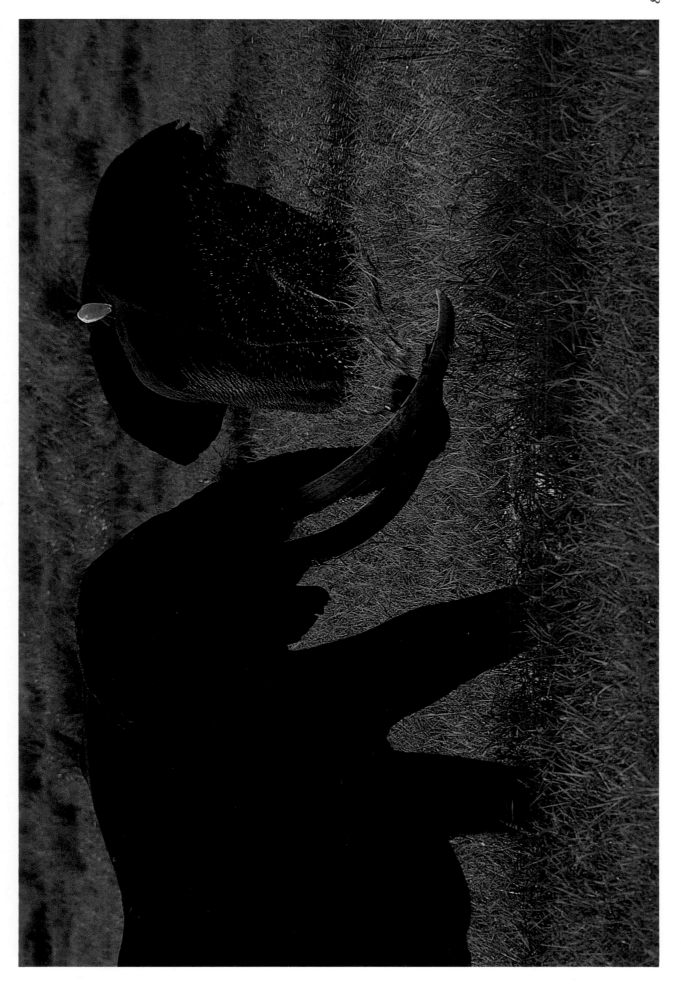

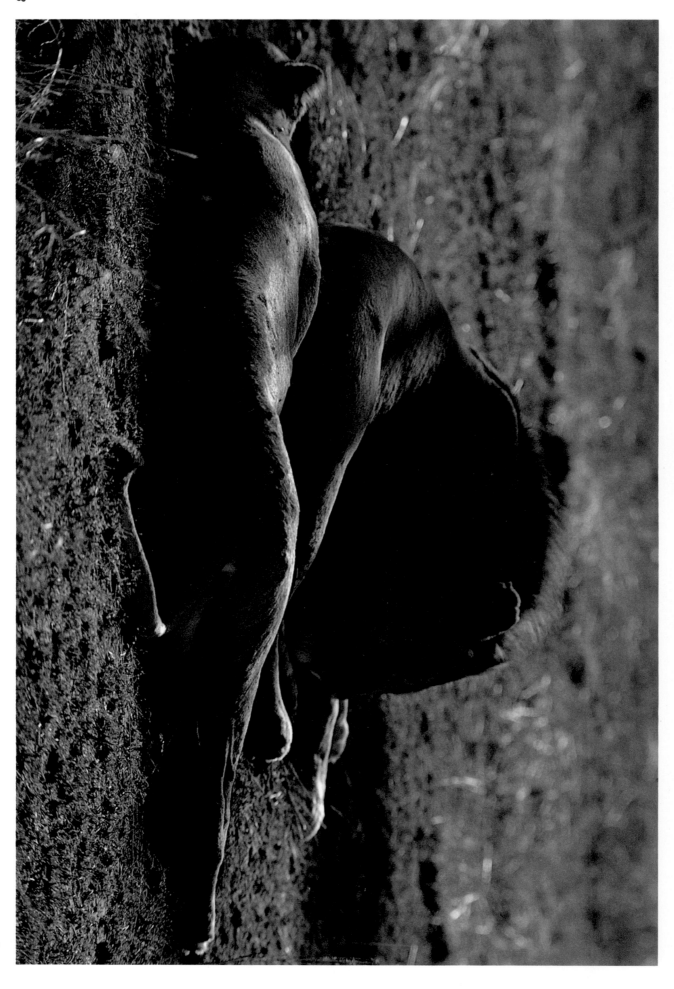

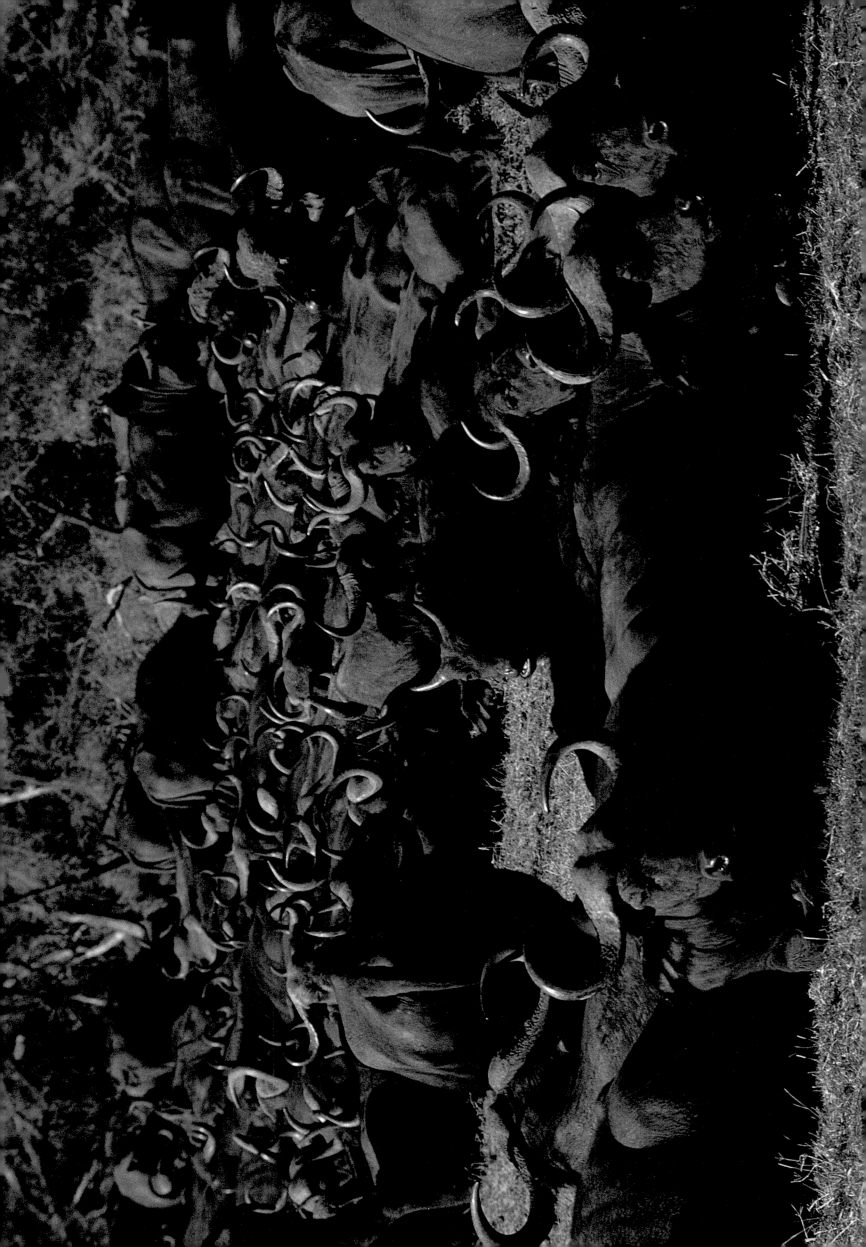

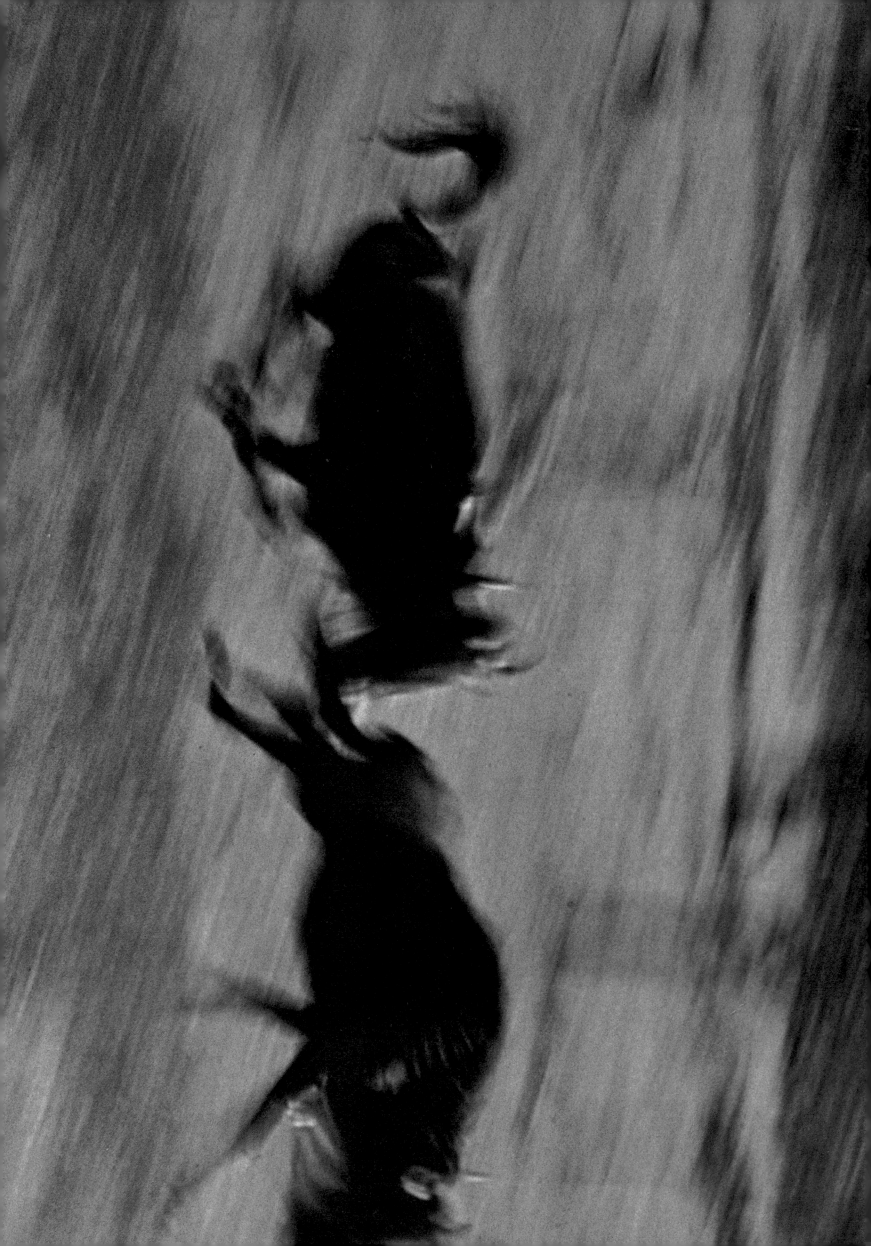

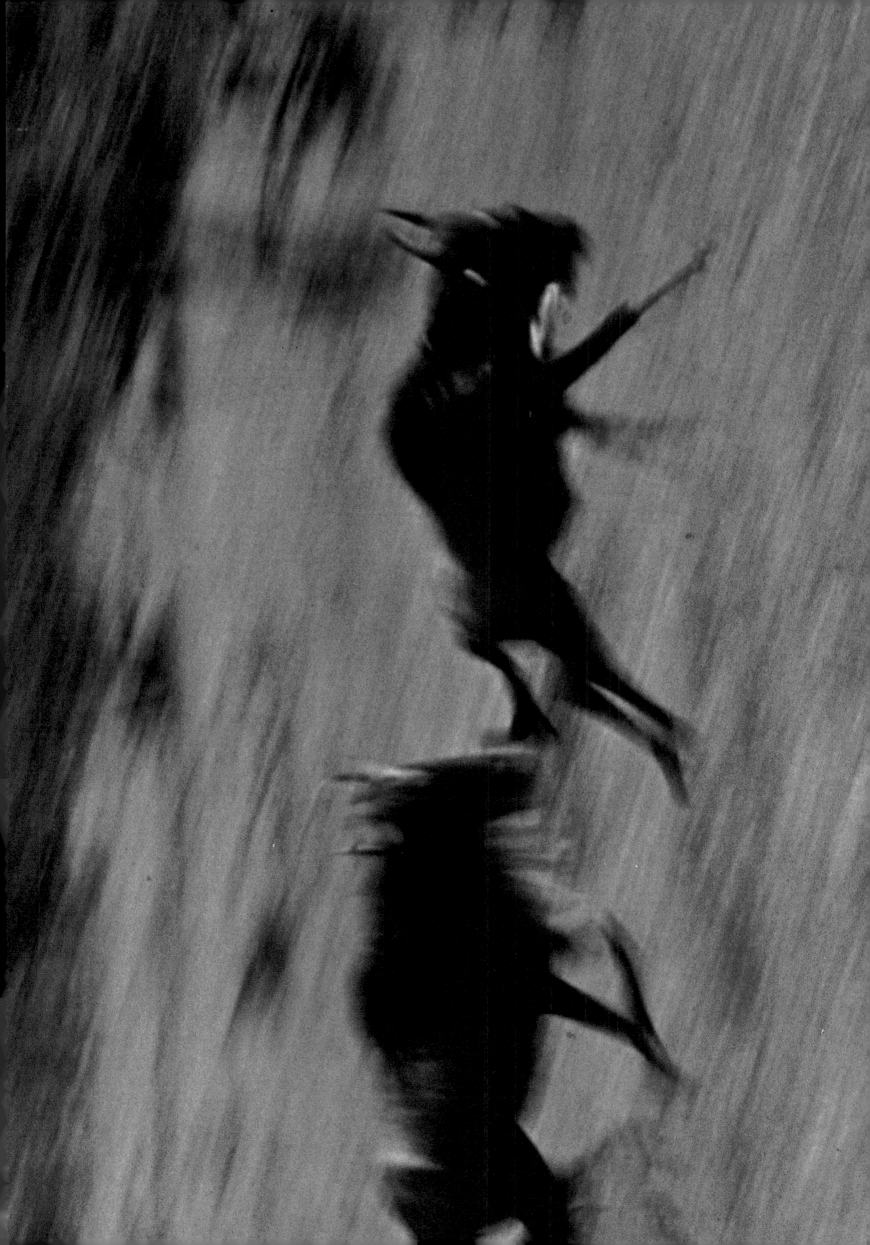

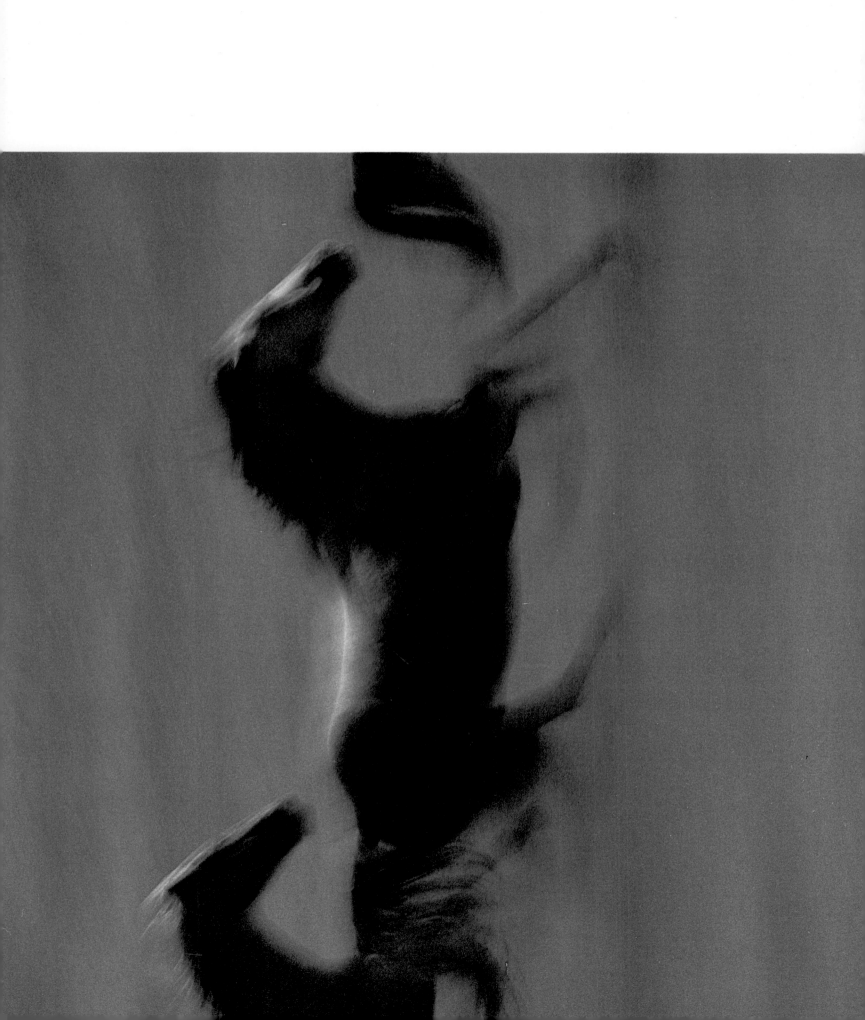

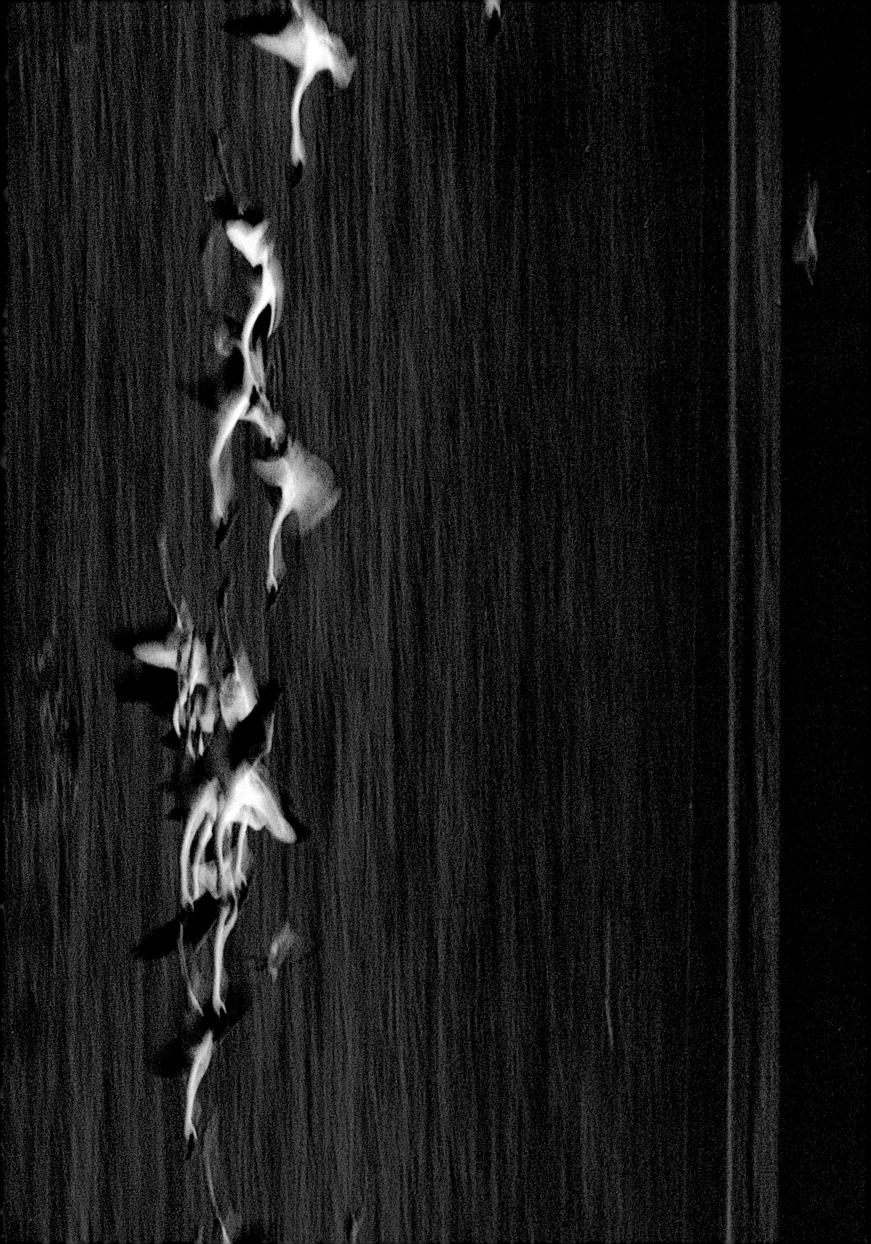

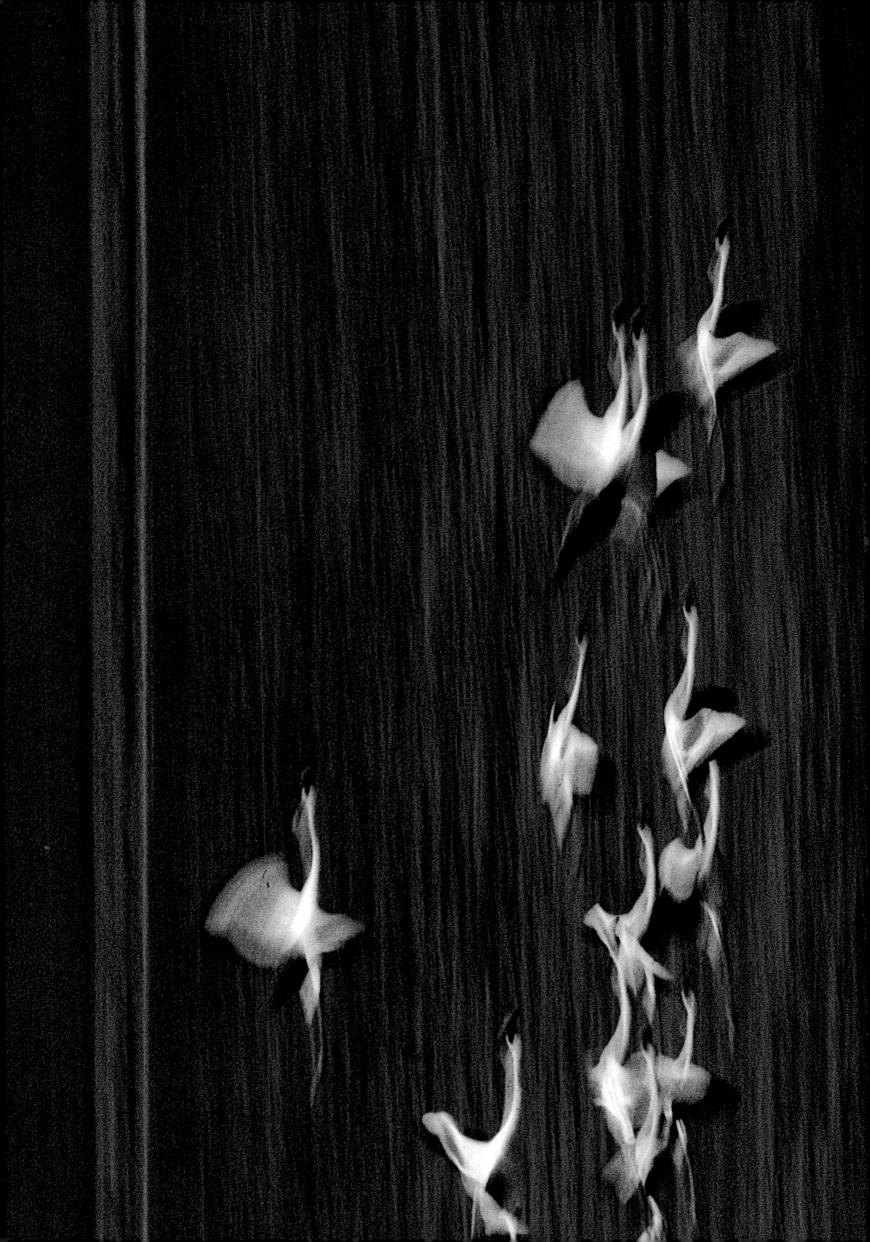

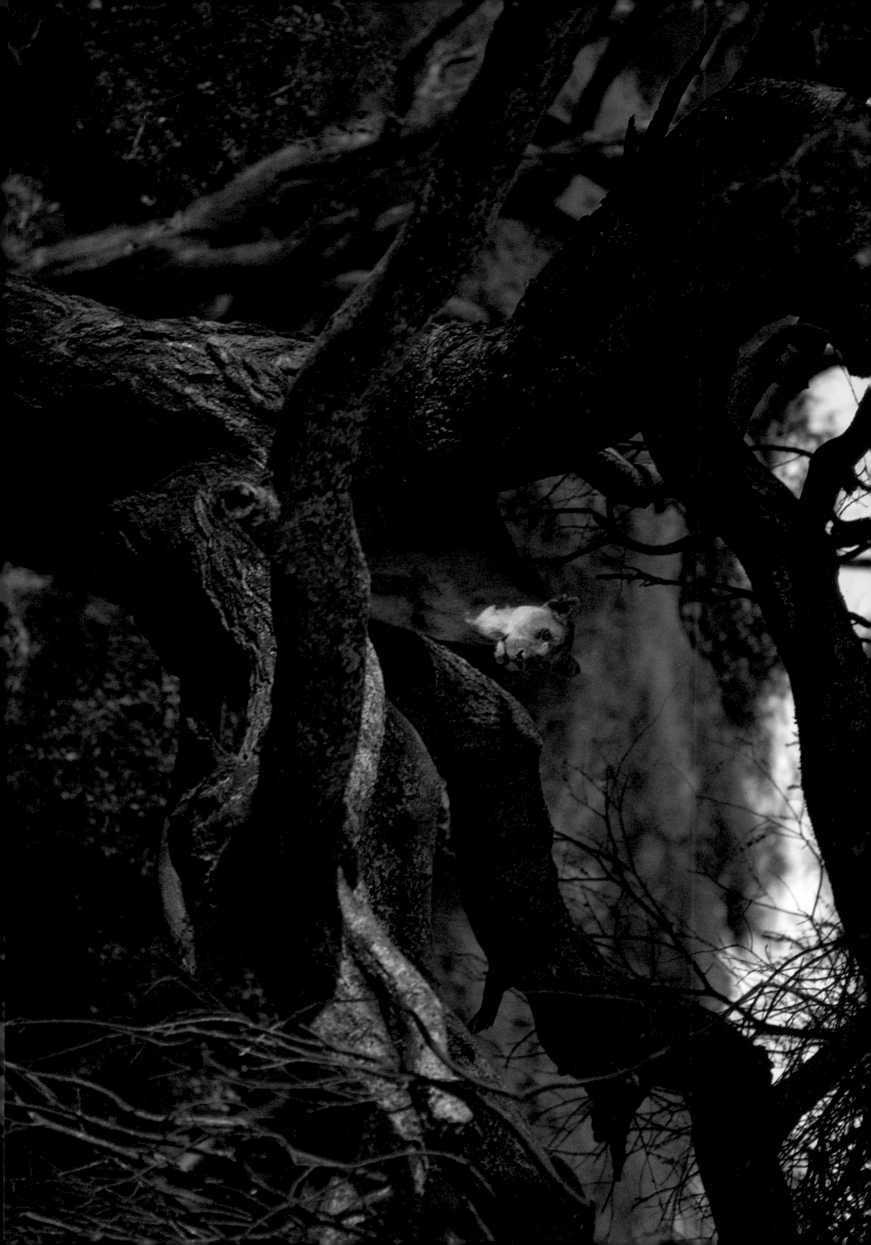

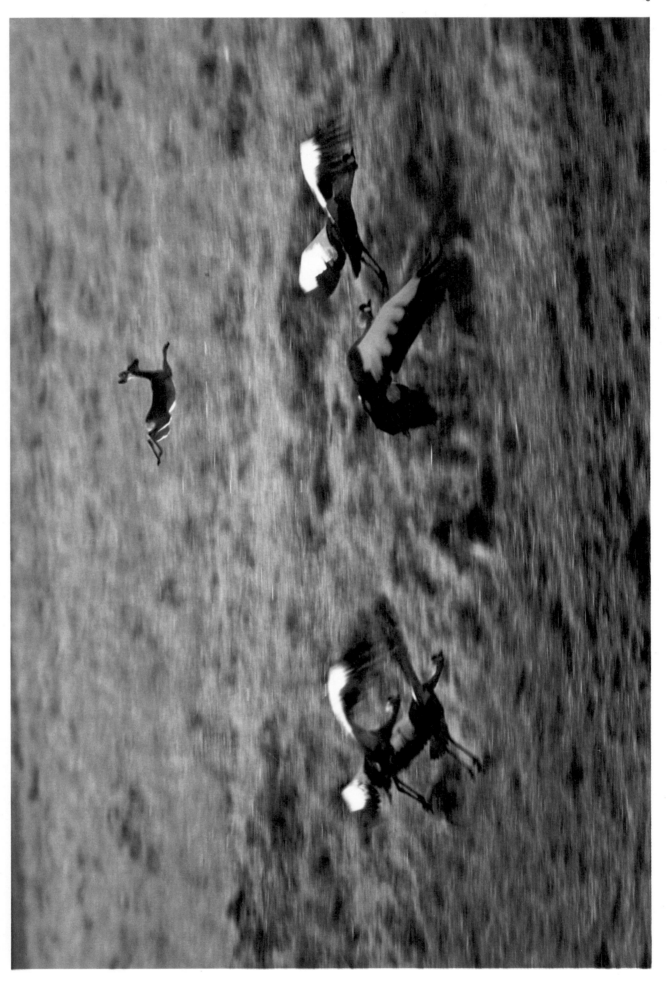

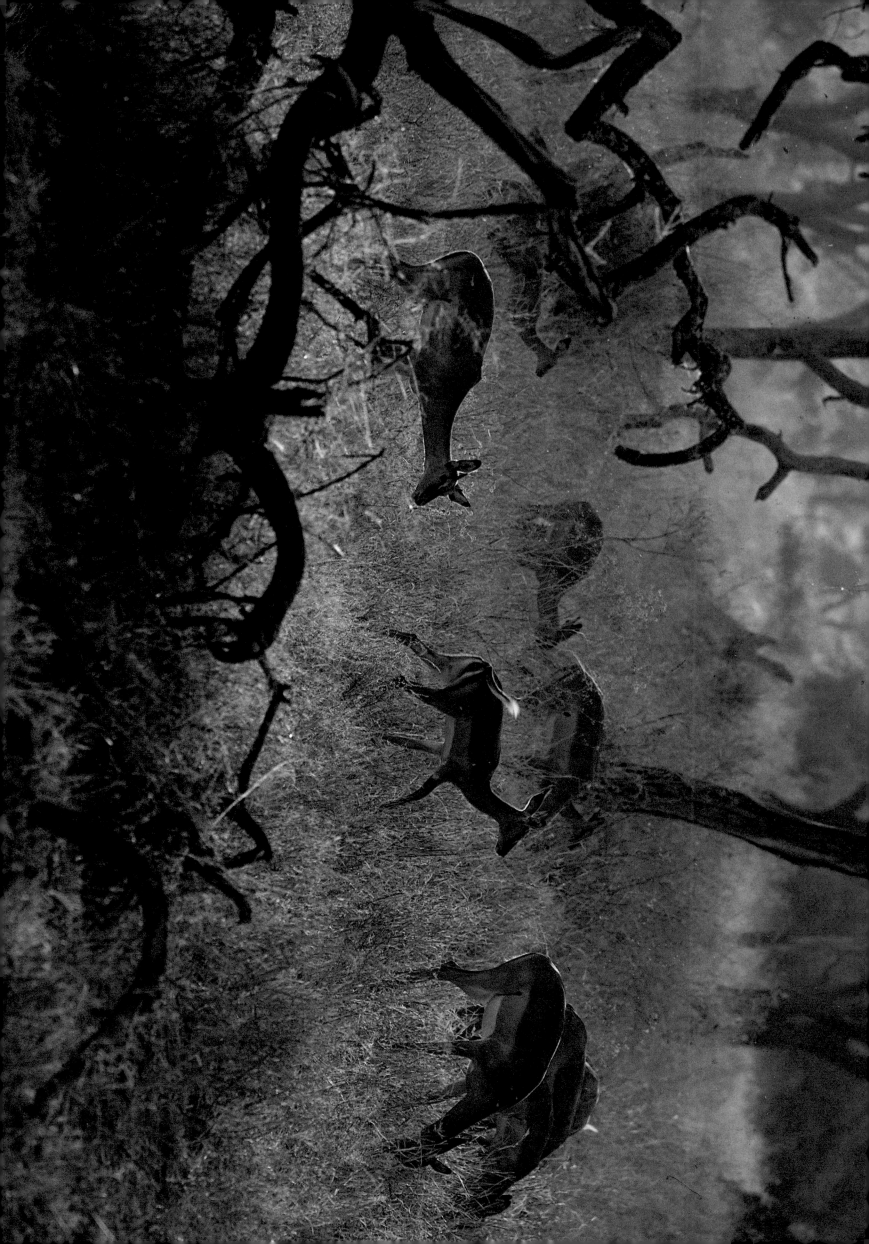

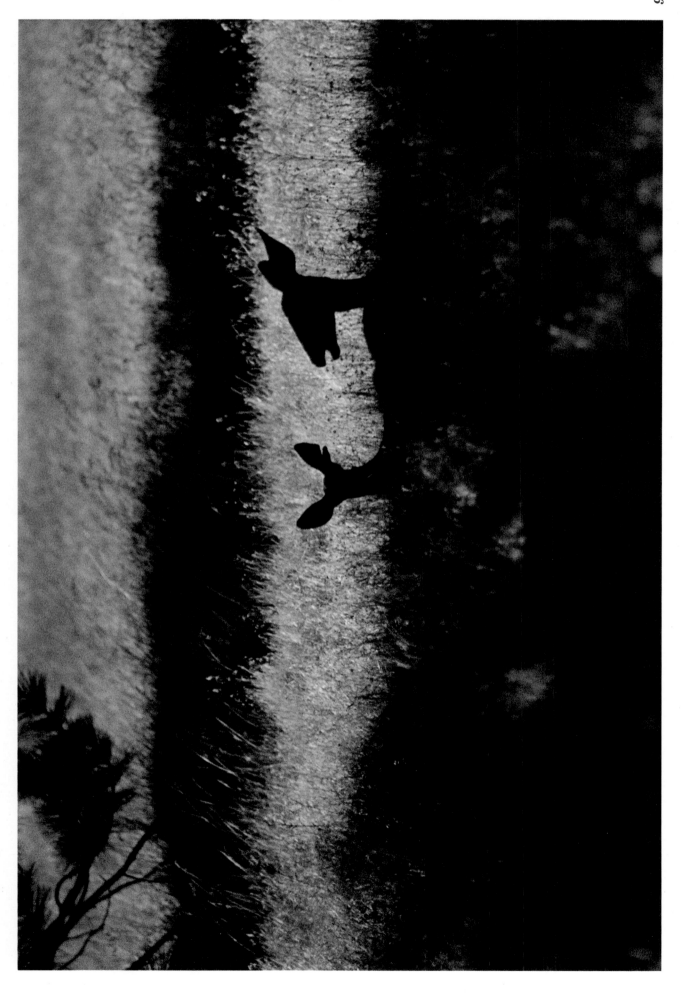

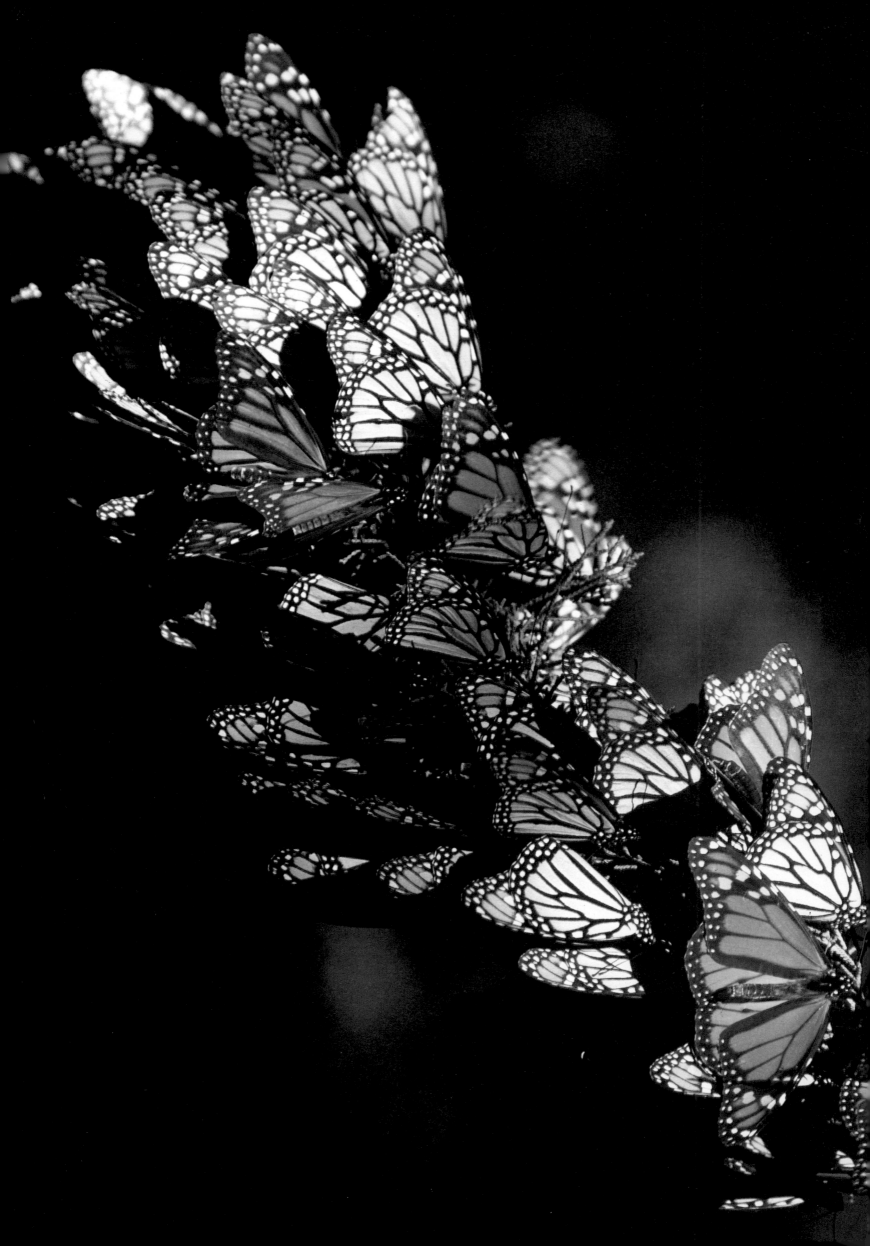

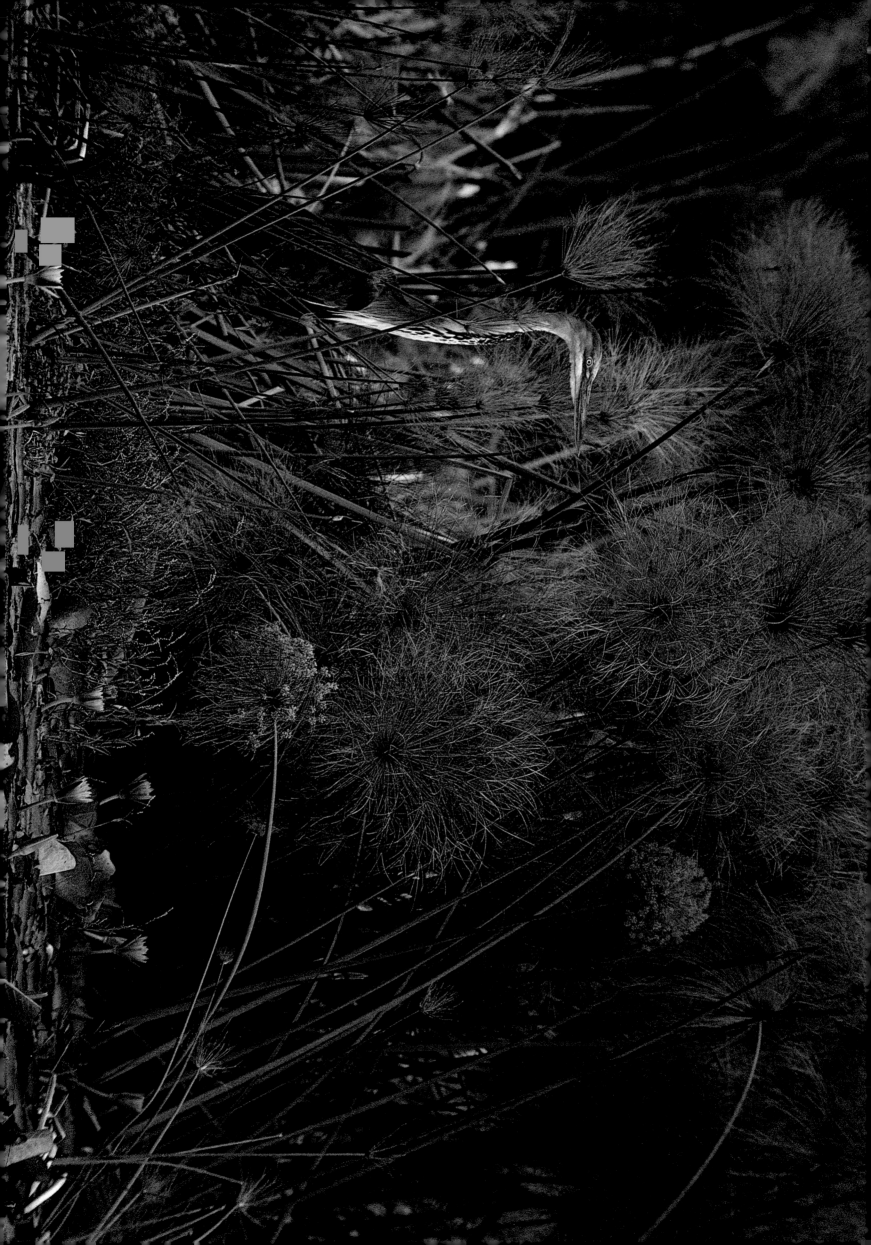

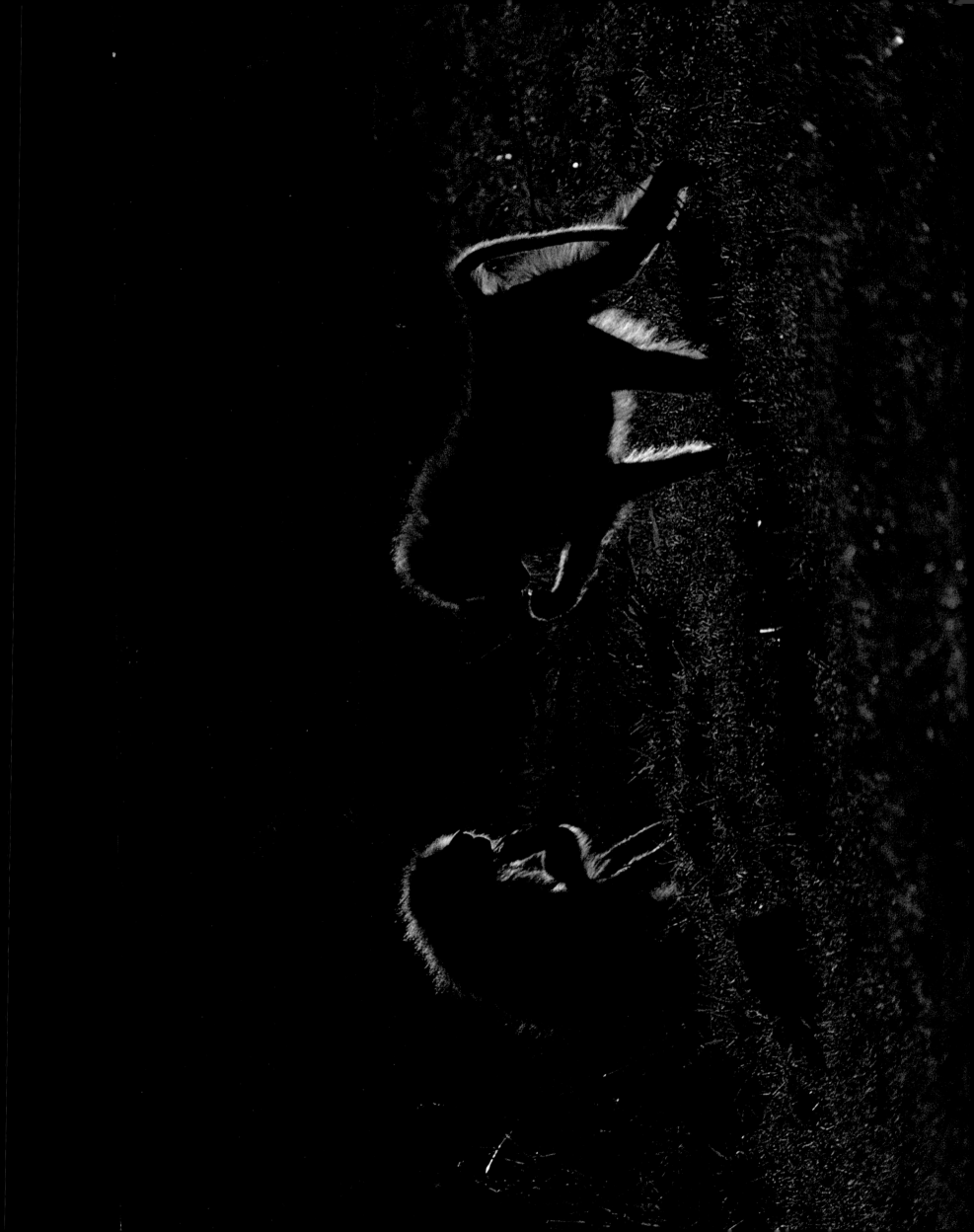

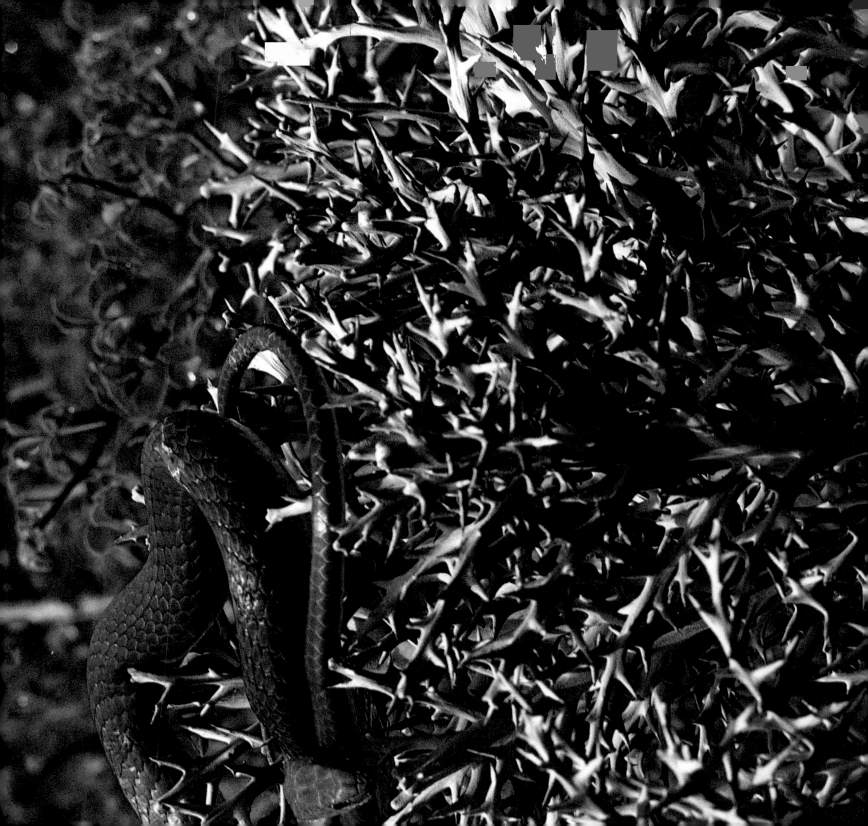

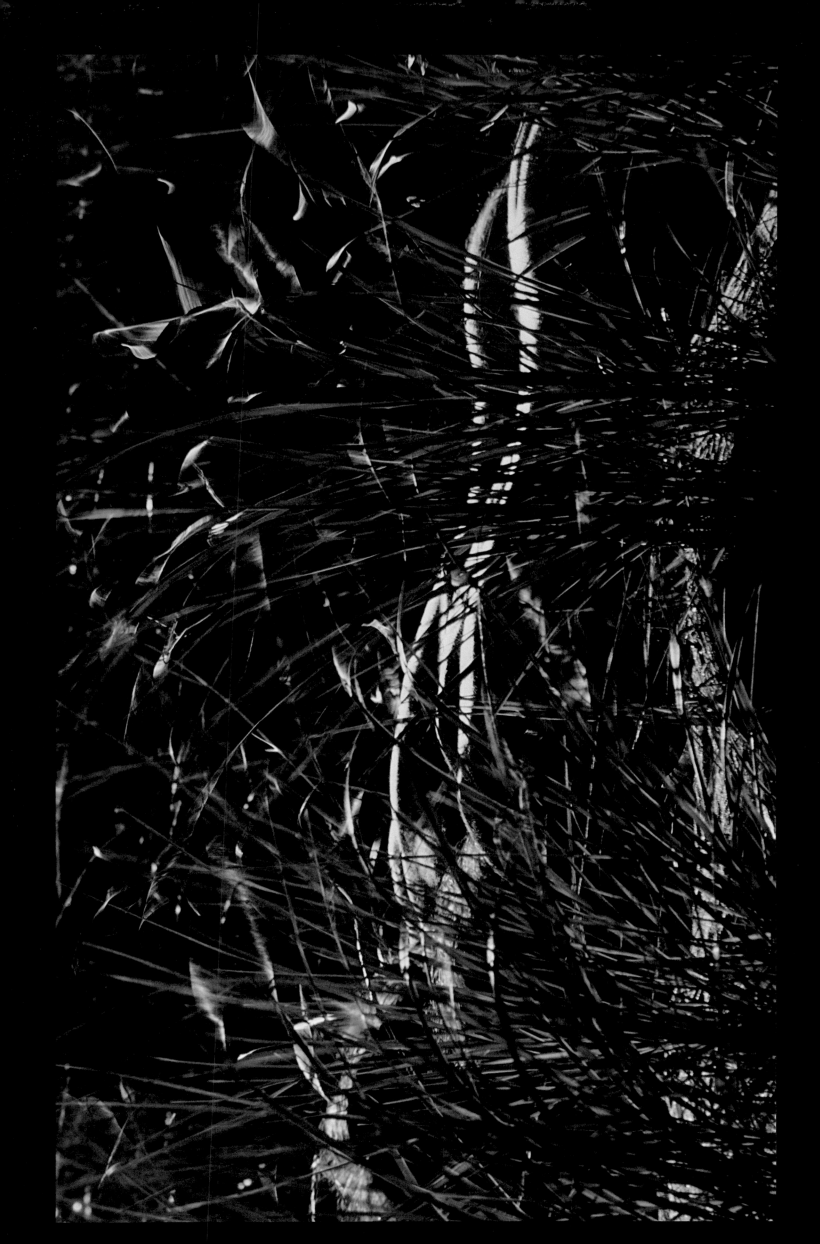

General Notes

Many people who saw the first edition of *The Creation* asked how the theme developed in my mind and how I actually took the photographs.

In fact, the book evolved gradually. Perhaps its roots go back to the day I was born; certainly they lie in my early fascination with natural history. Then, in 1959, I had an assignment—from an industrial company—that obliged me to think of dramatic ways in which to represent elemental power in photographic terms. I thought about the subject of power; I thought about the elements—air, water, fire, the earth. I also found myself thinking about sulphur, for, according to a text I had read about alchemy, sulphur was once considered to be the fifth element. I went to Yellowstone National Park and viewed the sulphur pits, where the natural formations reveal fantastic forms and textures. I took many photographs there, and in California; when the best of these were enlarged I found the results quite staggering. This led me to make further and further experiments along similar lines and in different regions of the world. It was not long before this collection of photographs numbered in the thousands. I sorted them out and catalogued them in my library under such headings as "air," "fire," "water," "minerals," "vegetation," ready for future use.

At this time it so happened that I had an assistant named—believe it or not—Michelangelo. And one day when I came back to the studio after a long assignment he had assembled a number of my photo-

graphs in the projector. With a sparkle in his eyes, Michelangelo turned on some music. It was Haydn. Then, as he started to project the photographs, Michelangelo said to me, ''Do you realize what you have photographed? You have photographed the creation of the world.''

I continued to refine the collection and to round it out with new photographs. Finally it was a question of dovetailing the pictures and making convincing sequences to symbolize the elements, the earth, the seasons—in fact, to symbolize the whole story of the Creation. This volume, as explained in the Introduction, is a re-creation of the book published in 1971.

For those readers who may be interested in how the pictures were taken, I have included a few brief notes about my equipment. These are followed by specific notes about the plates, keyed to the numbers which appear next to the photographs (plates 1–98) in the illustrated section of the book.

Within the last twenty years my camera equipment has changed somewhat, and so has the speed of color film. I have always used Kodachrome, and as testimony to its quality, I must say that even the photographs I took with the old film, Kodachrome I, have retained their color intensity through the years.

Since Kodachrome came on the market I have used it—Kodachrome I, II, 25, and 64—constantly. Because it has fine definition and almost no grain, I have never seen any reason to try out other materi-

als. I don't mean this to sound like a plug for the film; I have never worked for Kodak—only *with* Kodak, and in so many different situations that by now I know the film's characteristics by heart.

I keep my equipment to a minimum, using Leicas M3, M4, and the Leicaflex camera and lenses, which I find eminently satisfactory.

A final word about lenses and filters. I work mostly with lenses of 21, 28, 35, 50, 90, 135, and 180 mm., and sometimes with a 400-mm. lens. I seldom use a filter, except when I wish to reduce reflections and glare.

It is not my purpose to make this a technical treatise, and I assume that readers interested in learning what lenses to use for what occasions and, in general, how to handle a camera, color film, exposure meters, and other equipment will turn to the many excellent technical books on the market or to the literature that the various manufacturers supply.

If I have any word of advice to give, it is that a photographer should learn to work with a minimum of equipment. The more you are able to forget your equipment, the more time you have to concentrate on the subject and on the composition. The camera should become an extension of your eye, nothing else.

Notes on the Plates
The Elements

1. "In the beginning God created the heaven and the earth. And the earth was without form, and void." It was difficult to find an appropriate photograph for the opening plate, but I kept returning to this one, which to me has a very special quality of light, space, and purity of color. I have always called it "Blue Light." It was made at dawn, shortly after a thunderstorm, while I was in a plane flying at an altitude of about twenty thousand feet over the Amazon. (1965)

2. Many years ago, while engaged on a missile story for a series of advertisements, I tried to find ways of symbolizing the power of the universe through the normal use of my 35-mm. camera. This picture, a result of one of my experiments, is a portion of an abalone shell, a reflection on the surface of a small sphere, which suggests a vista of immense proportions. To me it also represents motion and changing light. I still own the shell and have tried many times to improve on this shot, but as yet I have never succeeded in rediscovering the angle and light that produced these particular reflections. The reason, of course, is that the surface of mother-of-pearl produces an infinite number of variations in color and shape. Looking into the shell gives almost as much to the eye as listening to a conch shell gives to the ear. (1959)

3. A section of another abalone shell. The surface is

concave, but the reflections it picked up make it appear convex, suggesting the formation of a crust over the molten earth. Like plate 2, this is a straight shot taken with a Micro-Nikkor 55-mm. lens outdoors by available light. It was made at sunset, which gives it the reddish glow. (1970)

4. While I was working on John Huston's film *The Bible*, my most exciting venture was at Surtsey, near Iceland, soon after the island was born. In the early morning the earth was still steaming from the lava of the previous night's eruption, which flowed down into the ocean. The huge crater kept erupting at irregular intervals and in different intensities. (1965)

5. This picture of the crater brewing and boiling at a fantastic temperature was taken around sunset, when there was just enough darkness to bring out the red heat of the lava flow. (1965)

6. At Surtsey a crew of us camped for four days on what was considered to be the safest site. It was as if we were watching a very fast and small-scale creation of the world. We rested in sleeping bags on very warm ground, changing our positions frequently to keep from getting too hot. (1965)

7. One night when I was in Khajraho, India, an incredible thunderstorm developed, miles away, around midnight. I set my camera (equipped with a tele-

photo lens) on a tripod and then, leaving the aperture open, simply let the lightning serve as a flash. I didn't know what had been recorded until after the film was developed. (1968)

8. The impressive sight of ice and snow high up in the mountains of the Yosemite suggested to me a way of representing the image of a supercolossal storm. The photograph, used horizontally here, was actually shot vertically. I often photograph one subject with the purpose of portraying another, remaining, however, within the same element or a closely related one. It is then a question of composition and scale, which may involve the enlargement of some detail, or what movie people call false perspective. (1960)

9. The island of Oahu, Hawaii, is noted for its surfing waves. Although certain months are better for waves than others, one sometimes has to wait days or a week before the ideal wave rolls in. When it does, the spectacle is awesome, and it is worth the wait. On this occasion I had been waiting with a movie crew for more than ten days, and the tension was comparable to the waves. (Hawaii, 1977)

10 and 11. At Gullfoss Falls, Iceland, in a landscape that is still untouched by man, the water pours over the falls in a powerful stream. Plate 10 is used to symbolize "Let there be a firmament in the midst of

the waters, and let it divide the waters from the waters," and plate 11, "Let the dry land appear." The same kind of mood prevails on stormy days along almost any craggy coast where the rocks are washed by big waves that create innumerable waterfalls as the water recedes and the surface of rock reappears. At Gullfoss it was easy to imagine a big flood surging over valleys and mountains, then gradually subsiding and leaving behind it a stream on the dry land. Plate 10 is a sandwich photograph: a duplicate transparency placed in reverse over the original one to produce the effect of divided waters. (1965)

12. Off the coast of Norway, over the North Sea, I was flying in a helicopter on my way to photograph some oil rigs. A storm was beginning and the sunlight was coming through some dense clouds, creating a constantly moving pattern that made it difficult to distinguish where the sky and water met. The atmosphere had a very threatening quality about it. (1980)

13. "Let there be light." This picture was taken in Norway from the deck of a boat during an early-morning fjord tour. I saw in this rare sight a perfect combination of the four elements—fire (represented by the sun), air, water, and earth. The scene expressed a unity I have never quite found again in this purely visual form. (1966)

14. This picture, which suggests the curve of the earth's surface, looks as if it might have been shot from way out in space, but in fact it is the result of false perspective. The lava ashes of the Surtsey volcano form a dome of such immensity and sharp, smooth outline that, whenever the sun rises or sets over its horizon, one can easily imagine that one is viewing the earth from a tremendous distance. Wind and rain must have smoothed the surface of this mound of ashes, which is so unlike an ordinary mountain. (1965)

15 and 16. "And God . . . divided the waters which were under the firmament from the waters which were above the firmament . . ." This difficult passage in Genesis is represented by a symbolic interpretation showing a rainbow over the sea. Taking the photograph for plate 15 proved to be quite a traumatic experience, for the small plane in which I was flying over Miami (in 1963) was sucked up by clouds and went much higher than the pilot intended it to go. The pilot, a young photographer embarking on his first solo flight, invited me along. Not understanding much about aeronautical problems, I became overenthusiastic about the perspectives he was revealing to me and I begged him not to fly higher. It hadn't occurred to me that he was unable, just then, to do anything but keep on going up, up, and up! There were two rainbows, a phenomenon I had never seen before. The second rainbow in plate 15 is

hardly visible because at this point we had suddenly started a perilous descent. What is seen is all that I managed to capture on film. The second time I photographed a double rainbow was in Iceland two years later. This is shown in plate 16. (1965)

17. The rocky coast of Maine has many natural and untouched habitats for sea flora and fauna. These algae, which caught my eye, were well tucked away in a crevice. Their rich color, which is in sharp contrast with the gray of the surrounding rock, is the result of their being constantly soaked by the tides. (1964)

18. This photograph was taken along the coast of Tobago, when the sun had begun to reappear following a thunderstorm. The shifting clouds threw shadows on the ocean, creating many different shades of green and blue. This beautiful sight is particularly Caribbean. I used a 180-mm. Sonnar lens and an exposure of 1/500 second at f.2. (1968)

19. The smooth, rippling water of a fjord touched by the glancing shadow of a mountain. The colors and patterns reflected in the surfaces of lakes and rivers provide almost endless variations for photographic studies. (1966)

20. Water left in the crevices of a coral after it had been washed by a wave. Small isolated puddles make

a mosaic of the beach and sky in several magnified long-distance reflections. (1963)

21. This picture, made from a plane shortly after take-off from California, represents something of a paradox. The almost wavelike fluidity of the mountains, which, I imagine, might have looked like this in the very beginning of the world, is in fact very modern smog shrouding the mountains around Los Angeles. (1962)

22. During movie-making, when locations are off the beaten track and long periods of waiting occur between takes, I have always used the opportunity to build up my collection of photographs of natural phenomena. Here at Mazatlán, Mexico, while I was working on *Kings of the Sun*, the sea was very close to the set. As I sat watching the waves roll in, my attention kept returning to the strange formations in the sand, which constantly changed with the movement of the very shallow, gentle waves. Through the use of a wide-angle lens, and a polarizing filter to eliminate reflections, I created a landscape that can assume any dimension the eye or mind might wish to give to it. (1963)

23. Shortly after World War II, I first saw and was inspired by the work of Edward Weston, although I tried in every possible way to avoid copying him. Many years later I found this water-covered rock on

the beach at Point Lobos, California, where Weston lived and took many of his famous photographs. Big waves kept sending streams over the surface of the rock, abstracting the many colors of the sea fauna below it and fragmenting it into innumerable hues of ocher, green, and blue. To freeze the fast motion of the water I used a shutter speed of 1/1000 second at f.2. (1959)

24. The broad, glittering expanse of a lagoon on Surtsey, seen from the summit of the volcano at sunset. (1965)

25. Looking down into Hveravellir Geyser in Iceland, just as the geyser had begun to show signs of eruption by sending up bubbles. In between eruptions the beautiful blue water is extraordinarily still and clear, permitting one to peer down into its depths, which harbor all kinds of mysterious images and reflections. (1965)

26. The still, coppery depths of another geyser, thousands of miles away, in Yellowstone National Park, Wyoming. (1960)

27 and 28. These pictures, which look like primeval landscapes with plants beginning to take form, are actually detail shots of the sulphur pits of Mammoth Hot Springs in Yellowstone National Park. Plate 27 shows a smaller detail, a section of the pit about

three feet wide by five feet long, while the area shown in the second photograph is approximately a hundred square feet. For both studies I used a 21-mm. Leica wide-angle lens. (1961)

29. In Utah there is a kind of desert rock called "picture rock," eroded by sand, wind, and rain into fabulous patterns that give the illusion of a third dimension. This photograph, taken at a quarry, gives one the impression of looking into a fantastic cave. (1961)

30. Great Sand Dunes National Monument, Colorado, preserves these dunes, piled at the foot of the Sangre de Cristo Mountains. In many places on earth, sand dunes seem natural, but why here, high in the mountains of Colorado? An important event occurred about seventy million years ago. "Colorado" had already seen billions of years pass. Mountains had come and gone; deep oceans had covered the land and then slowly retreated. Life had evolved from its initial simplicity to incredible diversity. Dinosaurs and rain forests, deserts and swamps, had developed, thrived for a time, and disappeared. Then a great uplift began, edging the sea eastward from Colorado once more. This slow rise has continued intermittently right up to the present; similar forces have acted for thousands of miles along the length of the continent, generating mountain range after mountain range. Today, the Rocky Mountains stand high above the plains from Alaska to Mexico. (1978)

31 and 32. Neither of these landscapes exists now except in pictures. Millions of years ago the awesome formations were covered with water, and today they are under water again owing to the building of the Glen Canyon Dam. I took the photographs in untouched lands along the Colorado River, the site chosen for the filming of *The Greatest Story Ever Told.* While waiting for the shooting to begin, I had days to wander through this fascinating territory right in the middle of the Navajo reservation. The earth, vast and dry, seemed to be waiting for a coming green. (1963)

33. Volcanic cones in the Andes around Quito, Ecuador, overgrown with grass and ripe for richer vegetation. (1965)

34. Whenever I travel by plane I always carry a camera with me. Cloud formations never cease to fascinate me—one can see in them so many variations of images and landscapes. This photograph of clouds and sunset was taken on a flight over India. (1976)

152

The Seasons

35. "Spring." An interpretation of the first of the seasons, photographed in Sicily. (1965)

36 and 37. Flowers are always full of surprises, and to me they always say beauty. Both of these pictures were taken in a botanical garden in Germany with the Leitz 85-mm. macro lens. I was intrigued by the cyclamen—not so much how they looked but how they related to each other. They seemed to have their own sense of space and communication; in a way they reminded me of ballet. (1978)

38. Showers are as characteristic of spring as warm sunshine is. Here I wanted to emphasize the feeling of rain, so I used a slow shutter speed, which enabled me to keep the pink blossoms in sharp focus while allowing the fast-falling raindrops to project themselves in long, wet streaks across the entire picture. (1970)

39. Masses of blossoms photographed from a hill in New York City's Central Park. Through one group of laden branches, others and yet others on more distant trees contribute to the soft profusion of pink and white. (1970)

40. These tulips were photographed near Kyōto after a very heavy spring shower. The combination of the light and the wetness enhances the color, and also the droplets act as tiny magnifiers. The heavy

rain caused one of the stems to bend and thus I was able to capture this composition. (1979)

41. While giving a workshop in Maine, I took the students on a walk in the early morning. This tangle of wild grass with early morning dew forms a perfect composition, one of the perfect accidents of nature that one so often overlooks. (1974)

42. This flower study was made outdoors and with a close-up lens. To get sharp detail I set the camera at f.8 and was obliged by the subdued light to use a low shutter speed of 1/10 second. I found a convenient piece of wood nearby, which I picked up and propped under my elbow to steady the camera in my hand. I would always much rather use some handy prop like this than carry a tripod around. (1971)

43. The miracle of creation is continually manifested by the cycle of plant life. I photographed the rose at intervals of half an hour or so as it gradually opened into full bloom. The picture was made indoors, using available light and my normal Micro-Nikkor 50-mm. lens. (1970)

44. "Summer." On the outskirts of Munich I saw this wild meadow. The day was very warm, and the tree with its slight shade was a very inviting place. (1978)

45. Looking across a valley in Italy, at a magic moment when the trees were tinged by the late-afternoon sun. The suggestion is of a river of gold flowing down through the hollow of the hills. (1964)

46. Detail of a forest floor. The interesting pattern of ground cover with a dominant shoot was photographed in midsummer. (1970)

47. On the island of Kyūshū, Japan, I commented to a Japanese friend that this was the closest thing I had seen to a mini Garden of Eden. She replied, "Yes, like a Japanese universe." All was in a natural state, and one could walk on winding paths and become thoroughly immersed in nature. (1982)

48. A marshy spot in Dark Harbor, Maine, dense with grasses and weeds in various shades of green. I find nature's background color the most challenging of all to photograph, especially in summer, when the light greens of spring have turned much darker. (1965)

49. In the normal course of viewing nature, we often overlook smaller images. When this highlight on a blade of grass caught my attention, I decided to make a close-up shot of it. By photographing the leaf against the evening sun, I was able to isolate and abstract the surface reflection with its several shades of green, leaving the rest of the blade in shadow. (1969)

50. While I was photographing the archeological site of Palenque, Mexico, I constantly came across these huge "elephant ear" plants and became very interested in them as subjects. I would do close-ups, then go under them; the light would shift and the leaves would become translucent. (1982)

51. This photograph, showing the leaves of a giant *Xanthosoma mafaffa* plant looming over a rain forest in Ecuador, symbolizes the end of the time of growth. The flesh of the leaves has been eaten away by insects, and only a skeleton remains. (1965)

52. This black-eyed daisy also symbolizes the end of summer. Its withered petals curl into wonderful forms of tiredness. Withering plants can have such interesting shapes of their own that you forget their original appearance. (1971)

53. During autumn Norway tends to be very rainy and damp, and this kind of weather always enhances colors in nature. This vibrant yellow tree was at its peak. (1979)

54. Autumn in northeast America is as colorful and spectacular as one can see anywhere. Near the George Washington Bridge on the New Jersey side I found these trees on a steep slope by the Hudson River. (1970)

55. This wet day was perfect for photographing some petroglyphs, because the carvings show up best when the rocks are moist. I was near Göteborg, in southwest Sweden, and while taking a break from the petroglyphs, I photographed this autumn tree. (1979)

56 and 57. Every country somehow manages to have some aspect of nature that is unmistakably its own. In the fall of 1981 I was photographing a great deal in Japan. These two pictures were taken near Kyōto, on different days, but after a shower in each case. I was very struck by the magnificent color combinations and varied forms of the leaves. (1981)

58. These jagged rock formations are of volcanic origin. The waterfall is one of the most beautiful I have seen. It is on Kyūshū Island, Japan. (1981)

59 and 60. Ice patterns. Seen through the almost frozen surface of a river, the rocks and stones lying at the bottom assume unusual shapes and colors. Plate 60 shows bubbles in a thin layer of ice covering a small stream. Both patterns seem to be reflections of the universe itself. (1966)

61 and 62. Two pictures that capture winter at its absolute. Accumulations of snow on the branches make the trees look as if they were covered with blossoms. Plate 62 is a double exposure: I trained my

Leica on the trees, photographing them at 1/25 second; then I took a second shot on the same frame of film (at 1/100 second), focusing on the flakes near to the camera. (Yosemite, 1966)

63. The inanimate often suggests the animate. Here, the smooth, flowing contours of newly fallen snow over stones in the bed of a shallow river bear an astonishing resemblance to human figures. (1964)

64. I had an assignment to photograph several national parks during the winter. When I was in Yosemite, I saw this early spring bud, totally protected by ice. (March 1966)

The Creatures

65 and 66. Primeval-looking iguanas moving across the rocks of Narborough Island in the Galápagos as the evening mist rolls in. The iguana in plate 65 was made to assume almost mammoth proportions through a close-up shot. (1969)

67 and 68. A swarm of flamingos, viewed from an airplane over Lake Huntington, Kenya. More than three million birds were clustered along the volcanic shoreline alive with hot springs. The flamingos go from lake to lake in search, particularly, of certain chemicals that are not always found in the same place. Both photographs were taken with a normal 50-mm. lens and a polarization filter. (1970)

69. Eagle in flight. Moving my camera to follow the bird's path of flight during a high-speed exposure reduced the trees in the background to an abstract pattern that intensifies the impression of motion. (1970)

70. A heron photographed during the last light of evening. The striking silhouette occurred as the bird was coming to a halt before landing on the stump of a tree. My camera was set at 1/500 second at f.2. (1970)

71. The blending of flying seagulls and shimmering waves creates a sort of optical illusion. I took this picture while standing on a high cliff overlooking the ocean on the west coast of Iceland. (1965)

72. At a fish hatchery in Kashmir. The water was crystal clear but filled with reflections from the sunlight. To eliminate this distraction I used a polarizing filter, which also helped to bring out the colors. (1968)

73 and 74. Both these pictures were taken in an aquarium. The moray is very primal in appearance and probably has changed little throughout the ages. The dolphins were photographed through the window of one of the exhibition tanks in the Miami Seaquarium. The available light allowed for an exposure of 1/200 of a second at f.5.6. (1968)

75 and 76. A giant turtle inching its way across a rock in the Galápagos. It was more than four feet in circumference and must have been at least a hundred and fifty years old. Although there are many of these huge turtles in the region, I had to walk for nearly seven hours to find one. The Galápagos Islands are also the breeding grounds for millions of crabs, which, in the evening sunlight, and especially after being washed by the sea, take on the strong, lustrous red hue shown in plate 76. (1965)

77 and 78. Few creatures give one a stronger sense of prehistory than crocodiles and hippos. Both these pictures were telephoto shots, taken from a small boat on the Nile near Murchison Falls, where exotic wildlife is still to be found in abundance. (1970)

79. The tenderest aspects of nature are beautifully expressed by the gentle behavior of this sea lion with its young. The smooth outlines of the rocks on which the two are sunning themselves correspond with those of the animals, while the background color is in happy contrast. (1966)

80. While in Trinidad I came upon this couple of water buffalo. It was a very hot day and they were cooling themselves in muddy waters. They communicated their enjoyment thoroughly. (1968)

81 and 82. The animal in plate 81 might at first glance be mistaken for a mammoth. Furthermore, the outline of the mountain in the background clearly suggests the form of a dinosaur, making this whole scene in Kenya seem to belong to a time long before the dawn of history. The elephants appear to pass their days in total contentment, refreshing themselves by splashing in the water. (1970)

83. The Serengeti National Park is famous for its population of lions, which hunt mostly by night and sleep during the day. I took many photographs of this couple in full sunlight but preferred the quiet mood and color of this shot, which was exposed as a cloud passed overhead. (1970)

84. Although this herd looks peaceful enough, the buffalo is one of the most dangerous animals in

Africa. I took the photograph from a Land-Rover, using a telephoto lens. (1970)

85. The wildebeest is often called the clown of the plains. The animals live in big migratory herds, and whether running or walking, they are always in perfect formation, one after the other. Their movements are well organized, like those of an army. I came upon this group between Serengeti and Masai Mara. (1970)

86. The fleeting image of this herd of horses was photographed from a small hill. The slight elevation was an advantage in capturing the sense of speed. (1978)

87. Flamingos flying in formation one evening over the dark green water of Lake Huntington. I used a polarization filter to reduce reflections and bring the background into a path of even color. The slow exposure, about 1/5 second at f.11 (using a Leicaflex 400-mm. lens), caught the graceful fluttering movement of the birds' wings. (1970)

88. It is not unusual to see a lioness perched on a tree. They are great huntresses. The late-afternoon sunlight enhances her color. (1970)

89. In Uganda I spent the best part of a day following a flock of cranes. While my camera was trained on the birds, I suddenly became aware of the leaping impala. It was as if this graceful animal had been inspired by the flight of the birds and was trying to compete with them by taking long flying jumps. I used a Leicaflex 400-mm. lens. (1970)

90 and 91. Two pictures that look as though they might have been photographed a few feet apart were, in fact, separated by many thousands of miles and ten years of time. The herd of graceful impala was photographed in East Africa in 1970, and the picture of the deer and faun, who are resting in the shade and appear to be holding an intimate conversation, was taken in California in 1960.

92. The Monarch butterflies are a very beautiful sight. They are indigenous to the west coast of North America, from Canada to Mexico. During their mating season they cover trees by the millions. These I saw near Monterey, California. (1971)

93. My intention here was to communicate what a bee sees when it enters a flower in search of nectar. The subtle light filters through the flower and thus the bee is silhouetted. I used a Micro-Nikkor 55-mm. lens. (1965)

94. Perhaps a corner of the Garden of Eden looked like this. For three days, working from a small rowboat between the lush green papyrus islands of the

Nyasa Lake district, I studied the life and movement of the beautiful Goliath heron. He stands tall and moves slowly and silently in the most colorful of settings. (1970)

95. Late one afternoon I came upon these two baboons along the banks of Lake Manyara and watched them playing and feeding. There was something very human about the pair, both in their appearance and in the way they reacted to one another. (1970)

96. In the National Park at Nairobi I turned in surprise to find this snake lightly coiled on the spiky branches of a thorn bush. The creature seemed to be suspended in midair and to symbolize the magnetism of all the snakes of the world. I photographed it with a 90-mm. Leica lens at a distance of about ten feet. (1970)

97. Perhaps the most challenging subject in the portrayal of "The Creation" is man. This photograph was taken, quite simply, on a sand dune. A gentle wind was blowing, and the rays of the early-morning sun fell directly on the two figures side by side in the grass. (1970)

Front cover. This photograph, taken near San Francisco, has an atmospheric feeling, a disturbing quietude—as if a storm could suddenly arise, or the sun could slip away through the rolling fog. (1980)

Back cover. This is a close-up of a detail taken in the La Brea Tar Pits in Los Angeles, which are like a museum of information about ecology. (1971)